Photojournalism

Photojournalism

Third Edition

by

Arthur Rothstein

AMPHOTO

American Photographic Book Publishing Co., Inc.

Garden City, New York

Foreword

In recent years, I have had the opportunity to attend various international meetings of photographers. In one instance, I was the United States judge at the World Press Photo Exhibition in The Hague, Holland. Here, representatives from the Soviet Union and its satellite countries met with other judges from England, France, and other nations of Europe in order to choose the best news photographs. I have also been a periodic exhibitor at the biennial Photokina Exposition in Cologne, Germany, where photographers from all over the world gather to observe, examine, discuss, and fraternize.

These, and other experiences in such diverse places as Moscow, Buenos Aires, and Tokyo, convince me that photography is truly the most useful and powerful universal language, transcending all boundaries of race, politics, and nationality.

We have not yet learned to use photography to its full potential in cementing international relations. Early in this century, several universal languages were developed, including Esperanto, Ido, and Interlingua. But none of these can equal the photograph in impact—simple and direct, easily understood.

Under the direction of a skilled photographer, the visual image may be used to draw comparisons, to distort, to emphasize, and to document social conditions. The photograph not only presents facts; it registers ideas and emotions as well. Moreover, the camera records events with greater accuracy than does the human eye.

Because powerful photographic images are fixed in the mind more readily than words, the photograph needs no interpreter. It means the same

thing all over the world. No translator is required for a picture of a soldier dying in Indochina, a refugee in the Bay of Bengal cyclone, a monk burning himself on a street in Saigon, an assassin striking at the Premier of Japan, or a man walking on the moon.

Just as the writer uses words, sentences, and paragraphs to express ideas and communicate information, the photographer assembles his images. The single still picture may be expanded into a sequence, as a series of highlights of chronological action, or it may be combined with related photographs to produce a picture story or photo essay.

The ease and economy of transmission of the still photograph from one part of the world to another strengthens its international significance. There are no restrictions on the distribution and movement of pictures by courier, mail, cable, or radio. In fact, a cooperative network of agencies and syndicates provides such excellent facilities that a still picture made anywhere in the world may be transmitted to any other part of the world within an hour.

Unfortunately, this cooperation does not apply to the photographer. Well aware of the power of the photograph, many governments and agencies are reluctant to provide true freedom for the cameraman. Even in the United States, there are places such as courtrooms where a photographer cannot operate, although word reporters are welcome.

The skilled photojournalist selects the significant moment. His pictures have the quality of truth and believability. They may inform, enlighten, convince, and persuade.

That is why I believe that the photographer who uses this universal language has a great social responsibility. His success will depend on how well he penetrates and probes the problems of our times and communicates ideas, facts, opinions, and emotions with inspirational vision.

Contents

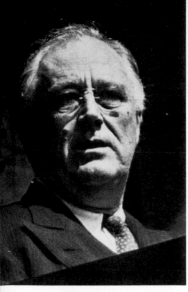 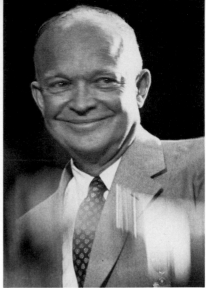

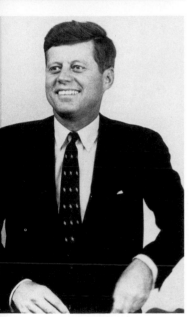

"The camera reporter makes a major contribution toward greater understanding among the people of all nations. Pictorial reportage is the most universal of all languages. It is an indispensable tool of freedom in these days when so many people are oppressed and personal freedom is restricted in many parts of the world."

Dwight D. Eisenhower

"Pictures, by telling their stories quickly and dramatically to all peoples of all nations, transcend all language barriers. Photo-journalism therefore assumes a position of vital importance in the expanding field of communications. By combining their skills, the reporter and the pictorialist can do much to increase understanding between Americans and all peoples of the world. The need for this understanding is perhaps greater now than at any time in the history of mankind."

John F. Kennedy

Introduction

Photojournalism requires a constant evaluation. For the photographer in this exciting field of visual communication, technical proficiency is not enough. It takes effort to keep up with the changes in photographic technology, such as new films and equipment, but this is a relatively easy task compared with the problem of maintaining high aesthetic standards and sustained intellectual curiosity.

The photojournalist who uses the camera as an effective form of communication should never forget the basic principles and unique assets of photography. As a means of expression, the camera in the hands of an intelligent, trained observer can perform in a manner that is unequalled by any other graphic medium. The photojournalist can reproduce fine details, render accurate perspective, emphasize tone or color, and capture the most revealing moment. There is opportunity here for infinite exploration.

However, there are other essential qualities. These are: anticipation, believability, and significance. *Anticipation* because photojournalism does not report the news; it anticipates what an audience will want and needs to know. *Believability* because photographers and writers must live with a story if the audience is to believe the photographs are what they purport to be. *Significance* because stories without it will soon bore, and one will quickly lose one's audience. And, when no one is listening, the photojournalist is, by definition, failing to communicate.

Certain techniques have been developed at the large national magazines to help tell a story effectively. These techniques differ radically from those used in other media—television, newspapers, special-interest magazines—but it is useful to see the full process as one medium developed it. Briefly, the techniques are:

1. *The idea.* Ideas are our lifeblood. When you are anticipating news, instead of reporting news, you do not have any crutches. You cannot lean on a scandal in government or a sudden political crisis abroad to bail you out of a dull period. You must examine hundreds of ideas each week in order to be ahead of events. You must anticipate the scandal or the foreign political crisis even if it seems sudden to most journalists. Once ideas have been selected, they are assigned to editors.

2. *The background.* The editor in charge of the assignment begins his investigation, assisted by trained research assistants. After he has digested the research, the editor must decide if there is a story in the idea, and if there is, what direction the story will probably take. Editors will quickly modify or even discard altogether the original idea if they find, when they get out into the field, that the actual facts are not what research had indicated they would be. There is no pressure to make facts fit the story.

3. *The photographer.* After conferring with the managing editor, the editor will ask to have a photographer assigned to the story. Once assigned, the photographer goes over the research with the editor. At this point our nomenclature changes. The editor becomes a writer–editor or a writer–editor–producer. No matter what you call him, he is in charge of "the idea" and the words for the story.

4. *Location.* The best way, if not the only way, to obtain believability is for the writer–photographer team to go out in the field, to live with their story, and to get to know intimately all the people who comprise their story. Needless to say, this results in astronomical travel bills. It also results in believable stories. Since travel is expensive and film is cheap, photographers shoot and shoot and shoot. Many of you have heard complaints about the thousands of photographs taken in order to get the five or six ultimately used. There are good reasons for this procedure. First, the camera has no eraser; you cannot fix up your mistakes. Second, since photographers are not there to make the facts conform to a story idea, they must photograph everything that may ultimately prove to be pertinent. They cannot just settle for five or six pictures that might work with the original story idea. Third, photographing the same subject from many different ways and different angles gives greater freedom to the designer when he makes the layouts.

5. *Assembly.* Once the photographer is satisfied and the writer (who is generally present for every picture) feels he has his story, the team returns. The photographs are then developed. Frequently the editors decide how much space to give a story by the quality of the photographs. Once the determination of space has been made, the photo-

graphs are brought by the editor, the same editor who was out on location, to an art director, who will be responsible for making the layout. If available, the photographer is also present, and he becomes involved with the editor and art director in producing the layout. The layout is done before a word of text is written. After the layout has been made and the photographs actually printed up, dummy type is ordered and a complete page is made up to show what the whole layout is going to look like.

6. *The writer.* The writer now gets down to the typewriter. Headlines, picture captions, text—it's all his now. The captions must add a dimension to that which is observable in the photograph. The writer cannot just describe that which is visible to the naked eye. His headlines must fairly, but dramatically, summarize and "sell" his article. And the text must come from his experiences in "living the story." It's a blood, sweat, and tears process. Other editors may make suggestions in order to help the writer express a thought more perfectly in his own individual terms. They do not write it for him. When he is satisfied that he has told his story, that's it. The story is ready for the typesetter.

The great challenge for the photojournalist lies in the blend of words and pictures. We must stress original, crusading, and investigative reporting. The modern photojournalist should not merely cover the news. He should make the news. The process of communication is so complex and expensive that to justify the cost and effort, the photojournalist must have something important to say and know how to say it. Above all, he has the power, duty, and privilege to bring light to a darkened world, the light of understanding.

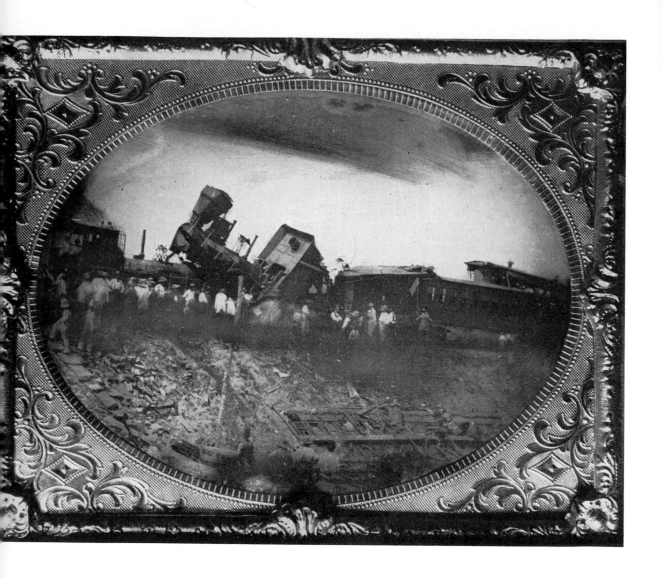

A "spot news" daguerreotype of a railroad wreck near Pawtucket, R.I., made in 1853, just 14 years after the announcement of the first practical photographic process. The newspapers of the time could not reproduce photographs except as hand-engraved copies.

1

Vision in Communication

The Evolution of the Photojournalist

These are the photojournalists: observers of people and events who report what is happening in photographs; interpreters of facts and occurrences who write with a camera; skilled communicators whose images are transmitted visually via the printed page.

Their audience consists of the readers of newspapers and magazines all over the world. Their subject is this planet and its inhabitants in all their aspects, for the photographic image speaks directly to the mind and transcends the barriers of language and nationality.

To those who practice this form of communication, the photograph is but a means to an end. This end is publication: the mechanical reproduction of the photographic statement so that the largest possible audience is reached.

Photography has three different aspects:

Creative—the aesthetic, interpretive art to which contributions are made by a relatively small group of amateurs and professionals.

Commercial—the production of functional pictures by skilled professionals for practical purposes like advertising, promotion, publicity, information, and publications.

Hobby—the art and craft practiced by millions of amateurs, many of whom take their efforts more seriously than professionals.

The product of photojournalism combines some of the first two classifications. The important and outstanding consideration is that the photograph is not the final effort; its publication is. This inevitable adjustment to the requirements of the printed page has created photojournalism and given its practitioners their limitations, disciplines, and greatest satisfactions.

Important Inventions

In the early history of photography, the two critical discoveries that contributed to the modern practice of photojournalism were:

The invention of a practical, workable method that gave, in the camera, a negative from which positive prints could be made. This was the discovery of William Henry Fox Talbot, who first reported it to the Royal Society in London in January, 1839.

The introduction of the halftone process made possible the quick and inexpensive reproduction of a photograph in conjunction with words set in type. It was the result of Stephen H. Horgan's experiments at the New York *Daily Graphic*. The first photograph to be printed in this manner was of Shantytown, a squatters' camp in New York, photographed by Henry J. Newton. It appeared in the *Daily Graphic* on March 4, 1880.

These two technical advances are the foundation of modern visual communication. But the concept of telling the news pictorially goes back to the wall carvings of ancient Egypt and Mesopotamia. The Chinese and Japanese alphabets today are collections of picture ideas that are combined to form mental images.

The great artists Hogarth, Goya, and Daumier were journalists, too. Certainly the concept of picture reporting is as old as man's drive to tell a story through drawing pictures. The use of the camera merely makes the pictorial presentation of the information more efficient, faster, and available to more people.

Essential Qualities

The photographic process has certain inherent characteristics that the photojournalist recognizes and emphasizes. They are: the reproduction of fine detail and texture; the accurate rendition or willful distortion of perspective through proper choice of lens and viewpoint; the infinite range of tonal values from light to dark, which may be combined or extended at will; and the ability to stop motion, to capture the decisive instant or the exact moment.

The photojournalist knows that the lens has a different standard of values from the eye. The camera can discover significance in things that seem unimportant. It also may be deficient in those areas where the eye is attracted psychologically. It teaches a new way of observing the commonplace and enriches the visible world of infinite detail. The reporting camera does what no other medium can do. It opens up new vistas and bares the relations of people to their environments with unequalled precision.

The men and women in this specialized field must be technically competent. They find it necessary to use many devices: cameras, lenses, and lights. But these techniques are used only to obtain more freedom, to make the mechanics of taking a picture so simple that they can concentrate on the subject, the idea, and the event. They realize that a picture is a reflection of what they see and understand, and their job is to mirror the world.

Lincoln attributed his first election as President to this portrait by Mathew Brady and to his address at Cooper Union made the same day, February 27, 1860. Many woodcuts and lithographs of this picture were circulated.

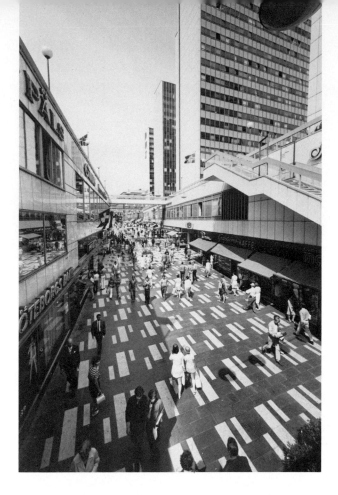

(Above) Perspective rendered by the camera and lens is controlled through choice of focal length and viewpoint. In this picture a wide-angle lens and closer viewpoint create a dramatic distortion. The control of motion offers many variables to the photographer. It may include frozen action or deliberate blur. In one picture (below left), aerialists at a circus are stopped in midair. In another photo (below right), a baseball pitcher's movements are blurred by combining a time exposure with action-stopping electronic flash.

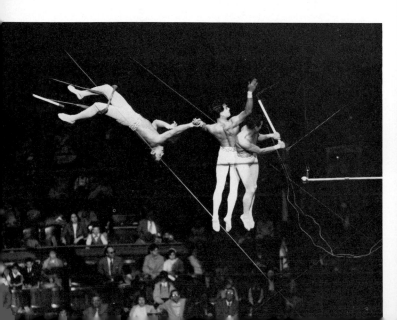

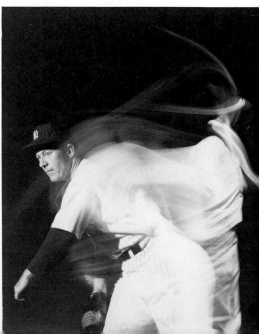

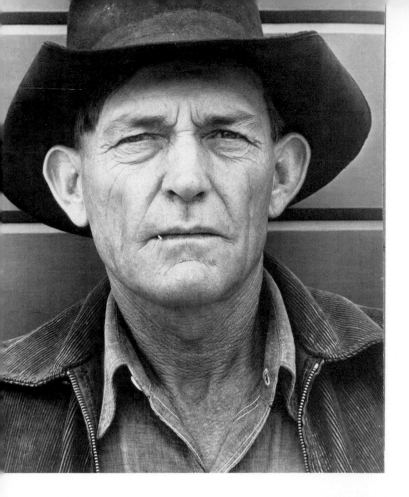

An inherent characteristic of the photograph is the reproduction of fine detail and texture as indicated in this photograph of a cattle rancher.

A complete range of tone is evident in this photograph of a Colorado farmer and his wife. Full detail is visible in highlight and shadow.

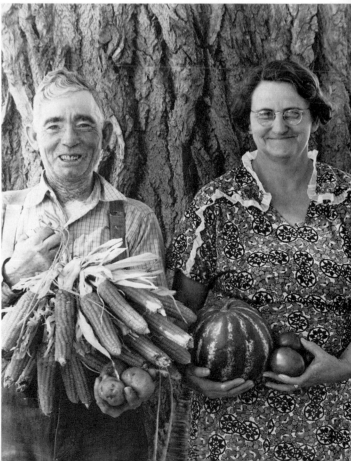

Photography and Politics

Today's photojournalist is a product of evolution in photography, a process that started in 1839 when Daguerre made public the details of his method. The use of the daguerreotype for portraiture established the medium as a superb means of creating a likeness. The portrait painter was put out of business, and the photographer took his place. An outstanding example of the early effectiveness of the photograph as an accurate record was Mathew B. Brady's famous portrait of Abraham Lincoln. When widely reproduced and circulated prior to the presidential election of 1860, Brady's photograph helped dispel the notion that Lincoln was a rough and uncouth backwoods character. The serious, thoughtful, and dignified appearance of Lincoln in the portrait, plus its extensive distribution, caused Lincoln to give Brady credit for helping him become President.

Now, more than a hundred years later, politics and photography are inseparable. The concept of the photograph as a truthful statement, the idea that the camera does not lie, has been carefully built up to the point where the photojournalist's efforts have been used and misused in many campaigns.

The importance attached to the appearance of the President of the United States in all visual media is indicated by the fact that he has an advisor to coach him on behavior before the television and newsreel cameras. The White House Press Photographers Association, representatives of newspapers and magazines, have probably one of the most specialized photo reporting jobs in that their subject is the President, his family, and his activities as Chief Executive. The influence and ethics of these photographers is best shown by the unwritten law to which they adhered during the late Franklin D. Roosevelt's administration. Roosevelt, who suffered from the crippling effects of poliomyelitis, was never photographed walking or moving from one place to another, where the strain of the effort was evident. The public never received the false impression that the President's disability made it difficult for him to discharge the duties of his exacting office.

On the other hand, a photograph was used unsuccessfully in the 1936 presidential campaign to attempt to discredit the administration's farm program. This was a picture of a steer's skull on a cracked alkali flat of the South Dakota Badlands. It was selected from the files of the Farm Security Administration by the Associated Press and circulated with a different caption as an illustration of the severe drought in the Great Plains area. When the alert editor of the *Fargo* (North Dakota) *Forum* saw this picture, he realized its improper use and the so-called government propaganda pictures were made a national political issue. Fifteen years later a Senator from Iowa used this incident to justify a completely unethical use of photography. A composite photograph was made of Senator Millard Tydings of Maryland and Earl Browder, a Communist leader, in

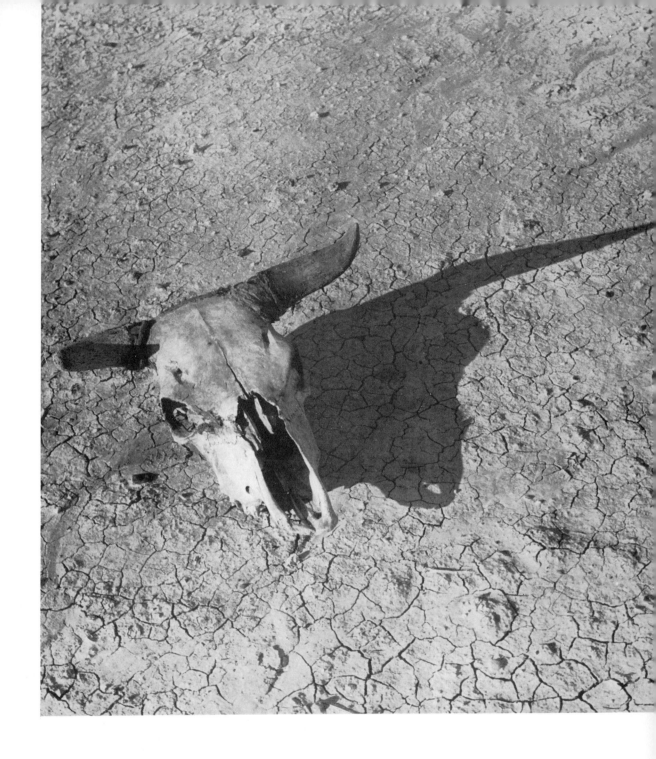

A bleached steer skull on the alkali flats of South Dakota's Badlands was photographed in May, 1936. Later that summer, a news syndicate circulated this picture with a different caption to symbolize drought conditions in the Great Plains. The photographer was at first accused of faking and the photograph became an issue in the presidential campaign of that year.

This is a composite, pasted up of two separate photographs of Earl Browder, the Communist leader, and Millard Tydings, then U.S. Senator from Maryland. Widely circulated late in the campaign, it contributed to Tydings' defeat for re-election.

apparently friendly conversation. Publication and circulation of these pictures resulted in Tydings' defeat and a subsequent Congressional investigation.

The camera as an accurate recording instrument and the existence of this concept in the minds of the public has been a fundamental factor in the development of the photojournalist. Coupled with this is the idea of the camera and its trained observer functioning as a witness to events.

When Roger Fenton photographed the Crimean War in 1855, the long tradition of the photojournalist covering history-making events began. Fenton's pictures could not be published, although wood engravings of some of the scenes were made and printed in the *Illustrated London News.* It was impossible, with the slow, wet collodion process used, to show the action of war. But even in the dull landscapes of the battlefields there was a sense of reality that had never existed before.

Considering the primitive methods used, Brady's work in documenting the Civil War was remarkable. He and his staff produced 7,000 wet plate

negatives, which, according to his catalogue, were taken on the spot, during the progress of hostilities and represent "grim-visaged war" exactly as it appeared. These photographs, now in the National Archives and the Library of Congress, have influenced war photographers ever since. Here, for the first time, the special qualities of photography, which are so important to the photojournalist, became evident: the strong sense of realism and truth and the feeling of participation with the photographer present at the scene and as a witness to the event.

Since the days of Brady, improved photographic techniques and faster methods of transmission have made war photography more significant and the cameraman a more vulnerable witness. In order to obtain pictures with dramatic emphasis, the photographer has had to expose himself to dangers as great as, if not greater than, the combatant. In modern times an outstanding photojournalist who carried on in the tradition of Brady was Robert Capa. Starting with the Spanish Civil War in 1935, Capa photographed the battlefields of his times for twenty years. His tragic death came

A dead soldier after one of the battles of the American Civil War. Mathew B. Brady and the photographers he hired followed closely after the Union armies to record the scenes of devastation and the dead and wounded of both sides with the relatively slow cameras of the day.

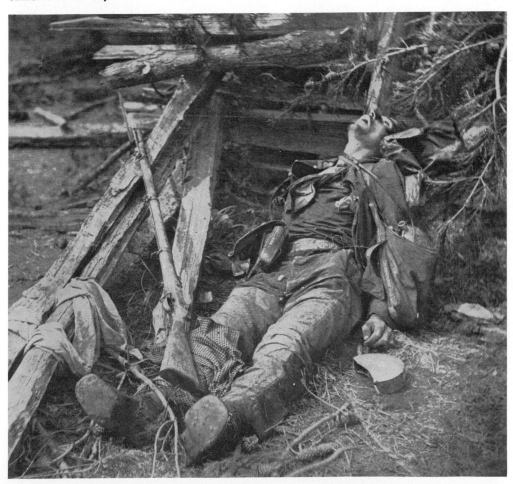

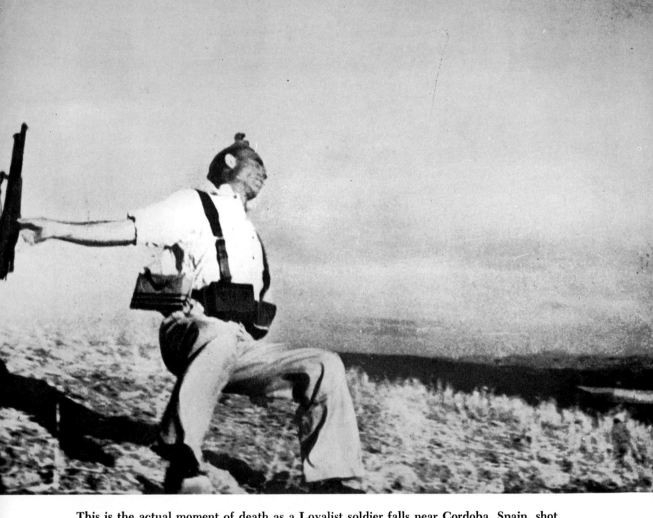

This is the actual moment of death as a Loyalist soldier falls near Cordoba, Spain, shot through the head by fire from a Falangist machine gun, 1936. This is one of the earliest of a great series of battlefield documentaries made by the cameras of Robert Capa. The photographer died at another war front in Indochina in 1954 while on assignment.

when he stepped on a landmine while covering the war in Indochina. Here is the ultimate sincerity in photographic evidence, conclusively demonstrating the recurring sacrifices made by these appointed observers on behalf of the world.

This concept of the camera guided by a trained observer—the mind-guided camera—was outlined in the original prospectus of the picture magazine, *Life*, in 1936, "to eyewitness great events" and also to see the significance of more ordinary happenings; to see for enjoyment and to see for instruction.

Pictorialism

The photojournalist has also been strongly influenced by the emergence of pictorialism and its emphasis on the virtues of photography as an art form. One of the first men who made this contribution to creative visual communication was Alfred Stieglitz. He maintained that photography was more than factual recording of truthful observation—it could be an expression of emotional reaction to life and an independent art. Stieglitz fought all his life for the recognition in artistic circles of the aesthetic qualities of photography. He organized the Photo-Secession in 1902 to advance photography as applied to pictorial expression. Through the publication of *Camera Work*, from 1902 to 1917, Stieglitz reproduced with excellent quality a variety of work by skilled and talented photographers. The publication of these photographs was designed to convey the artistic potentialities of the medium.

One of Stieglitz' associates in the Photo-Secession, Edward Steichen, began his career as a painter and later became a great photojournalist. As a member of the Condé Nast staff, Steichen photographed the fashions

Hardy pioneer photographers carried heavy and clumsy wet-plate cameras into the unexplored West after the Civil War to record territory never visited by white men. This picture was one of a series which influenced Congress to pass the first National Park legislation.

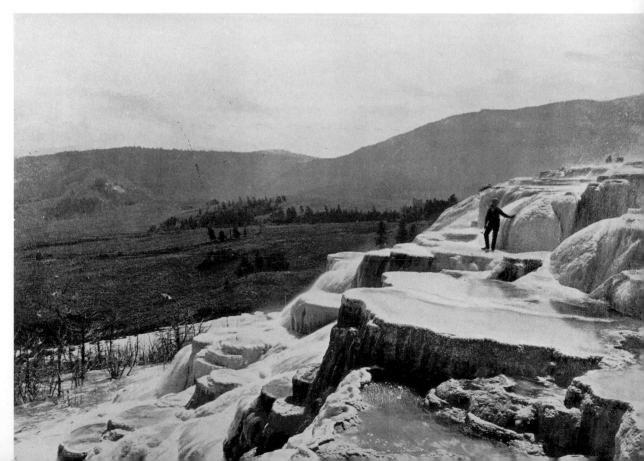

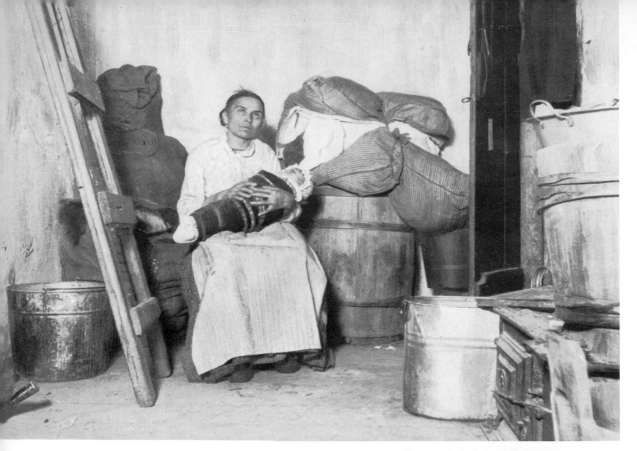

(Above) Jacob A. Riis described this photograph he made in 1888, the home of an Italian rag-picker, as a clear case of the survival of the fittest. Riis was the first photojournalist to make use of flash powder to document the social scene. (Right) Lewis Hine recorded the faith, hope, and dignity of the immigrants milling around, bewildered, frightened, and badgered by unsympathetic officials. This photo was made in 1906 with a view camera and tripod. Lewis Hine continued his social documentation for many more years.

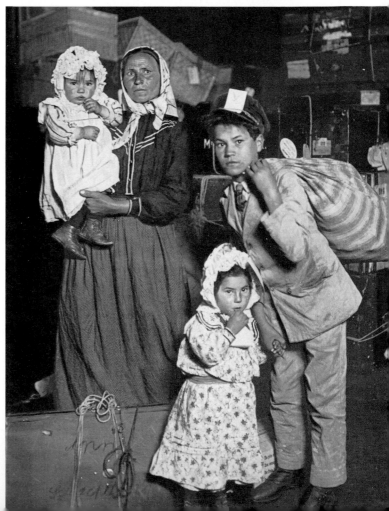

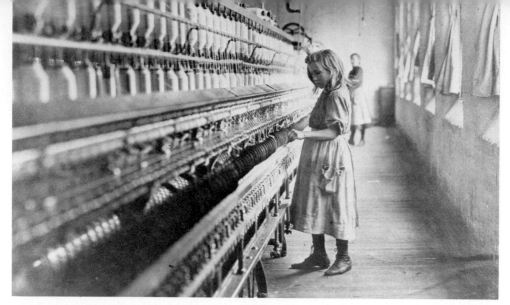

The camera was used by Lewis Hine in 1908 to document the need for social reform. This photograph of child labor in a Carolina cotton mill gave strong impetus to child labor legislation.

and celebrities of the twenties and thirties. He stressed a straightforward approach and relied on his ability to capture the spontaneity of his subject and combine it with an ever effective sense of composition. Steichen's influence on photojournalism has been increased further by his selection of magazine photographers to work during World War II with his Navy photographic unit, his critical editing of photographs for *U.S. Camera Annual*, and his crowd-pulling photographic shows at New York's Museum of Modern Art. His 1955 exhibit "The Family of Man" set attendance records and became a best seller when published in book form. It consisted of the carefully selected efforts of photojournalists and photographers from many countries. Combined with a dramatic display, it was an outstanding example of the use of photography to make a statement, to transmit emotions and ideas, to convey the message of the universality of man.

Documentary Tradition

During the same period that pictorialism was expanding, the documentary photographer made a substantial contribution to photojournalism. While all unretouched photographs are documents in the sense that they may be accepted as evidence or proof, the term *documentary* has been applied more specifically to photographs that not only present facts, but comment on them. The most effective documentary photographs are those that convince their observers with such compelling, persuading truth that they are moved to action. An early example was the work of William H. Jackson, who photographed the natural wonders of the West in 1870. Jackson's photographs of the Yellowstone area convinced Congress of the importance of preserving the region for the public and the first National Park was created.

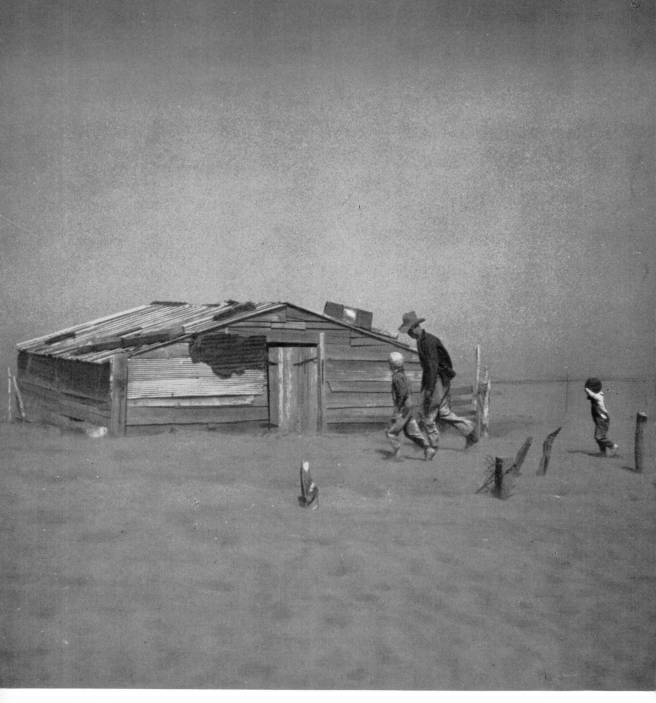

This photograph, by the author, of a farmer and his sons in an Oklahoma dust storm became the evidence of a natural disaster. Widely reproduced, it combines the honest social comment of the documentary with the eyewitness impact of spot news.

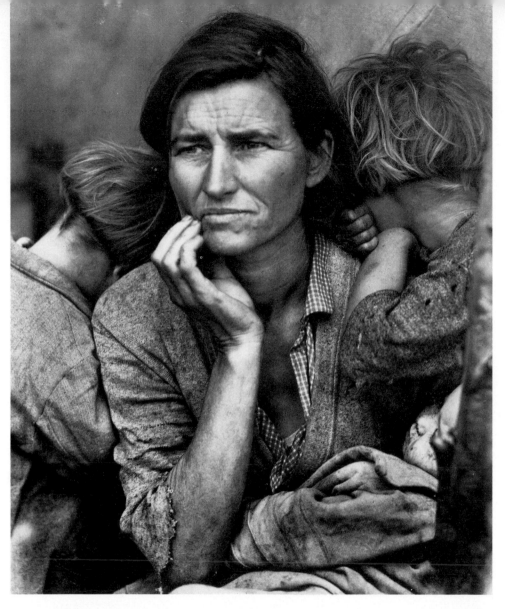

In the 1930's, a group of photographers employed by the Farm Security Administration surveyed America's rural problems. One effective series illustrated with great sensitivity the plight of the migrant workers of California, like this destitute mother by **Dorothea Lange, 1936.**

In 1890, Jacob Riis, one of the first to use flashlight powder, photographed the sordid slums of New York and used these pictures to help his crusade for housing reforms. In the early nineteen hundreds another effective commentator with the camera, Lewis W. Hine, was the first to employ the photo story as a journalistic device. His coordinated pictures and captions on child laborers, immigrants, and coal-miners had a strong influence on legislation designed to correct social injustices affecting these groups.

29

Under the stimulation and encouragement of Roy E. Stryker, the Farm Security Administration photographic project used the camera most extensively to interpret and comment. From 1935 to 1942, photographs of agricultural conditions, widely reproduced in newspapers and magazines, made the public aware of the need for rural rehabilitation and affected farm legislation. In addition, the thousands of photographs, now in the Library of Congress, synthesized the best trends of modern photography and influenced the attitudes of many of today's photojournalists. The idea content of these photographs, combined with fine technique and artistic perception, resulted in pictures that had a profound effect on the observer.

Respect for the Image

In the nineteen-twenties, a group of photographers practiced an aesthetic approach based on the production of unretouched prints from unretouched negatives that emphasized the clarity and detail of the image. A pioneer in this approach was Paul Strand, who, seeing the limitations as well as the potentialities of photography, strove to realize the full range of tonal values, without resorting to print manipulation.

Edward Steichen, as a colonel in charge of aerial photography in World War I, had to obtain brilliant and distinct photographs. This led him to experiment with such problems as the photography of a white teacup on black velvet; he evolved a standard of craftsmanship and technical accomplishment that placed his magazine work on a high creative level.

The subtle and direct use of photography, emphasizing the inherent characteristics of detail and tonal gradation, was part of Edward Weston's approach. But most important for the photojournalist was his insistence in visualizing the final print before making the exposure. Although Weston used an 8″ × 10″ camera, this same straightforward technique, incorporating the utmost respect for the final image, marks the work of a great contemporary photojournalist, Henri Cartier-Bresson, who uses a 35mm camera.

Revelation

Finally, in recent years, many unusual technical achievements in photography have affected the work of the photojournalist: films so fast that action can be stopped under available light; color films of high emulsion speed and fidelity that produce negatives or positives when processed by the user; cameras that are automatic, make hundreds of exposures per second, cover panoramic areas of 140° hand-held; lenses of higher resolving power, apertures of $f/1.1$, lightweight telephotos; powerful and portable electronic flash units. Photography grows as a science as well as an art. The appreciation and use of these technical achievements by those photojournalists who have the necessary skill result in photographs that

reveal more than the eye can see. This contributes a feeling of extrasensory perception, the sense of revelation that the photojournalist adds to his special way of viewing the world.

The editorial photographer is aware, too, of the satisfaction of working with a functional, artistic medium. All great art has been functional; it has served some purpose beyond the gratification of the artist. The photojournalist wants to make photographs that have universal appeal, that are seen by a large audience, that inform, entertain, or provoke the viewer.

Background of Photojournalism

Our contemporary photojournalist has been aware from the days of Daguerre that he is recording a likeness. From the era of Fenton and Brady, he has been inspired to witness history-making events. The growth of pictorialism created an appreciation of the potentialities of photography as an art. The documentary worker has made him think of content and interpretation. A consciousness of straightforward technique and honesty in approach stems from the pure photographers like Strand and Weston. New techniques and strides in the research laboratories have enhanced the photographer's power to reveal what the eye cannot see. Those who make the photographs published in today's newspapers and magazines and seen on television combine the best elements in photography's past as well as the willingness to experiment and think creatively.

In the photojournalist today, we have the synthesis of all the elements of evolution in photography.

Free Lance and Amateur

Although, for the most part, professional photojournalists are affiliated either as staff employees or by contract with a given newspaper, magazine, or television station, a large number of published photographs are submissions by free-lance or amateur photographers.

The amateur gets involved in photojournalism usually as a result of accident or coincidence. He may be the only one with a camera to witness an important news event. The amateur who succeeds under these conditions is usually a very capable photographer who appreciates the visual significance of news. He understands, too, the need for speed in getting the photographs to a publication or television station. An outstanding example of this is the series of photographs made in Atlanta, Georgia, of the Hotel Winecoff fire by Arnold Hardy, who sold his pictures to the Associated Press and later won a Pulitzer prize.

The free-lance photographer, on the other hand, as a professional, rarely works on speculation. He is in contact with newspapers and magazines either personally or through an agent. Sometimes he submits story ideas

to a publication and asks them if they are interested in their execution. The free-lance photojournalist is usually very versatile, very proficient technically, and ready to go anywhere, anytime.

One effective way to obtain assignments is to channel a flow of ideas, tailored to the specific publication, into the editor's office. These ideas should be written out in the form of a brief paragraph stressing the visual aspects of the subject. Even if the percentage of those accepted is low, the editor will become conscious of the free lance or amateur's news sense and imagination.

Market for Photographs

Another method of keeping in touch with the picture market is to employ an agent. The greatest market for photographs, at present, is in New York City; for those who live in other places, New York representation is important. Picture agents are always eager to see the work of photographers and will offer their opinions in person or by mail. If a photographer's work indicates a potential saleability, the picture agency can offer many valuable hints and suggestions. One agency, Magnum, employs a full-time executive editor to advise its photographers, contact editors, and help create assignments. The agent's commission will vary, depending upon the services offered. Some agencies handle film processing, purchase supplies, and provide office space. Others limit themselves to keeping the photographer busy and selling his work.

Although New York City may be considered the primary picture market, most news agencies and national magazines have bureaus all over the world. The free-lance photographer should get acquainted with the bureau chiefs in his region and make them appreciate his willingness to carry out assignments with a complete understanding of the needs of their publication. If a photograph or story has been produced that has national news significance, the local newspaper will be aware of its value and arrange for its distribution.

When a free-lance photographer does not use an agent, his dealings with a publication should be governed by a thorough understanding of their rates and working conditions. As an example of the many considerations involved, the table on the next page outlines the policies of a fictitious magazine called *Today*. Many magazines and picture supplements have similar working conditions, but it is wise for the free-lance photographer to determine the specific agreement in advance.

When a free-lance photographer's pictures are not successful and cannot be sold, his prompt realization of this fact will save much time, money, and effort. The photographer's energies and creative abilities are put to much better use if he decides to produce another set of pictures rather than wear himself out trying to sell those that are unsuccessful. The sensible free-lance photojournalist knows that shoe leather is more expensive than film.

Today	480 Madison Avenue New York City Telephone: MAdison 2-2112		William Jones, *Editor* Ed Brown, *Photographic* *Editor*

RATES:
Black and White ..	$ 350	per page
Color	450	per page
Cover	1000	per page
Shooting Time	200	per day
Travel, Research, Standby	100	per day

Pays Time or Space rate, whichever is the greater

Note: Assignments on a single location taking less than two hours for all time with the exception of processing, and resulting in one published photograph, are paid as half a shooting day rate or space rate, whichever is higher. Color assignments paid at color rate even though converted to black-and-white.

HOURS: Rates predicated on eight hours or any part thereof, with exception noted above. From eight hours to ten hours, rate is pro-rata additional; beyond ten hours is deemed additional day's pay. Night travel paid as day's travel time.

EXPENSES: Actual expenses incurred paid, including processing charges. Use of special equipment, studios, models, props, strobes, assistants, etc., to be mutually agreed upon at time of assignment, and are deemed as additions to minimum.

PAYMENT: Initiated upon delivery of work. Advances to be agreed upon at time of assignment. Assignments confirmed in writing upon photographer's request.

RIGHTS: Photographs for a single editorial reproduction in national edition, and promotional use by TODAY, its advertisers and member papers when used in context. Unless otherwise stated before acceptance, TODAY reserves the right to buy *all* rights and in this case will pay at least twice the minimum for single editorial rights. If first rights only are purchased, photographer retains copyright, negatives and transparencies. Photographer may make negatives available when magazine requests on terms to be agreed then.

CREDITS: Credit appears with work. In case of spread or larger display, credit appears at least once. In exceptional cases where credits interfere with layout, the photographer will be consulted if possible. Credit to accompany promotional use where practicable.

RELEASES: Photographs to be as represented in accompanying captional material and releases to be provided when requested and possible.

This is a photographic rate card for an imaginary magazine, *Today,* but is typical of the scale and arrangements of the leading magazines which employ skilled photojournalists.

Although newspapers and magazines have competent and adequate staffs, their job would be more difficult if it were not for the supporting staffs of public relations agents and photographers.

Education and Training

For one who intends to make photojournalism a career, it is possible to outline an ideal general course of instruction that will be of both immediate and future use.

His first requirement is education on a college level, either by attending an institution of higher learning or through self-education. He must become intellectually mature. Photography has evolved from many academic sciences containing elements of the scientific method. It also demands an artistic, creative approach. Most important is the knowledge of human beings and how they live, work, and play. This comprehension is often developed through formal education.

In order to understand the technical problems of this medium of expression, the prospective photojournalist should learn something about physics and chemistry. Photography owes its progress to development in these physical sciences. To take full advantage of the photographic processes, he must know such subjects as optics, light, and the chemistry of photography. It is important that the photojournalist get an understanding of the mechanical operations of precision instruments so that he can make adjustments and immediate repairs to equipment.

The present use of light sources that depend on high-voltage circuits requires some knowledge of the fundamentals of electricity. Today most photojournalists use one or more types of electronic-flash device. A typical unit involves power sources, condensers, transformers, rectifying tubes, gaseous-discharge tubes—in all a complicated and delicate apparatus that demands skill and knowledge to use.

An appreciation of basic physics will also provide an understanding of how to use lenses properly, where to place lights, how to adjust exposures to various light intensities, how to control sharpness or diffusion in pictures, and how to perfect the quality of negatives and prints.

In addition to physics and chemistry the most obvious adjunct to the intellectual development of the photojournalist is a knowledge of sociology, the study of groups of people and their cultures.

The reporting photographer often finds himself in out-of-the-way places and must be ready to adapt to many different environments. A fundamental appreciation of all this may be obtained by taking a formal course in sociology or reading books on the subject. Another most effective understanding of the ways in which people live and react is obtained through close personal contact. The success of the photojournalist often depends on his ability to understand people who have a way of life that is different from his own.

The aspiring photojournalist should study economics and government. It is important that he have an appreciation of the changing levels of society, the effects of economic laws on people, and the ways in which they earn their living.

Not only is it desirable to understand how people think and act because of their political, social, and economic status in this country; a knowledge of the sociology of foreign countries is also important. With distances shrinking the world over and the increasing American concern with people in other lands, editors are more concerned than ever about good picture coverage by their own staff photographers overseas. It is obvious that a photographer who has lived abroad and who has had a chance to learn the language and the customs of the people has an advantage. Such knowledge may win a choice assignment.

The photojournalist should take courses in painting and drawing. Rapid sketching sharpens the perception of just when to catch the most expressive movement of the human body. The ability to direct models will be improved tremendously if an appreciation of the flow of the body's lines has been developed by the study of anatomy.

A photojournalist is a reporter as well as a photographer and should know how to communicate with words as well as with pictures. The modern photojournalist is as literate as possible (in the most serious sense of the term). Sometimes considerable research is required in the preparation for a story. In its execution it may be necessary to obtain factual, written material to accompany the photographs. The modern camera reporter knows more about writing than merely how to obtain captions. After taking his pictures, he is able to put into words the background and emotions involved in their production. The equipment of the photojournalist often includes the typewriter as well as the camera.

Although broad education and wide experience are desirable in training for this work, it need not be acquired formally and deliberately. Many of our great photojournalists have had little formal education, but their knowledge and mature wisdom is greater than that of many with advanced university degrees.

Any intelligent person can learn the mechanics of photography in a few months. For the photographer who hopes to communicate with a vast audience of newspaper and magazine readers, there must be a greater goal. He must obtain through education and experience a combination of perception, sensitivity, tact, and feeling, as well as the sense of where to point the camera and when to click the shutter. He must have the inherent talent and intuitive ability to be capable of portraying events and ideas in unusual visual terms.

Ten requirements for the photojournalist:
1. A broad, general education providing a knowledge of physics, chemistry, sociology, languages, history, and geography.

2. A social conscience that implies a liking for people and an appreciation of how they live.
3. A sense of adventure that combines the desire to go anywhere and do anything with an enthusiasm for the most trivial assignment.
4. A constant interest in books and magazines on photographic and general subjects.
5. An understanding of the mechanics of photography.
6. The development of an individual style.
7. The skill to report with words as well as pictures.
8. A knowledge of art, composition, painting, and rapid sketching.
9. The ability to feel emotion, yet remain objective.
10. The maintenance of good health; an alert mind and body that react quickly to the unexpected.

Instruction in photojournalism is increasing at the college level. Over 100 institutions now offer such courses as a regular part of their curriculum.

101 Schools and Colleges Offering Courses in Photojournalism

Alabama
Spring Hill College, Mobile 36608
U. of Alabama, University 35486

Alaska
U. of Alaska, College 99701

Arizona
Phoenix College, 1202 West Thomas Road, Phoenix 85013
U. of Arizona, Tucson 85721

Arkansas
Arkansas Polytechnic College, Russellville 72801
U. of Arkansas, Fayetteville 72701

California
Art Center College of Design, 5353 W. 3rd St., Los Angeles 90005
Brooks Institute of Photography, 2190 Alston Rd., Santa Barbara 93103
City College of San Francisco, 50 Phelan Ave., San Francisco 94112
East Los Angeles College, 5351 E. Brooklyn Ave., Los Angeles 90022
El Camino College, El Camino 90506
Fullerton Junior College, 321 E. Chapman, Fullerton 92632

Los Angeles City College, 855 N. Vermont Ave., Los Angeles 90029
Los Angeles Valley College, 5800 Fulton Ave., Van Nuys 91401
Orange Coast College, 2701 Fairview Rd., Costa Mesa 92626
Palomar College, San Marcos 92069
San Diego State College, San Diego 92115
San Fernando Valley College, 18111 Nordhoff St., Northridge 91326
San Francisco State College, 1600 Holloway Dr., San Francisco 94132
San Joaquin Delta College, 3301 Kensington Way, Stockton 95204
U. of California, Berkeley, 2223 Fulton St., Berkeley 94720
U. of California, Los Angeles, 405 Hilgard Ave., Los Angeles 90024

Colorado
U. of Colorado, Boulder, 80302
Mesa College, Grand Junction 81501

Connecticut
U. of Bridgeport, Bridgeport 06602

District of Columbia
American U., Massachusetts and Ne-

braska Ave., Washington 20016

Florida
U. of Florida, Gainesville 32601

Idaho
Idaho State U., Pocatello 83201

Illinois
Bradley U., Peoria 61606
Northern Illinois U., De Kalb 60115
Northwestern U., Evanston 60201
Southern Illinois U., Carbondale 62901
Illinois Institute of Technology, Institute of Design, Chicago 60616

Indiana
Ball State U., Muncie 47306
Indiana U., Bloomington 47401

Iowa
Drake U., 118 Meredith Hall, Des Moines 50311
U. of Iowa, Iowa City 52240

Kansas
U. of Kansas, Lawrence 66044
Kansas State U., Manhattan 66502

Kentucky
U. of Kentucky, Lexington 40506

Louisiana
Louisiana State U., University Station, Baton Rouge 70803

Maryland
U. of Maryland, College Park 20740

Massachusetts
Boston U., Boston 02215
Franklin Institute of Boston, 41 Berkley St., Boston 02116
Massachusetts Institute of Technology, Cambridge 02139

Michigan
Central Michigan U., Mt. Pleasant 48850
Michigan State U., East Lansing 48824

Minnesota
Bemidji State College, Bemidji 56601
U. of Minnesota, Minneapolis 55455

Mississippi
Mississippi State College for Women, Columbus 39701

U. of Mississippi, University 38677

Missouri
U. of Missouri, Columbia 65201

Montana
U. of Montana, Missoula 59801

Nebraska
The Creighton U., 2500 California St., Omaha 68131
Omaha U., Omaha 68100
U. of Nebraska, Lincoln 68508

Nevada
U. of Nevada, Las Vegas 89100
U. of Nevada, Reno 89507

New Mexico
New Mexico State U., Las Cruces 88000
U. of New Mexico, Albuquerque 87106

New York
Columbia U., Graduate School of Journalism, New York 10027
Cooper Union Art School, New York 10003
Germain School of Photography, 225 Broadway, New York 10007
New School, 66 West 12th St., New York 10011
New York U., 80 Washington Sq., New York 10003
Rochester Institute of Technology, Rochester 14623
Syracuse U., Syracuse 13210

North Dakota
U. of North Dakota at Grand Forks, Grand Forks 58201

Ohio
Bowling Green State U., Bowling Green 43402
Ohio State U., 242 W. 18th Ave., Columbus 43210
Ohio U., Athens 45701

Oklahoma
Oral Roberts University, Tulsa 74105
U. of Tulsa, Tulsa 74014

Oregon
Oregon State U., Corvallis 97331
U. of Oregon, Eugene 97403

Pennsylvania
Bucks County Community College, Newton 18940
Carnegie-Mellon U., Pittsburgh 15213
Temple U., 1949 N. Broad St., Philadelphia 19122

South Carolina
U. of South Carolina, Columbus 29208

South Dakota
South Dakota State U., Brookings 57007

Tennessee
U. of Tennessee, Knoxville 37916

Texas
East Texas State U., Commerce 75429
North Texas State U., Denton 76203
Sam Houston State U., Huntsville 77341
Southwest Texas State U., San Marcos 78666
U. of Houston, Cullen Blvd., Houston 77004
U. of Texas, Austin 78712

Utah
Brigham Young U., Provo 84601
Utah State U., Logan 84321

Virginia
Virginia Commonwealth U., Richmond 23221

Washington State
Everett Community College, 801 Wetmore Ave., Everett 98201
U. of Washington, Seattle 98105
Washington State U., Pullman 99163

West Virginia
West Virginia U., Morgantown 26506

Wisconsin
Milwaukee Technical College, 1015 N. 6th St., Milwaukee 53203
U. of Wisconsin, Milwaukee 53201
Wisconsin State U., Oshkosh 54901
Wisconsin State U., Whitewater 53190

Wyoming
U. of Wyoming, Laramie 82070

Canada
Loyola College, Montreal 262
Vancouver City College, Vancouver, B.C.

2

Presence and Instinct

The News Photograph

The news photographer has a distinct and specialized mission. As the representative of a large audience of newspaper and magazine readers, he must report to them in pictures, efficiently and rapidly, the dramatic highlights of a fast-moving event.

The goal of a news photographer is the publication of a single picture or sequence that is direct, straightforward, factual, and realistic. It may record an incident of interest to the community, present a well-known personality, or isolate a significant action. It shows conflict, tragedy, and emotion. Working under the pressure of events, he who covers the news fights against time. The news photographer seeks the essence of the story, shoots it, and rushes the exposed film back for quick processing.

Improvement in the technique of news coverage means that a photographer must do more than be physically present at a scene. He must be an artist, a skilled craftsman, and a reporter. He has trained himself to develop an instinctive insight and sensitivity to news events so that his pictures translate the news into human terms and emotional values that the reader can appreciate.

The news photographer is most successful when three basic facts exist:

Presence—He must get to the spot where the action is taking place.

Instinct—He must know when to take the picture.

Anticipation—He must be prepared for coverage of the event with the proper mental attitude and physical equipment.

The problem of getting the photographer to the scene depends on the type of news. For local coverage of accident and crime, radio-equipped automobiles are useful. In some cases like floods, fires, wrecks, or catastrophes, the helicopter, airplane, or speedboat is necessary. Modern means

A staff photographer for The New York Times waits in the photographers' room for his next assignment.

Details of the assignment, a protest demonstration, are discussed with an editor.

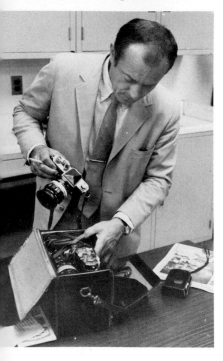

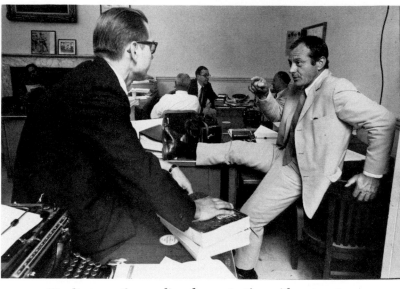

He discusses the pending demonstration with a reporter.

The photographer gets his equipment ready before leaving for City Hall.

The protestors assemble and the photographer works quickly.

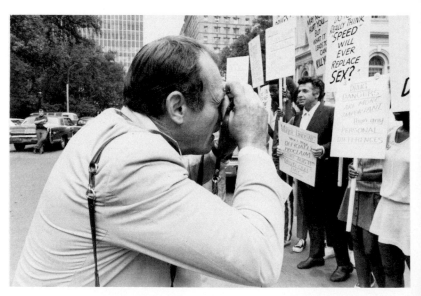

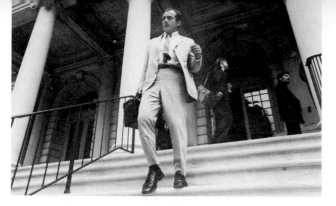

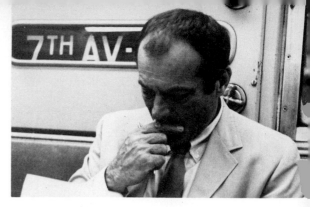

He rushes down the City Hall steps on his way back to the newspaper office.

Returning on the subway, the photographer reviews his notes for captions.

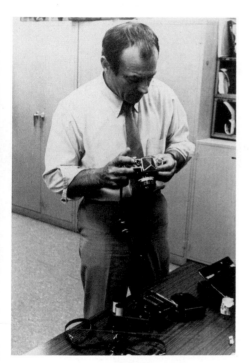

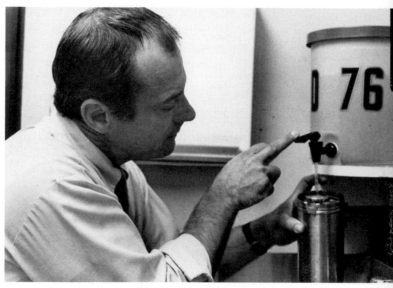

The exposed 35mm film is developed in the photolab.

Back at the paper, he unloads his cameras.

Before printing, the photographer checks the negatives with a magnifier.

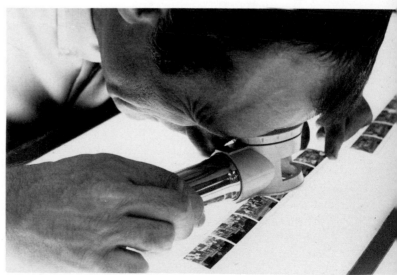

of communication keep the photographer informed. Telephone, teletype, telegraph, television, and radio are used to learn about the news and where it is happening. For other events such as politics, parades, and sports, there is more advance notice and the photographer's presence when the most significant action occurs depends on his own leg work.

The appreciation of the exact moment, the decisive instant, when to take the picture, is an instinctive action on the part of the news photographer that is comparable to the perfect pitch of the musician. Anyone can be taught the mechanics of operating a camera. News sense can be sharpened by experience. But every great news photographer has a unique attribute that cannot be cultivated. It is an unconscious awareness of the unusual and unexpected; an attraction to and perception of the momentous event; an instinctive reaction that causes him to take the picture at the height of the unfolding drama.

On Assignment

The coverage of a rapidly moving story requires foresight and preparation. Mechanically, the news photographer must have his equipment in readiness and good repair. He should be able to choose the right camera for the job—a telephoto lens may be needed or perhaps an unobtrusive 35mm camera. Mentally he should be alert, familiar with the background of the story, know the names of the principals, foresee the direction of the action, and anticipate the sudden or extraordinary act that will make a more revealing photograph.

The news photographer may receive his assignment from the managing editor, city editor, picture editor, assignment editor, or chief photographer, depending on the publication. He usually takes enough film with him to cover several assignments because he is expected to keep in touch with his office and may have to go off immediately on another story.

While on the job, the news photographer is expected to have patience, tact, and good judgment. He must be calm and cool under pressure and diplomatic with people. His attitude toward people and events must be observant, yet objective and impartial. He must never get emotionally involved in the situation he photographs.

When his assignment has been completed, the photographer sends or brings his film back to the office for processing. If a reporter or writer is not on an assignment with him, it is essential that he record all the details for captions, making sure the spelling and order of names are accurate.

A person viewing a good news photograph should have a feeling that he is seeing reality. He should not be conscious of the photographer or his camera. Under ideal circumstances this effect can be achieved only when the photographer works quietly, quickly, and with a minimum of equipment. For this reason many news photographers have taken to the smaller cameras, those with negative sizes of $2\frac{1}{4}'' \times 2\frac{1}{4}''$ or 35mm. It seems obvious that the photographer burdened with a large, heavy, clumsy camera

Skill and ingenuity are characteristics of many veteran news photographers, as this picture of Greta Garbo testifies. There is both humor and pathos in this shot of a woman who does not want to be photographed but has the laws of reflection stacked against her.

will not be able to react promptly to a fast-moving event. By using a smaller camera, the photographer will have greater freedom to cover an event and a greater variety of pictures to select from. Whereas the miniature camera makes possible pictures that could not be obtained with the more cumbersome larger cameras, it does require more care in exposure, lighting, and processing. The contemporary news photographers and news photo labs have readily adapted themselves to these demands on their skills and technique because of the compensating advantage of the small camera format in convenience and unobtrusiveness.

Direction

In order to tell the story properly it is often necessary for the news photographer to direct people and to control their actions. This direction may take the form of asking a person to look at the camera, posing a large group, or re-enacting a scene. The best way to pose people is by example or by carefully worded direction. Often superior results are obtained when a friend or the reporter engages the subject in conversation.

There is always the problem of "should the subject look at the lens?" One solution is to allow only pretty girls and handsome men to look at the camera! It requires great ingenuity to pose a group so that prominence is given to the right people. Where left-to-right identifications are given in

The premature and erroneous headline of the newspaper is the only caption needed for this.

the caption, the celebrity is usually at the left of the group or in the middle. Since newspaper cuts are measured in column widths, a compact grouping is desirable. The alert photographer will invent some bit of business or seize upon a prop to keep his subjects from looking posed.

The re-enactment of a news event is a problem for every photographer's conscience. It can be resolved only when the photographer honestly believes that his directions are creating a true picture of what actually happened. Direction by the photographer supposes a conception of what the final print will be like. It should add to the realism of each picture by coordinating the events or subjects before the camera to make the visual impact more effective. Direction has its greatest value when it is least discernible.

Captions

It is a rare photograph that can be printed without a caption. The caption is an important part of the picture. It is read by twice as many people

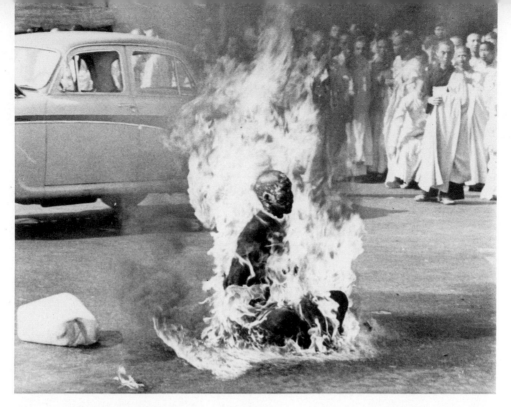

The suicide of a Buddhist monk in Saigon is a remarkable example of a spot news photograph made by reporter Malcolm Browne of the Associated Press. Although millions of words had been written about the crisis in Vietnam, the visual impact of this photograph served to focus world attention and change the course of history.

as the number who read the story. The purpose of the caption is to give the picture more meaning by completing the information that the photograph presents. A good caption is written in short, terse, direct sentences. It avoids the obvious things in a photograph that are taken in at one glance. The good caption explains the photograph concisely and briefly. Most newspapers have eliminated the headline or overline above a photograph. The key words in a caption are now often set in bold-faced type and serve as a headline for both picture and caption. Although caption writing is neglected on many newspapers, it gets special treatment on the New York *Daily News*. It starts with the photographer. He must get the "left-to-rights" properly. He must explain the where and the why of the pictures. Then the caption writer looks for one key word. He may draw on the title of a popular song, a movie, or a book.

Great News Photographs

Many pictures remain in our memory because of their symbolic nature or because of the importance or the drama of the event which they reflect. On this and the following pages are a number of such news photographs selected from the most memorable of the last 50 years. Some of them are great purely as pictures; others depend more for their interest on the significance of the event itself. Alternate selections of great news pictures could certainly be made, but many of these pictures would be found in any list of important pictures—as would some of the illustrations elsewhere in this book.

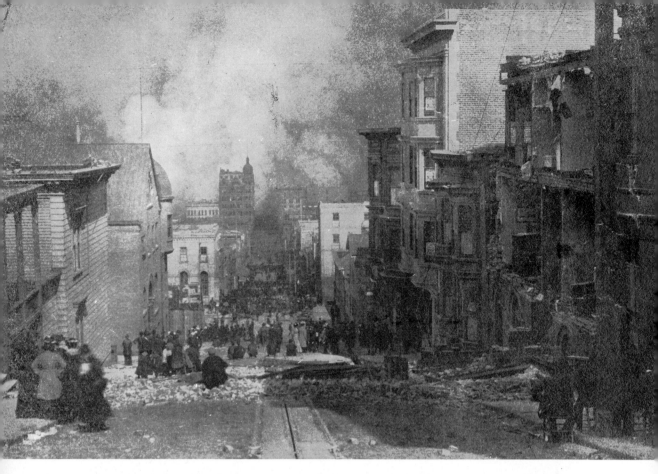

The great fire was at its peak in San Francisco on April 18, 1906, when Arnold Genthe borrowed a Kodak 3A to make this photograph looking down the cable car tracks.

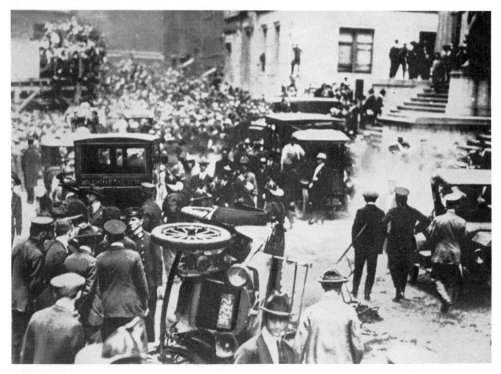

Wall Street was rocked by a blast which blew an abandoned horse and wagon to bits on September 16, 1920, killing 39 people and injuring 200.

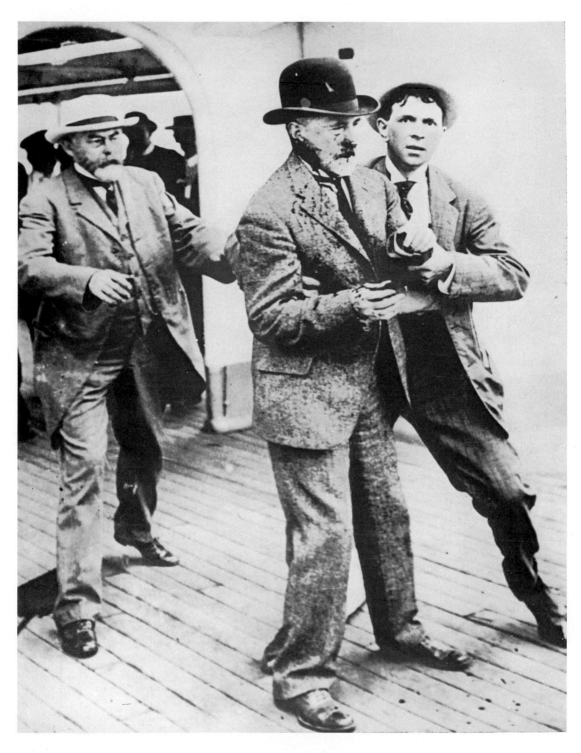

William Warnecke was the only photographer remaining at the scene of Mayor Gaynor's departure in 1910 when he was shot by a would-be assassin.

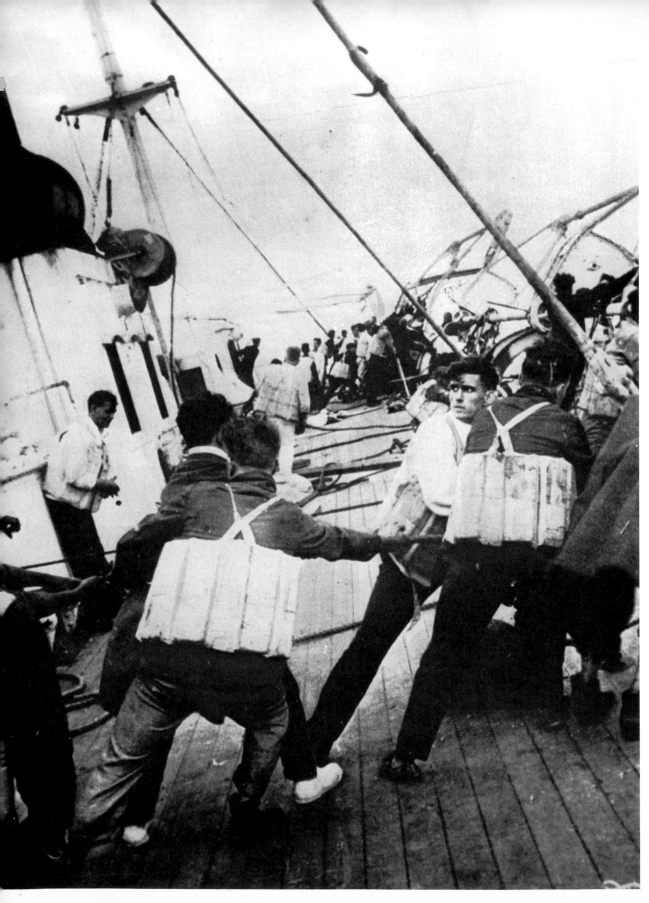

One of the most dramatic of all shipwreck pictures was made by a crew member of the Vestris, an amateur photographer, with a camera purchased just before the voyage. The Vestris went down off the Virginia capes, November 12, 1928.

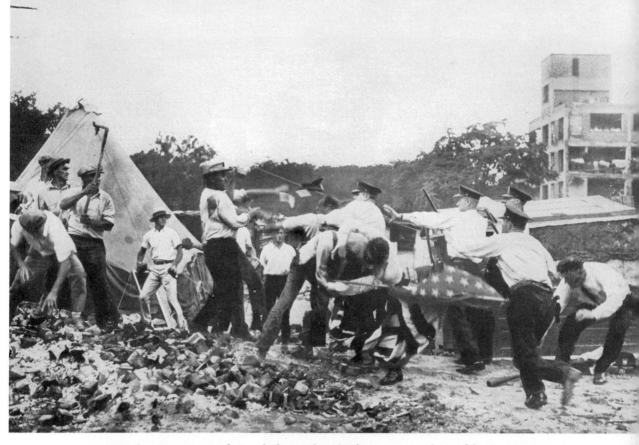

During the Depression days of the early 1930's a group of World War I veterans marched on Washington to demand a bonus and clashed with Capital police.

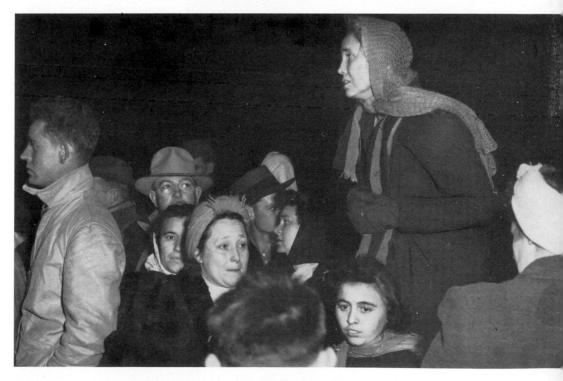

Relatives await news after a 1947 mine explosion, Centralia, Ill.

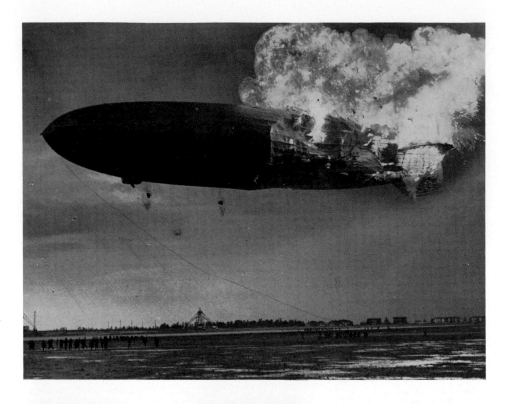

As the German dirigible, Hindenburg, approached its mooring in Lakehurst, N.J., in 1937, photographers were present for routine pictures of its arrival. One of them (above) caught the first flash as the airship exploded, caught it five seconds later (opposite) as it touched the ground, and (left) as it was completely consumed.

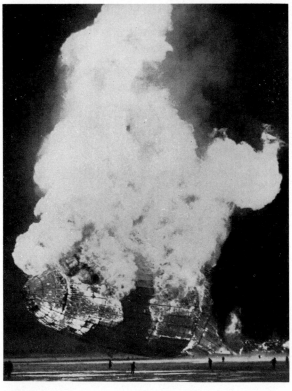

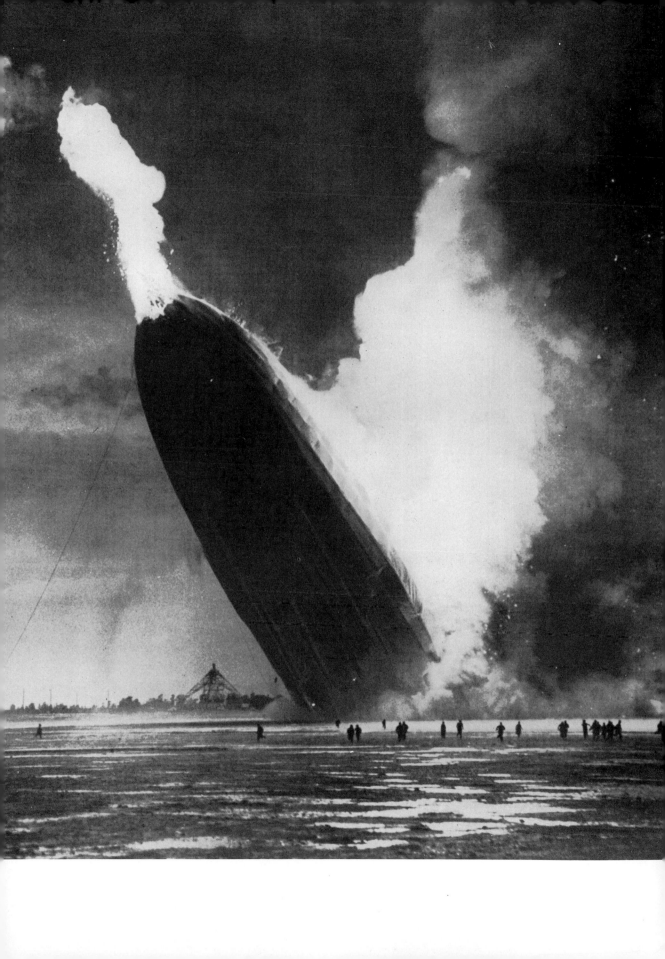

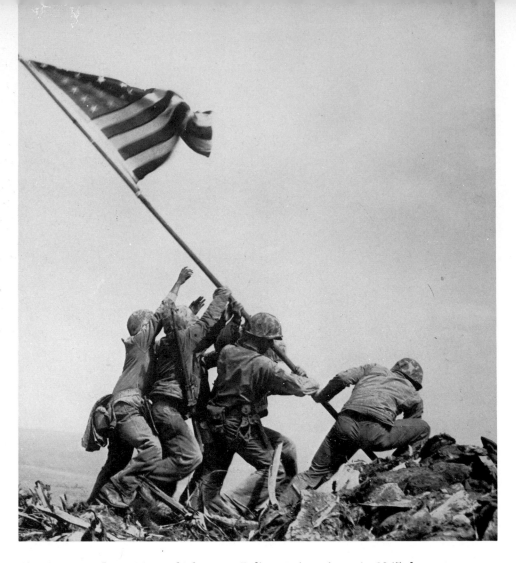

The Iwo Jima flag raising, which was a Pulitzer-prize winner in 1945, became an even greater symbol to an America at war. It is interesting to contrast the spontaneous grouping above with the other two pictures made at nearly the same time atop Mount Surabachi.

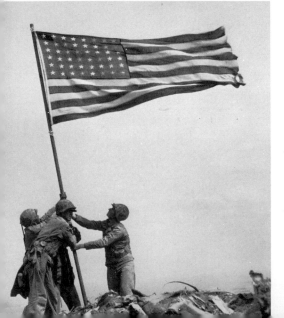

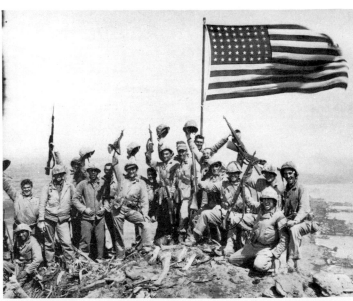

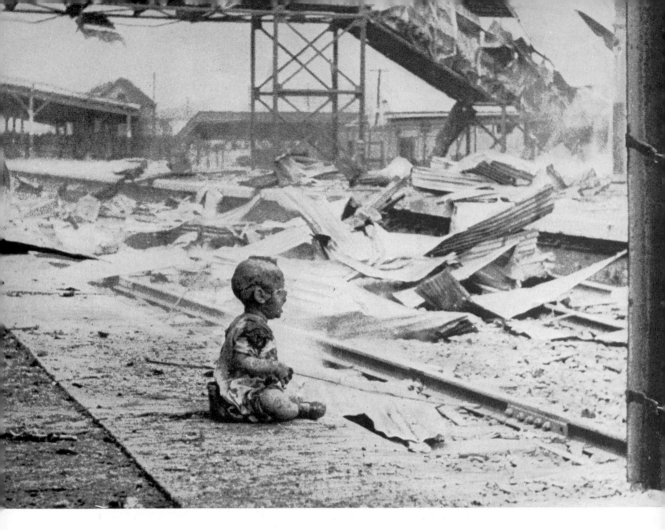

This crying Chinese baby (above) in the rubble of a bombed station in Shanghai during the Japanese invasion became a symbol of great impact, although the photographer "borrowed" the baby and set up the shot. (Below) Three mourning Queens form a tragic group in 1952.

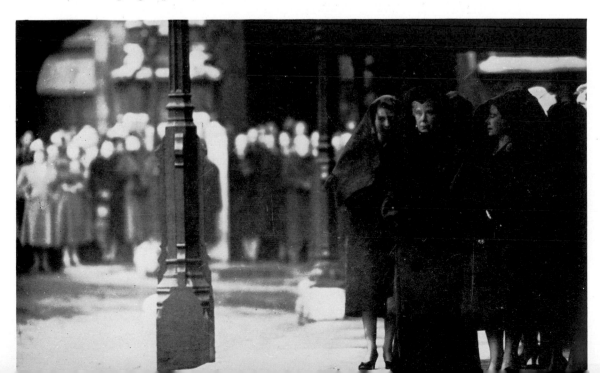

Often he reworks clichés, figures of speech, and other gags. This results in a lively treatment that enhances the readers' interest. The news photographer is aware of the importance of the caption. He is often the basic source for this important information. His contribution to the successful use of his photographs will be the answers to who, what, where, when, and why.

Special Departments

Although major publications may employ specialists to cover the specialized fields of sports, women's interest, and entertainment, often the news photographer is assigned to cover an event for one of these departments.

Sports

The news photographer who covers sports must have physical endurance and split-second timing. The sports photographer running up and down the sidelines of a football field gets as much of a workout as the players he photographs. In addition to being alert, the sports photographer must be thoroughly familiar with the sport he is covering. In this way he can anticipate the dramatic moment that will give him the best picture. Since much of what he is covering is routine, the sports photographer is always striving for a fresh, new approach. To achieve this he leans heavily on equipment and technique. He uses long lenses and high powered strobe lights. The action-stopping qualities of electronic flash contribute greatly to the reader's interest as he studies the sports pictures after the event.

On the Des Moines *Register and Tribune,* football coverage is a big operation. On a normal Saturday during the football season photographers, sports writers, the art department, and even news staff assistants work on football coverage. Airplanes are used to transport equipment, photographers, reporters, and film. The photographers work with various kinds of cameras and lenses of different focal length. Sequence cameras are used to cover each play. The sequences are combined with single photographs made at the sidelines. Arrows, diagrams, and players' names are added to the photographs to explain the action.

The *Columbus Dispatch* decided that two-thirds of all sports pictures were posed groups or posed action. They made a deliberate effort to increase the interest in this type of shot. Each photographer was told to study grouping and lighting. In Columbus, football is king and the photo department is held responsible for every play. The sequence cameras photograph every time Ohio State has the ball. The entire staff reports on the field an hour before game time and someone is around for an hour after the final gun. The result is 1,500 football negatives every season, including many good photographs that push other shots off page one. This newspaper believes in using the long lens for football coverage. It puts the action in the reader's lap and captures facial expressions. On the other hand, basketball pictures are best covered from behind the basket with a wide-angle lens. Basketball and all other indoor sports are covered with plenty of light. The *Columbus Dispatch* sets up two big electronic flash units and

a fill-in light at the camera so that the photographers can stop down to $f/45$, at which point everything is in focus.

The sports photographer does not have to rely on technique alone. He can often get effective and different pictures by showing the reactions of the spectators or the players to the game. A thorough knowledge of the game and its personalities will help him plan for better sports pictures.

Women's Pages

Most newspapers now have sections devoted to news and photographs that are of interest to women. In addition to photographs of brides and engaged girls, coverage is given to food, fashions, home living, and child care. This is a much neglected area and presents many opportunities for the photographer to do something different. The formal wedding picture can be supplemented by an informal, candid photograph. Fashion photographs should not only show the clothes but a realistic use of them in the proper setting. For newspapers, the best food photographs are of the how-to-do-it type. Color and skillful lighting are necessary to create the desired appetite appeal in a food photograph. In covering any of these women's service stories the photographer should try to motivate the reader. He should be aware that there is a close relationship between the women's page and the advertising department. He should also realize the limitations placed on this type of photography by the reproduction process of his paper.

Entertainment

There is room for original picture thinking on the entertainment pages of a newspaper. These contain information and reviews and comments on stage, screen, radio, television, music, and dance. This is where the photographer can put modern, fast films and fast lenses to use in capturing the highlights of rehearsals and performances. Interesting and unusual effects can be obtained by photographing motion picture and television images right off the screen.

Wire Services

A great many news photographers do not work directly for publications, but instead cover the news for one of the wire services. These are Associated Press Wirephoto and United Press International Telephoto. The first commercial wire transmission service for photographs between New York, Chicago, and San Francisco was opened in 1925 by the American Telephone and Telegraph Company. Today the wire services have over 300 stations. Each one of these services transmits more than 100 pictures every day. As a result, all over the world daily newspapers bring us photographs of the events that happen within the day (or in some cases within the hour) no matter how distant. It also means that the news photographer supplying the insatiable syndicate must sacrifice quality for volume. This problem, however, may soon become academic for television has had a definite effect on spot news coverage. There is no doubt that the im-

THE WORLD WIDE SERVICES OF THE ASSOCIATED PRESS

The extensive coverage of the Associated Press Wirephoto network is illustrated by these maps of its operations. Local news photos are distributed over the ten state networks and pictures of greater importance are distributed all over the nation. The transmission system not only operates photo printers, but also permits continuous consultation between the New York control desk and the other stations regarding photographic possibilities and picture projects.

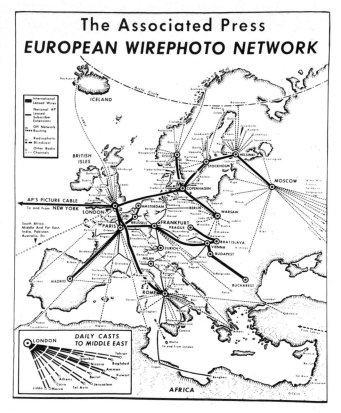

The Associated Press
EUROPEAN WIREPHOTO NETWORK

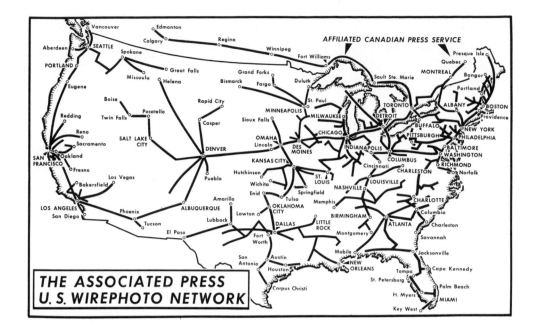

THE ASSOCIATED PRESS
U. S. WIREPHOTO NETWORK

mediacy of the television image destroys some of the impact of the news photograph, but this does not mean that the perceptive and imaginative still photographer is becoming obsolete. Television coverage can only provide a superficial survey of a news event. The television image is transitory. The news photograph can be studied, analyzed, and evaluated. A single news photograph taken by a perceptive photographer can sometimes sum up an event much better than a television report. Even though the public can hear it first on radio or see it first on television, they will still turn to the newspaper for the background of the news and the interpretive photograph.

Small-Town Paper

The picture content of the small-town newspaper has received a new impetus as a result of the availability of cheap engravings. Plastic halftones are produced quickly, simply, and inexpensively. By utilizing this process, most newspapers find that it now costs less to print pictures than text. A newspaper with a circulation of ten thousand or less can easily have a one-man picture operation. The one full-time photographer is often aided by reporters and editors who can also handle cameras. In contrast to the visual images of television and the wire and radio news picture networks, the small town paper's coverage is local and exclusive. Its photographer produces a daily diary in photographs of events in the community. This type of news photography presents a great challenge to the imagination. It is also a great opportunity for a beginning photographer to learn every aspect of his craft.

57

Big City Paper

At the other extreme from the one-man operation on the small town newspaper is the large photo staff on the big city paper. The photo department of one metropolitan newspaper has 16 photographers, a lab technician, 3 color technicians, a color artist, and a receptionist—a total of. 22 people. The department operates from 7 A.M. to 12 midnight, and on Sunday from 9 A.M. to 10 P.M. Its total regular coverage is 120 hours a week. Every day two men arrive at 7 A.M., one at 8 A.M., three at 9 A.M., and one each at 1 P.M., 2 P.M., and 3 P.M. On Sunday there are three men on regular shift. The weekly schedule is posted a week in advance and the men are rotated to share the night and Sunday shifts.

The photo department serves the entire newspaper. The major share of its work goes to the editorial department—about 70 per cent; 15 per cent goes to the promotion department, 10 per cent to advertising and 5 per cent to all the other departments. There are between 40 and 60 daily assignments. They may come from over 20 editors, 40 advertising salesmen, promotion people, and executives from the business and circulation and mechanical departments. In one year 18,000 assignments are completed. These vary from aerial photos to close-ups of a diamond ring. One assignment may take several hours, another a few minutes. About 300 jobs will be done out of town and may take from half a day to several weeks. The photographers travel a third of a million miles during the year taking pictures. The paper leases 16 cars for the photo department, which are replaced yearly. Each one is equipped with a two-way radio for constant communication with the office. This saves valuable time in covering spot news events.

Each photographer has an official card issued by the police department, which gives him the privilege of street parking while on assignment. The photographer takes his car home at night and is thus available for emergency assignments between midnight and 7 A.M. when there is regular staff coverage. His equipment consists of a 35mm single-lens reflex camera with normal, wide-angle, and telephoto lenses.

Some editorial assignments originate from the picture desk, but all others come from the photo department. Assignments are made by written order as far in advance as possible except for emergencies, which are handled by phone or by a written order. The photo department has a wide variety of special cameras and lenses for use by its photographers. Among them are aerial cameras, fisheye 180° lenses, mirror optics, long telephoto lenses, and underwater and motorized sequence cameras. Many of the staff photographers are enthusiastic over the effectiveness of 35mm cameras. They have become aware that the quality of the lenses, films, and developer available is high enough so that results from the 35mm cameras, although enlarged many times, compare favorably with the work of the larger cam-

The long-focus lens for sports pictures puts the action into the reader's lap.

eras. They have also found that the 35mm camera is smaller, less conspicuous, faster to operate, more versatile, and more economical than the larger camera.

Communications

The efficient operation of a large picture staff depends heavily on communication. An integral part of the news picture operation is the job of assigning staff photographers to fast breaking news stories and transmitting additional information, such as changes in location, while the photographer is on his way. This problem has been solved by the use of mobile radio. Cruising photographers may be contacted in their vehicles, given assignments, information, and changes in location on the basis of latest details received at the editorial office. The use of portable two-way radio makes possible more efficient organization in the coverage of a big news event. During the national political conventions, two-way radio communications were maintained between all UPI photographers and the picture-assignment editor in the UPI workroom, where a television screen kept the editor abreast of what was happening in the convention hall. He was able to give directions for specific pictures at any time. Mobile radio equipment is used also to cover the World Series. The New York *Daily News* was thus able to maintain contact between photographers at first and third bases, the editor underneath the stand who was monitoring the game on a television receiver, and the picture desk in the *News* building.

Ideal News Photographer

The ideal news photographer is a dedicated craftsman with imagination and courage. He has an unlimited amount of energy. He always has the right equipment and never misses a picture. He is big enough so that he can shoot over the heads of a crowd, and small enough so that he is never noticed while working. He has an extensive wardrobe and always dresses to suit the occasion so that he is socially acceptable and not conspicuous. He knows when to flatter and when to be tough and ruthless. No matter how routine the assignment, he never makes the cliché photograph for his mind is always full of fresh ideas. He always has a fund of amusing anecdotes that will help relax his subjects and put them at their ease. He is a good enough writer so that when no reporter is present he can handle the story and get accurate facts, names, and addresses. When other photographers from rival publications are on the same assignment, he never worries about being scooped. The ideal news photographer is always friendly with the competition, but he never lines up with the hacks who travel in packs. He avoids the handshake and the cheesecake photograph. He knows how to take advantage of the latest photographic techniques and tries to give a fair appraisal to every new camera, lens, film, and light that may help him in his job. He is consistent, reliable, and brings the same amount of enthusiasm and effort to every assignment, no matter how trivial it may be!

Pulitzer Prizes

Since 1942 a Pulitzer prize has been awarded for the year's best news photograph. This award is one of the many prizes in journalism awarded by the trustees of Columbia University under the will of Joseph Pulitzer, famous newspaper publisher. The photographs judged are limited to those published in a United States newspaper. The prize is open to amateurs as well as to photographers regularly employed by newspapers, press associations, or syndicates.

The most famous photograph to win the Pulitzer prize is Joe Rosenthal's "Marines Plant Old Glory On Mount Suribachi." This photograph, generally referred to as "the flag raising on Iwo Jima," was made on February 23, 1945. Rosenthal said that as he laboriously climbed up the steep mountain trail, sidestepping Japanese mines, he wondered whether a picture at the summit would be worth the effort. However, he climbed up on a sand-

(Opposite) An amateur caught this split second before death as an unidentified woman leaps from the burning Winecoff Hotel, Atlanta, Georgia, which took more than 100 other lives. This picture won the 1947 Pulitzer prize. The same photographer made other pictures on the same occasion, including the one (following page) which many photo editors consider has greater informational content than the prize winner.

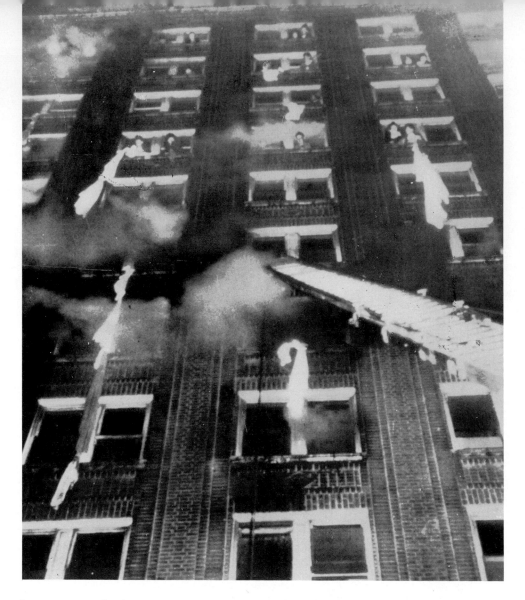

bag to get a better view and took the famous photograph of the flag being raised. Then he took another photograph of the marines cheering, after the flag was up. When congratulations began pouring in for his photograph, Rosenthal had the mistaken idea that it was the second picture that was being acclaimed. Rosenthal's photograph, probably the most famous picture of World War II, has inspired paintings, drawings, art work, sculpture, and postage stamps.

The Pulitzer prize of 1947 was won by an amateur photographer and student at Georgia Tech. The photographer, Arnold Hardy, arrived at the scene of a fire at the Hotel Winecoff, in Atlanta, Georgia. He had a camera that he had bought one month before and five flashbulbs. It was his last flashbulb which enabled him to capture the prize-winning photograph of a woman leaping to her death. This photograph had the widest use of any news picture in 1946. Hardy sold his pictures to the Associated Press for $500, and realized a total of $1,290 with his prize money.

62

Most of the many photographers present on the dull, dark day when Babe Ruth retired, used flash bulbs and made conventional pictures. One, however, made his exposure with available light and from a position behind the famous player. This picture caught the essence of the moment and was awarded the Pulitzer prize for 1949.

In 1949 the Pulitzer prize was awarded for "Babe Ruth Bows Out," by Nat Fein of the New York *Herald Tribune*. The story behind this photograph is an excellent example of imagination and ingenuity on the part of a cameraman.

There were 25 photographers present when Babe Ruth made his farewell appearance to his Yankee Stadium fans on June 14, 1948. As the band played *Auld Lang Syne*, the famous ball player stood, with the well known number 3 on his back, his shoulders slightly stooped. Fein was aware of the dramatic moment. Some of the photographers caught Babe Ruth from the front, and others from the back, but they all used flashbulbs because it was a dark, dismal day. However, Fein opened up his lens and shot the picture with natural light, thus capturing the mood more effectively.

The 1951 Pulitzer prize award went to Max Desfor of the Associated Press for his highly dramatic "Misery on the March," a picture of Korean refugees crawling over a wrecked bridge to escape the approaching enemy

63

Civilians flee North Korea over the twisted girders of a bombed-out bridge. Awarded the Pulitzer prize for 1951.

forces. In 1952 the Pulitzer award for news photography was conferred on two members of the Des Moines *Register and Tribune* photographic staff for a sequence of six photographs. This photo sequence showed a football player's jaw being broken. Both photographers used special cameras designed for football coverage. Their cameras were instrumental in bringing the public's attention to focus on a bad condition in college sports. Publication of the pictures stirred a public interest and resentment that soon had national echoes.

There has been considerable criticism of the Pulitzer awards in news photography. Photographers who work for newspapers believe that full

(Opposite) Don Ultang and John Robinson of the Des Moines Register and Tribune were awarded a Pulitzer prize in 1952 for outstanding news photography, including this series with special sequence camera that proved that Johnny Bright, Drake U. star, was deliberately injured by an opponent. Elaborate equipment is now used for sport coverage.

IOWA FAILS, 21-0; IOWA STATE WINS

(Bert McGrane's Story on Page 3.) *(Brad Wilson's Story on Page 5.)*

Bright's Jaw Broken, Drake Streak Ends, 27-14

JOHNNY HURT ON FIRST PLAY, THEN HURLS SCORING PASS (STORY: PAGE 8)

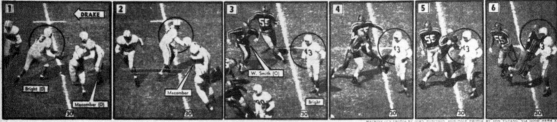

EVER SEE A JAW BROKEN?—On the first scrimmage play of the Drake-Oklahoma Aggie game Saturday at Stillwater, Okla., Drake's John Bright is shown as he hands the ball to a teammate, then moves out of the action. As he watches his teammate charge toward the line, two Aggie defenders close in on him. One turns off toward the Bulldog with the ball, but Wilbanks Smith of the Aggies has only eyes for Bright. Smith cocks his right fist (Picture No. 5 above), then drives it into Bright's jaw (No. 6). Picture No. 7 (the top part of the photo below) shows the overall scene. Note every player, except Smith, is watching the ball carrier. Bright was knocked down on the play. (X-rays later showed Bright's jaw was broken). Even this didn't stop Bright. A moment later he threw a 61-yard touchdown pass. But the bottom part of the picture below shows what happened to Bright a few minutes later. Again Wilbanks Smith goes for Bright, who is out of the play—about eight yards behind the Drake ball carrier. Other Aggies converge on the Bulldog runner. Not Smith. Bright's head goes back like a fighter being knocked out. And this was the end of John Bright—probably for the season. He was half carried, half led off the field (Picture on Page 8).

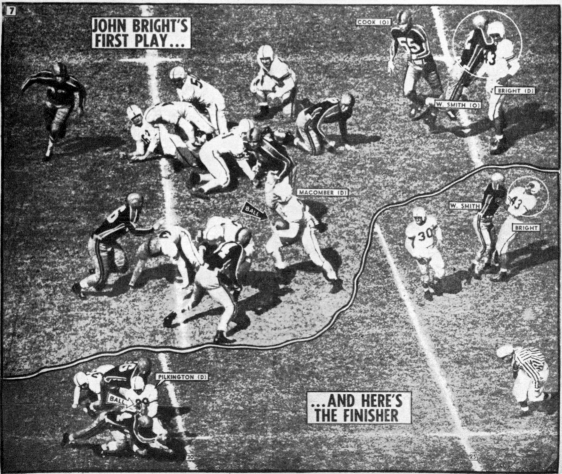

JOHN BRIGHT'S FIRST PLAY...

...AND HERE'S THE FINISHER

consideration is not taken of the fact that news pictures fall into many classes with regard to technique, application, and influence of publication deadlines. Although many Pulitzer awards are given for various types of reporting, all the photographs produced by news photographers are put into one category.

As magazine and news photographers approach their common basis of photojournalism, some believe that the Pulitzer award should be broadened. The emphasis on the accidental shot has also been decried.

One group of photojournalists suggests that the prize be awarded for:

"A distinguished example of a photographer's work published in an American news periodical during the year, the determining qualities being that the photographs or picture story shall embody an idea made clearly apparent, shall show the mastery of camera technique and striking pictorial effect, and shall be intended to be helpful to some commendable cause of some importance, due account being taken of the whole volume of the artist's work during the year."

In 1956, a step in the right direction was the award of the Pulitzer prize to the New York *Daily News*. The citation reads:

> "*The 1956 Pulitzer prize for News Photography was won by the New York Daily News for its consistently excellent news picture coverage in 1955. . . .*
>
> "*Any one of the forty-two photos entered by the News could be admired in any exhibit or salon. It is a collection remarkable for its variety of subjects and the wide sweep of human emotions—a woman thumbing her nose at a rival for the affections of the former's husband, a hound dog with an ice pack on his head, a baby being lowered on a fire escape, a baseball manager shaking his fist in the face of an umpire, and an 86-year-old woman refugee from Romania waiting for her ship to dock in New York. . . .*
>
> "*[The photographers'] collective work is a well-rounded coverage of life and death and hope and despair in a great city twenty-four hours a day.*"

The skill, instinct, and timing of the news photographer have been recognized in recent Pulitzer prize awards.

(Opposite above) This picture of the fatal stabbing of Japanese socialist leader Inejiro Asanuma on Oct. 12, 1960, won the Pulitzer prize in News Photography. Award went to Yasushi Nagao of the Mainichi newspapers of Tokyo. (Opposite below) This 1960 Pulitzer-prize winner was shot by Andrew Lopez of United Press International. Cpl. Joe Rodriguez of Batista's defeated Army is kneeling before a priest the day before he was executed in San Severino Castle courtyard at Matanzas, Cuba.

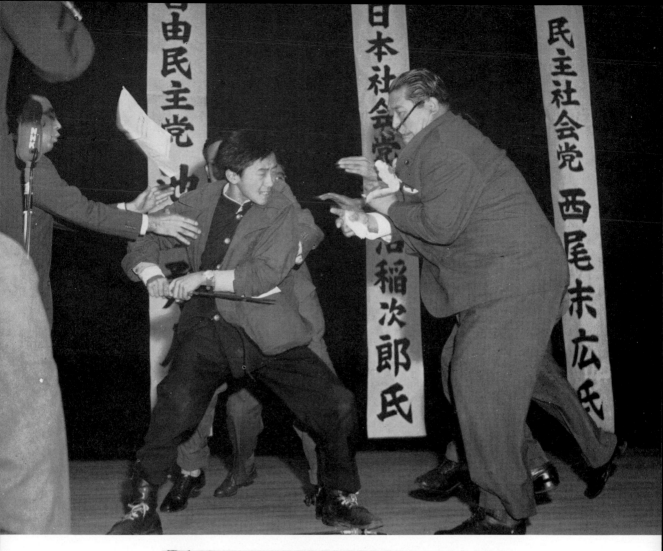

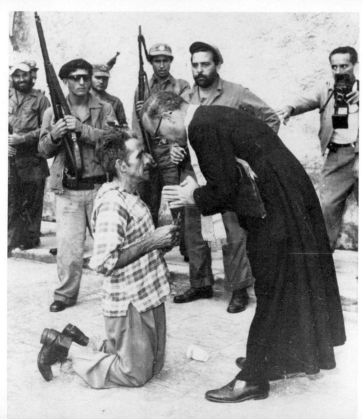

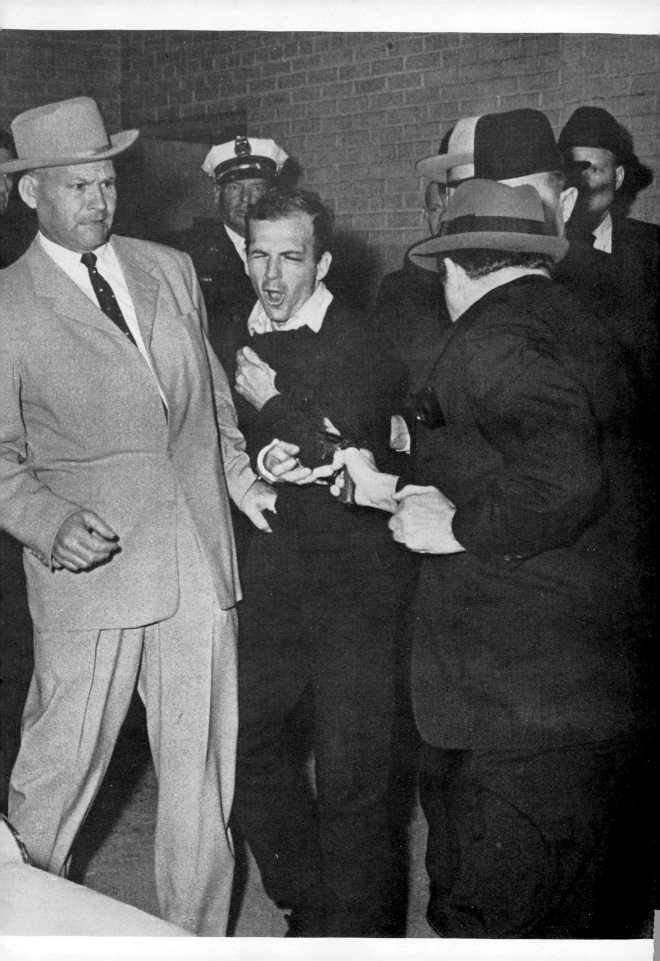

(Opposite) Bob Jackson's award winning photo of Jack Ruby shooting Lee Harvey Oswald in Dallas, Texas, won the Pulitzer Prize in 1963. (Right) Father Luis Manuel Padilla holds wounded government rifleman shot down in the streets of Puerto Cabello, Venezuela, during bloody revolt against President Betancourt. More than 200 people were killed before the rebels were beaten.

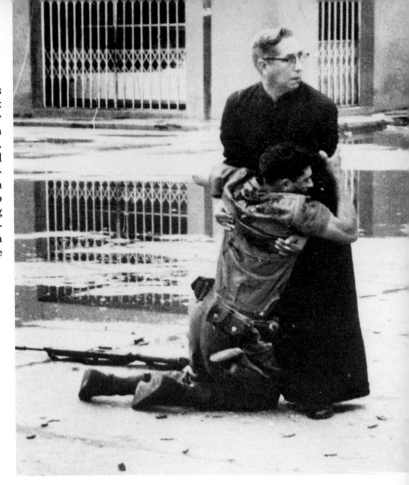

The body of a child killed in a battle in South Vietnam is held by his father as rangers of the Vietnamese Army look down from a tank. The child was killed in battle as the Government forces pursued Viet Cong guerrillas into a village near the Cambodian border. This photo taken by Horst Faas of Associated Press won the 1965 Pulitzer Prize.

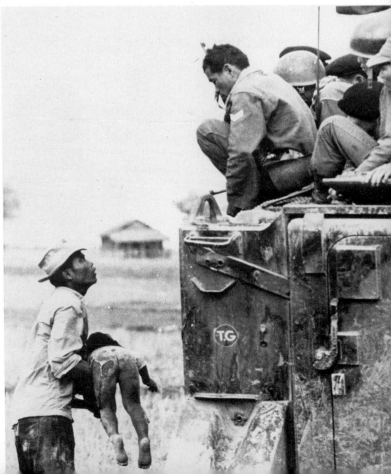

The following dramatic series of pictures by Eddie Adams of the Associated Press tells the grim story of how a suspected Viet Cong officer met his fate on a street pavement in the war-torn capital of South Vietnam. The incident took place in Saigon Feb. 1, 1968, as the communists continued their major offensive for control of the capital. Reports have it that the suspected Viet Cong officer was captured after a long battle in the area of An Quang Pagoda. He was in civilian clothes and was carrying a pistol. He was also, according to reports, slightly injured.

Hands tied behind his back, the prisoner is escorted by Vietnamese Marines. Marine at right carries pistol found on the prisoner.

The suspected Viet Cong is brought to stand before National Police chief Brig. Gen. Nguyen Ngoc Loan.

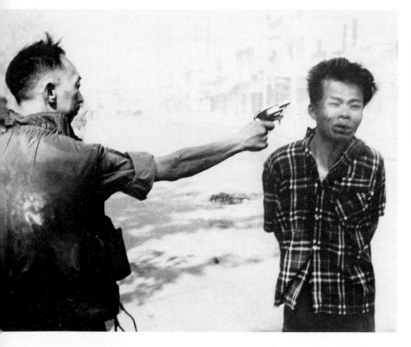

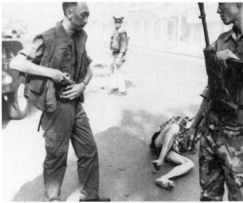

Loan then re-holstered his weapon and walked away saying, "They killed many Americans and many of my men."

Loan then ordered the Marines to move away, leveled his pistol, and shot the prisoner in the head. This photo won the Pulitzer Prize in 1969.

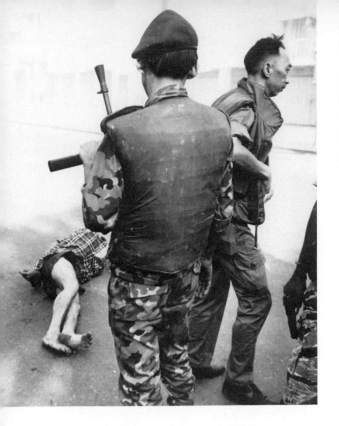

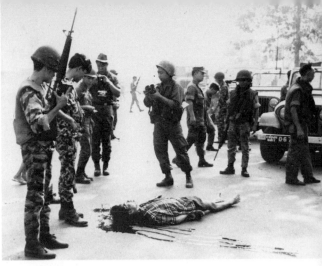

Blood streams on the pavement from the fatal wound. Gen. Loan walks away at far right.

As Loan is leaving, a soldier watches the prisoner die.

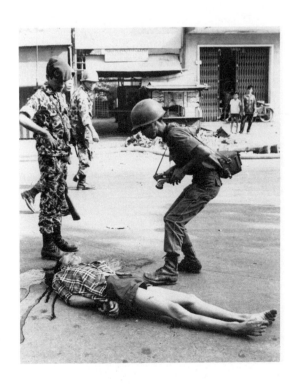

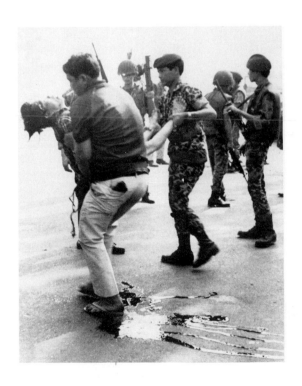

Vietnamese Marines watch as combat photographer takes pictures of the body.

The remains of the suspected Viet Cong officer are then carried away.

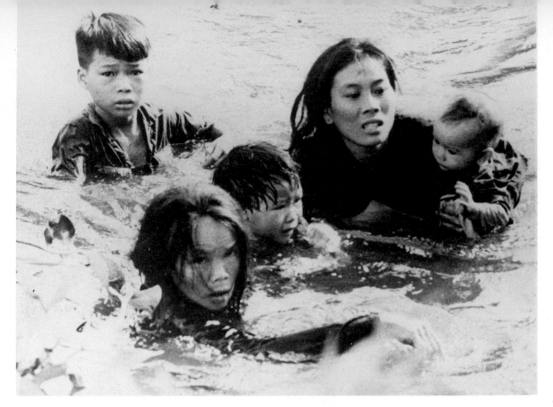

This is the work of Kyoichi Sawada, staff photographer for United Press International, who was awarded a Pulitzer Prize in 1966 for his coverage of the Vietnam War. This photo, titled "flee to safety," shows a Vietnamese family wading across a river to escape an attack on their village. Sawada was killed in Cambodia in 1970.

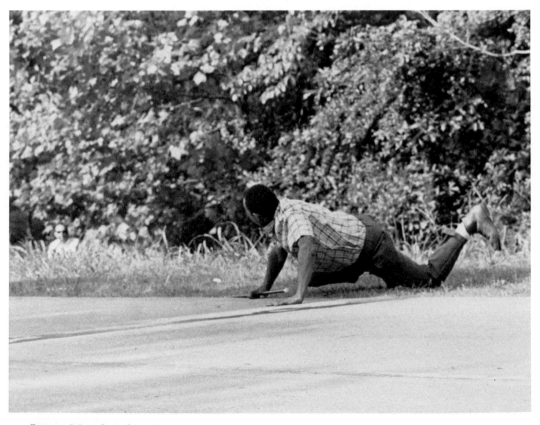

James Meredith hits the dirt after he was shot during his Civil Rights march to Jackson, Miss. His assailant is visible in the bushes at left edge of photo. This was a 1967 Pulitzer prize winner for Jack R. Thornell of the Associated Press.

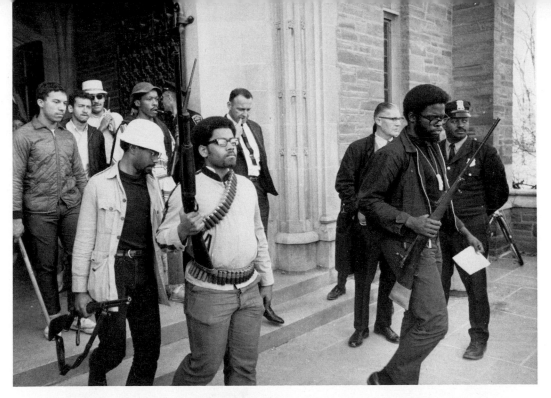

This picture won the Pulitzer Prize in 1970 for spot news photography. It shows the militant black students at Cornell University evacuating a University building they had occupied for 36 hours in April, 1969.

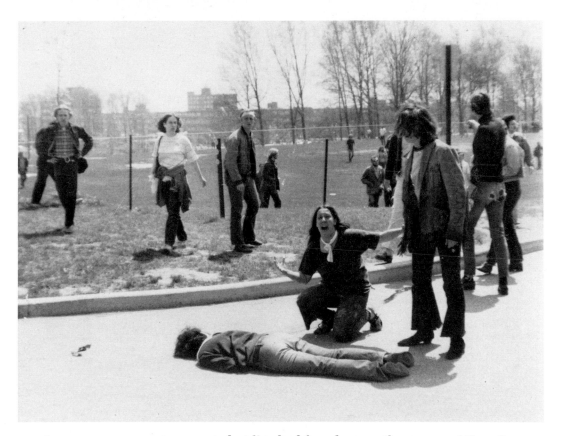

A young woman screams as a student lies dead face down on the campus of Kent State University. National Guardsmen fired into a crowd of demonstrators and four persons were killed and eleven wounded. This Pulitzer-prize winner for 1971 was made by a student at Kent State.

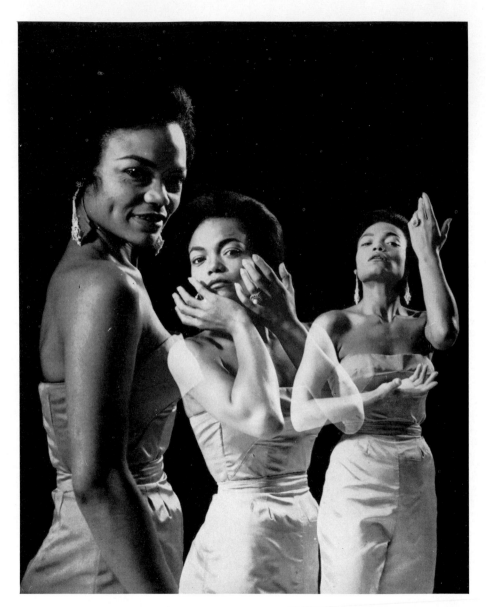

Eartha Kitt is caught in three moods by three exposures on the same sheet of film. Each was drawn on the camera ground glass as it was posed for a planned effect.

3

Creative Images

The Feature Photograph

A feature photograph is a single picture of an event that is of continuing interest, creating a mood, presenting information, or recording a timely subject, rather than spot news. If often embodies elaborate technical effects and unusual compositions, but may also be extremely simple. The photojournalist who takes a feature photo works carefully, and has time to evaluate and consider his approach.

Although major publications consider features a specialty, some photographers alternate between covering spot news for the daily paper and shooting features for the Sunday supplement. It becomes necessary for them to adjust to a change in pace. Instead of compressing the story into a few pictures, as with spot news, feature photographs cover the event comprehensively and more of the atmosphere can be interpreted. The photojournalist working on a feature assignment does not have the drama, excitement, and pressure of spot news. On the other hand, he can exercise more control. The subject, lighting, and composition can emphasize the specific details that the photographer wants to show.

In analyzing his subject the feature photographer must be able to select the significant. The selection of what to photograph is just as important as the technique used for making the picture. The process of selectivity starts with a thorough knowledge of the subject, so that the photographer can analyze the important elements. Composition is then utilized to make the resulting selection interesting and effective.

Composition

Composition refers to the arrangement of the elements in a photograph so that a pleasing design is created. The photojournalist uses it correctly to help make his visual message clearer. The position of the main subject,

the horizon line, light and dark areas, and the introduction of diagonal lines and "S" curves are controlled by the photographer with regard to the best telling of the story. Complicated compositions should be avoided. When the subjects are arranged, he must think of what is included, what is left out, and what is implied.

The photographer's ground glass or viewfinder may be compared to the painter's canvas. Both photographer and painter have the problem of organizing the elements of their picture to make its presentation most effective. But the painter has a different kind of control. If anything detracts from the strength of his statement, it can be removed. He can add something to make his meaning clear; a color in the original scene that is wrong for his interpretation can be changed.

The photographer must use other means for creating compositions. One of the first considerations is selection. Edward Weston said that composition is merely the strongest way of seeing. It is the photographer's perception and imagination that controls how he views the world and his selection of the significant that makes his composition effective.

Most rules for composition are attempts to transfer the formal concepts of design in painting to the photographic approach. For example, a circular design is supposed to produce a sense of unity. A triangular arrangement results in a feeling of symmetry. A strong horizontal line creates calm and tranquility. Diagonals and verticals imply action. The photographer who works only by these rules of composition will make pictures that can be done better by a painter.

Allow the subject to determine its own arrangement within the framework of selection and based on its inherent form. Once this is established, stress some aspects of the picture and play down others in order to give the final composition a personal interpretation.

Formula for Composition

Thus, the only valid formula for composing photographs is to perform two voluntary and deliberate actions—select and stress.

The selection of the image may be influenced by three conscious efforts. One of these is the viewpoint. The camera may look up or down; it may observe from a distance or closeup. Each point of view changes the composition of the picture.

The second factor of selection, perspective, is controlled by the lens. A wide-angle lens produces a different composition from a long telephoto. Through his choice of lens, the photographer can vary the arrangement of the elements of the picture in relation to each other.

Finally, there is the moment of exposure. This may determine the position of the subject, especially if action is involved.

Three Controls

To stress the desirable elements in a photograph, there are three addi-

Simple lighting is often best in a photojournalistic portrait. This photograph of baseball player Jackie Robinson was made with a single flash on the camera.

tional controls. The first is color. In the studio, light sources and filters may be used to obtain an infinite variety of effects. Outdoors, filters in front of the lens and the time of day may affect the appearance of the final picture. Color may separate the elements of the composition, isolate the subject, and indicate the center of interest.

A second control of composition is sharpness. Sometimes called selective focus, this is one of the most useful aids to composition. With it one can blur a foreground and background in order to concentrate on a more interesting subject in the middle. This is a most effective way to place stress on the area of greatest significance.

The final method of control is exposure, which can determine the saturation of color and, thus, stress the mood of the picture. It may have a high-key or low-key effect. Deliberate under- or over-exposure will either suppress or bring out details that can contribute to a more affirmative statement.

The importance of careful composition in color increases as the final picture gets smaller. In black-and-white photography there is always a second chance to help the composition. During the process of enlargement, further selection of the best arrangement of elements in the picture is possible. With color transparencies this becomes impractical and with color negatives there is a deterioration of quality. The ideal approach is to try to obtain the best composition at the time of exposure.

In photography, more than in any other visual art, form follows content. The idea for a picture must come first, followed by a composition based on the geometry of the subject. Rather than get involved with ar-

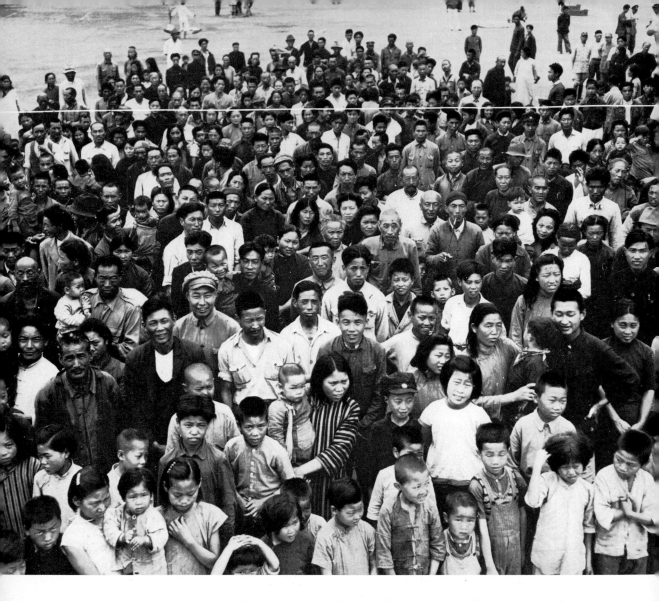

When the upper portion of this photograph of a crowd in Hankow, China, is cropped as indicated by the white line, the crowd seems to stretch back endlessly. When composing a photograph or when cropping it later, the photographer and editor must be concerned with what is left out as much as with what is included, and the total implication of the picture.

rangements of forms and lines that please the eye, photographers should think of composition as a means of making the picture more intelligible.

Pictures with Impact

When faced with the problem of dramatizing an editorial idea, the photojournalist has many tools with which to work. Insight into the subject and the selection of the significant is basic. Imaginative lighting can be used to create a mood. Many photojournalists, taking advantage of fast films and lenses, use available light. Natural and realistic effects are created

by bouncing the light on a ceiling or wall. Lighting should create an adequate exposure and set the proper mood for the photograph.

In order to make a picture more forceful it is sometimes desirable to distort or accentuate the perspective with lenses of various focal lengths. This also changes the relationship between an object and its background. The position of the camera is important also. A distant panoramic shot will set the scene while an extreme closeup will emphasize a significant detail. If the feature photographer has enough time, he can shoot all around the subject. Photographs may also be taken from other than the normal viewing angle. Shooting upwards from a low angle adds stature and impressiveness to the subject. Shooting down from a high angle creates a sense of detachment and sometimes shows more clearly what is happening.

The photographer's control of action can add interest and variety to his pictures. Electronic flash and high shutter speeds are used to freeze action and record that which happens too quickly for the eye to see. The skillful

This effect is one originally devised by time-motion study engineers. Small six-volt bulbs were attached to the hands and feet of dancer Igor Youskevitch. A time exposure in darkness traced the patterns, then a flash caught the leap while the shutter was still open, combining motion record and sharp picture.

Both of these are strong pictures and effective by themselves. Used together, however, their contrast establishes what has been called "the third effect," communicating an idea beyond the message of either picture alone. Good picture editing makes use of this juxtaposition for additional visual effectiveness whenever possible. "Emily" (left) is from a story by Kosti Ruohomaa on a child's discovery of the countryside, the other (right) is from a photographic essay by Earl Theisen on the Navaho Indians.

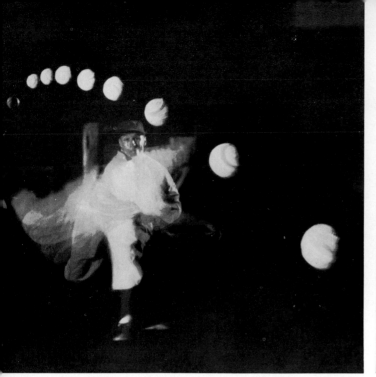

(Left) Ten electronic flash units, automatically firing in close sequence, trace the pitcher's ball for a carefully planned picture.
(Right) Deliberate blur to indicate fast action is used in this fashion picture. Light from two 1000-watt bulbs was "bounced' from the ceiling and a slow (1/25 sec.) shutter speed was employed. The fast-moving extremities disappear as the model is caught at the top of her leap.

use of slow shutter speeds to blur moving objects gives another kind of illusion of motion. Movement can also be shown by a series of multiple exposures against a black background. Time exposures of moving lights create patterns of motion. Panning the camera in the direction of a moving object makes the object sharp against a blurred background.

Selective Focus

The imaginative photographer also makes skillful use of depth of field. Small apertures create photographs in which extreme sharpness exists from the very close foreground to the distant background. Using the lens at full aperture, the photographer can throw either the background or the foreground out of focus. Selective focusing can also add emphasis to the important parts of a picture. The photojournalist should also know how to use films like infrared, and radiation like the ultraviolet to help get his visual message across.

Humor

The obvious straightforward approach is sometimes the best. Originality and excitement can often be achieved by using a strange prop or putting the object into incongruous surroundings. The production of humorous

feature photographs presents a challenge to the photographer. Even when he resorts to technical tricks, the photojournalist is still forced by the nature of the camera to deal with real objects and real people under comparatively plausible conditions. A photograph can make us laugh when it shatters our expectations by showing the impossible happening. We see an overall plausible situation possessing something that differs from the facts and our sudden surprised recognition of this incongruity is humorous. A photograph that upsets our conception of things as they are has comical possibilities.

When a photograph contains a fantastic resemblance to the truth, if we can see what the truth is and detect the error, there is humor in the false statement. When a picture presents a distorted view and we know the real situation, we can recognize and enjoy whatever is at variance. Thus we laugh at an exaggeration, a caricature, or pictorial sarcasm.

There are photographs that make us laugh sympathetically. We identify with the subject or perhaps have had experiences similar to those pictured. In its simplest form, this type of humorous photograph might be a picture of a person or group enjoying a good laugh. In its more highly developed form, this type of picture employs the technique used so effectively by Charlie Chaplin. The photograph may show an ordinary man doing something very simple and familiar, but with humorous consequences.

Humorous photographs are made in several ways. Frequently a photographer quite seriously takes a picture of a serious event. In retrospect, however, the situation contains laugh-provoking qualities. This type of humorous photograph will always exist as long as unpredictable things happen when we click the shutter. Also, there are photographers with a sense of humor who see things that they realize are comical and proceed to record the funny situation on film so that others may laugh too. Sometimes a photographer deliberately decides to take a picture that will make us laugh. Unfortunately, these pictures are rare. Perhaps it is because photography is such a comparatively new and unexplored medium of expression.

Publicity Pictures

The publicity photograph is made for publication. It is designed to sell an idea, product, or service. The publicity photograph is simply a form of free advertising. It may degenerate to "propaganda" or rise to the benevolent heights of "information."

The producer of publicity pictures is working somewhere between advertising illustration and photojournalism. Unlike the news photographer who *takes* a picture, the publicity photographer *makes* a picture. The basic idea in publicity photography is to get space that the client would normally have to buy at regular advertising rates. It is obvious, therefore, that these photographs must be of unusually high quality to warrant such preference. Large numbers of publicity photographs are used regularly. If

Humor in photography, whether posed or unposed, is a rare commodity, requiring either a quick eye and response to the incongruous like the ambidextrous waiter (above), or the skill to create pictures which require no verbal explanations (opposite).

the flood of these photographs and press releases should suddenly stop, most newspapers, magazines, and news agencies would find it necessary to substantially increase their editorial overhead.

The publicity photograph may be used to sell a brand name or a product. More recently it has become a means of keeping an idea or general commodity before the public. Publicity photographs are less obvious to editors and readers alike when they deal with the concepts of vacationing in Florida, sponsored by airlines, or safe driving, sponsored by insurance companies.

The photographer who makes photographs for public relations purposes must keep in mind the publication in which the picture is to appear. When furnishing material to a newspaper, the photographer should be aware of its pictorial policies. For example, a tabloid newspaper would be more receptive to the girl, gag, dramatic, or sensational photograph than such

papers as *The New York Times* and the *Chicago Tribune*. The newspaper
that has built its circulation upon a sensational approach to the news is
more likely to print photographs of the same type. A conservative news-
paper, however, will have a conservative attitude towards the photographs
it prints.

For magazines, the publicity photograph does not require immediate
spot news value; exclusiveness is more important. The magazine editor will
be much more receptive to any set of photographs of good quality and
interest if he is sure that no other publication will print it. Also, magazines
are using more and more color today. The publicity photographer desirous
of seeing his work in print would do well to become technically proficient
in color as well as in black-and-white.

For general magazines it is desirable to camouflage the basic idea with
a human interest angle. For example, the Hilton Hotel chain has con-

Publicity pictures call for ingenuity to become good photographs in their own right and not obvious set-ups for company promotion. This little boy with his oil can is from the files of one corporation which encourages imagination.

sistently obtained free publicity by staging elaborate, well-photographed parties attended by large numbers of celebrities at the opening of each new hotel.

Personalities

If a photographer is publicizing a relatively unknown personality and the picture is being taken with two well-known subjects, the client should be placed in the center of the picture. The reason for this is that editors are ruthless in cropping portions of a print that they do not consider especially newsworthy. However, if all three people are of approximately the same importance and there is little danger of the photographer's client being omitted, it is best to place him at the right of the other two, so that he appears on the reader's left. This means that his name will be mentioned first in the caption and may even appear in bold-faced type.

Portraits made for publicity purposes are usually different from those intended for display in the home. Backgrounds should be minimized, as they will otherwise require the attention of the publication's art department and the extra time involved for this frequently determines whether

the picture is ever used. A white background is best as it sharply defines the face. Lighting should be full and shadows avoided.

Equipment

As in other aspects of photojournalism, the subject to be photographed will determine the kind of equipment that is used. The photographer who makes architectural publicity photographs, for example, should have a substantial tripod, a fairly wide assortment of filters and lenses, and at least one large camera with revolving back and adjustable swings for correcting distortion. The cameraman who works on sporting events may require telephoto lenses. The publicity portrait photographer will need a studio, appropriate lighting equipment, and the services of a good retoucher.

The publicity photographer has several clients. One of these may be the public relations firm with which he is associated. The other is the individual or the company whose product or services the photograph is selling. The third and most important is the editor or art director who will eventually decide whether or not to run the picture in his newspaper or magazine. In seeking to satisfy each of these three there may sometimes be considerable conflict. The fact that the client is paying his public relations firm and photographer may lead him to believe that he has the privilege to transmit a commercial message in the editorial space of a publication. This attitude is wrong, and pictures made under such circumstances rarely get printed.

The art of the publicity photographer, in addition to his technical skill, consists of being able to retain the identity of his client in the photograph without affecting its interest to the reader.

Requirements

For the public relations firm that wants to make good publicity photographs and get them printed widely, the following requirements prevail.

1. Know your subject.
2. Know the medium in which the picture is to be published.
3. Get a good photographer.
4. Decide how to tell your story visually.
5. Give the editors what they need.

The creation of pictures for publication in a magazine or newspaper can only be achieved successfully by a specialist with adequate training. This type of photographer must not only be able to take well composed, technically excellent photographs, but, in order to communicate he requires the broad education and varied background that will give his work meaning.

The photojournalist producing feature photographs usually finds his work published in magazines or gravure supplements to a newspaper. This means that photographs can be produced with a more subtle range of

tones than those prepared for newsprint reproduction. The feature photographer can devote more thought to the problems of composition, camera perspective, and pictorial values. Another point worth considering is that the deadlines on these publications are often weeks in advance. In a period of changing seasons the photographer must be aware of when his pictures are going to be used and make proper provisions for that. Color is often printed far in advance and as a result it is not uncommon for Christmas photographs to be made in September and Easter photographs to be done in January.

However, in spite of these special requirements for feature photography, the photojournalist must still do a significant job of picture reporting. This comes from his ability as an alert photographer to see and interpret the full meaning of a situation skillfully and truthfully. No amount of technical proficiency can help convey the vital essence of a story without a warmth of understanding.

Creative Thinking in Feature Photographs

Creative photography involves the most skillful use of technical means to make the reader see a subject as the photographer sees—and feels—it. It may involve selective focusing as in Hansen's picture (opposite) of a scene at the Kohler strike or a wide-angle lens and a "patient's eye" view as in the same photographer's picture (below). It may involve selection of detail, lighting, multiple exposure, or the use of special films. An editor, too, may strengthen impact or significance by his placement of pictures.

The ballet dancer, Tanaquil LeClerc, is stopped in midair by the light from four electronic flash units, placed behind a diffusing screen to give a semi-silhouette.

(Above) A wide-angle lens used close up distorts the features of comedian Jimmy Durante, exaggerates his famous nose. (Below) To illustrate the first day of school, the wide-angle lens looks down the rows of desks toward the teacher, gives greater depth and apparently lengthens the rows.

(Above) These swimming children were photographed through a window in the side of a pool below water level. It was given an award by the New York Art Directors' Club, following its publication. (Below) A three-dimensional, sculptured effect is achieved in this classic pose of a shot-putter by means of multiple electronic flash which records successive phases of the action on a single sheet of film.

(Above) A guard of the Alaskan command is silhouetted against the weak Arctic sun as he guards the radar dome in the background. Extreme cold affects cameras and lowers the emulsion speed of film, adding to the photographer's hazards. (Right) This sports photograph is more dramatic than any action shot would be. It conveys the intensity of physical struggle and the emotional pitch of great sports contests.

(Above) Infrared-sensitive film can transform a landscape, as in this scene of the Rocky Mountains in Colorado. (Below) The dull light of this rainy day and the reflections in the street enhance the composition and the mood of this photograph of the funeral of General LeClerc in Paris, 1948.

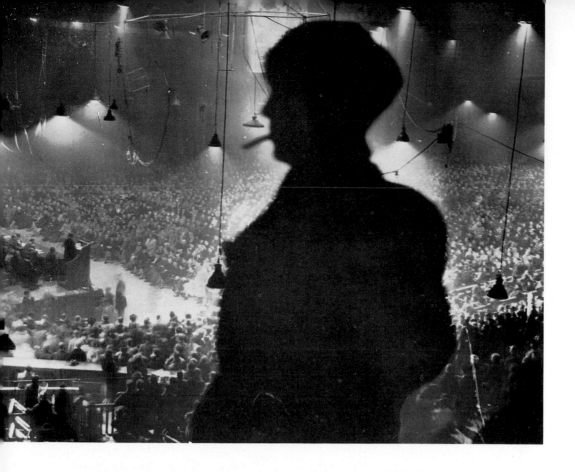

The silhouetted figure (above) adds drama, and also helps establish place and mood in this picture of a political rally in Paris. The crowd shot alone would have been less effective. (Below) The artist John Marin is in his studio. The photograph was made with a wide-angle lens in order to present the subject in relation to his environment.

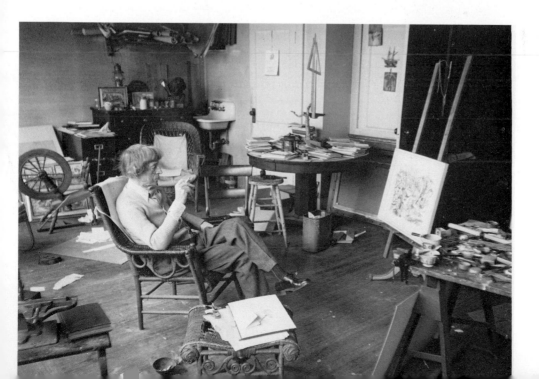

Creative effects are often achieved through the use of inexpensive attachments. These two photos demonstrate the use of a 180° Fisheye auxiliary lens (above) and a prism type multiple image lens (below).

4

Progressive Continuities

The Photo Sequence

A photo sequence or picture series consists of more than one photograph dealing with the same subject. It may tell a story, describe a scene, record an event, or reveal a person. The sequence or series is most effective when it creates several visual images all containing highlights of revealing action.

The first photo sequence ever made demonstrated conclusively the limitations of the eye when observing action and the revealing power of the camera under the same circumstances. A photographer named Eadweard Muybridge was commissioned by Governor Leland Stanford of California to photograph a horse galloping. Governor Stanford had contended that in a gallop all four feet of a horse were off the ground at once. Muybridge's photographs made in 1878 proved that the Governor was right. This historic sequence was made by allowing a horse to gallop past a series of cameras. The galloping horse broke strings stretched across the track, which in turn released the camera shutters.

Another pioneer in sequence photography was Paul Nadar, who, in 1886, made a series of the French scientist, M. E. Chevreul. This revealing candid photographic interview was published in the Paris newspaper *Le Journal Illustré*. Paul Nadar made instantaneous exposures on the newly introduced dry plates while his father engaged the 100-year-old chemist in conversation. A stenographer recorded Chevreul's words at the moment of exposure and these were printed as captions under the photographs. This type of picture series is still in use today. The modern photographic interviewer may use a miniature camera, electronic flash, and a tape recorder, but the result is basically the same.

In cinema production a series of scenes are edited and combined so that they tell a story. A photo sequence is actually one of these scenes or takes. Although it is not a complete narrative, it does convey more in-

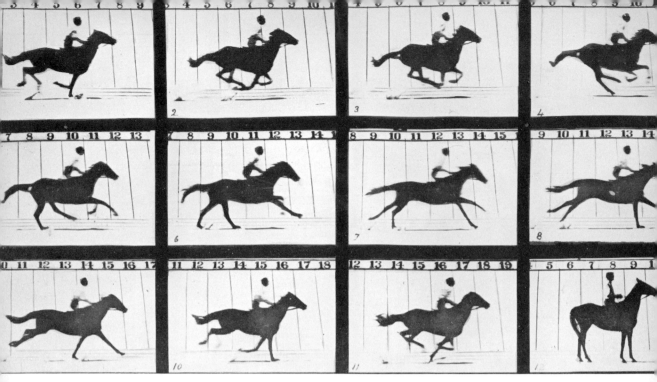

This galloping horse sequence was made by Eadweard Muybridge in 1878 and demonstrated conclusively the disputed point that a horse in this gait had all four feet off the ground at intervals. Muybridge devised his own equipment to push the slow plates and cumbersome cameras of his day to record action sequences too fast for the eye to resolve.

The first photo-interview was recorded by Paul Nadar in 1886 as Nadar, Sr., chatted with the centenarian, Marie Eugene Chevreul.

P Nadar

«...Je me rencontrai avec Monsieur Hersent, le peintre académicien, en 1840, dans la cour de l'Institut, en sortant de la séance dans laquelle Arago, &ᶜ... et je lui dis que le jaune à côté du bleu donne de l'orangé, et que le bleu à côté du jaune passe au violet...»

P Nadar

«... Arago avait, dans son rapport sur l'héliographie omis de mentionner le nom de Niepce, le véritable inventeur...»

P Nadar

...Notez que je les crois volontiers de bonne foi!.. Mais...

P Nadar

«.... Remarquez que je suis loin de blâmer ce que je ne puis expliquer; mais je vous dirai qu'il faut que je voie...»

A sequence of Molotov during a session of the United Nations in 1946 was made from the press booth, about 150 feet from the subject, using a 300mm lens. About 200 exposures were made during a long session of the Security Council.

formation than a single frame. It is an expansion in time of a single picture and thus creates an illusion of action and seems more realistic. Sequences may be classified according to their methods of production.

1. *Camera and subject are fixed.* An example of this type of sequence is the photographic interview with Chevreul by Paul Nadar. A more modern example is a series of Molotov taken at the United Nations. During a session of the Security Council, Molotov had to remain in his seat for several hours. The camera could only be used from a press box, 150 feet away. The photographer took over 200 photographs with a telephoto lens, which were edited down to a revealing series of the Russian leader. To the photojournalist, this is a valuable device for capturing the real characteristics of a personality.

Another example of this technique is the series of J. Arthur Rank, the British film producer. These photographs were made from the seat opposite Rank in a dining car. As Rank talked animatedly to another person, a 35mm camera, equipped with rapid winder, captured every gesture and expression.

It is important for the photojournalist producing photo sequences to realize that film is the cheapest commodity in his operation. When it is apparent that the opportunity for a photograph or a series of photographs will not present itself again, it is foolish for the photographer to be inhibited by the amount of film he exposes. A much neglected virtue of the 35mm camera is the fact that a sequence of 36 exposures taken in rapid succession will capture many expressions that can be edited later.

2. *Camera in fixed position, subject changes position.* Muybridge's famous sequence of a galloping horse is an example of this type of picture series. Modern sequences of this type are often used in sports photography. Ordinary single-picture coverage is inadequate in a fast moving sport like baseball, football, or boxing. The photographer is never sure of getting the exact peak moment of the action. He is also handicapped by having to adjust his camera or change film when the action may be important. For this reason, special cameras have been devised to produce this type of photo sequence. While they vary in negative size, shutter speeds, and frames exposed per second, all have in common the creation of many instantaneous exposures automatically. Photo sequences of this type have tremendous interest during the World Series baseball games. Even though the baseball fan may have seen the action on television, he will want to study and discuss the sequence at his leisure when it is reproduced in the newspaper or magazine.

Although this type of photo sequence is used primarily for sports, it may also be applied to other events. An example of this would be photographing a parade from a rooftop. At Minneapolis, the annual Aquatennial Parade was photographed from a high vantage point; thus a series of photographs of the floats and the pageantry communicated a vivid impression of the event.

Camera and subject were both in fixed positions during this photo-interview with the British film producer, J. Arthur Rank. The series was made with a Leica equipped with a rapid winder, on a private railroad car enroute from New York to Hollywood.

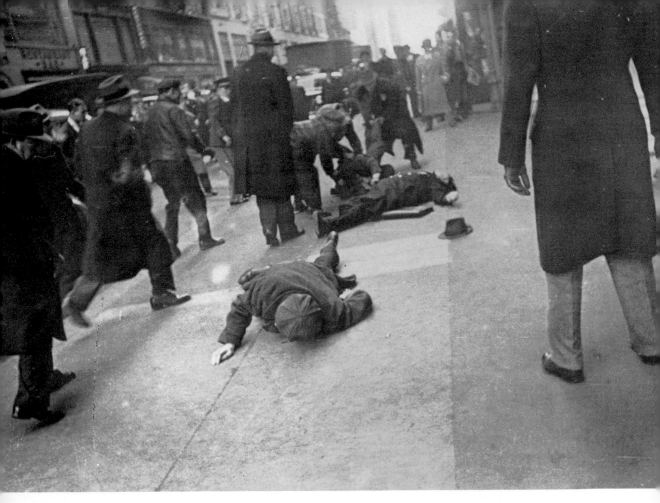

One of the most remarkable spot-news sequences ever made is the set of photographs of the Esposito brothers shooting their way up Fifth Avenue in New York City. It indicates, too, the advantages of a miniature camera for rapid coverage. The photographer heard the sounds of shots, seized his Leica and ran downstairs to follow the action for several blocks making exposures as he went. He processed the film immediately and sold the pictures to the New York Daily News. This is one of the set which covers the fast-moving event.

A series of photographs may also be taken from a fixed position in the audience of a theater. The resulting series may then become a photographic review of the performance. Such a sequence presents the highlights of amusing action in the musical comedy, "Wonderful Town."

3. *Camera moves, subject is fixed.* This is an approach to sequence photography that often makes the subject more interesting. It can be used to reveal different aspects of a given subject, such as several angles or views of a statue or a building. It also adds variety and interest to the ordinary series.

4. *Camera moves, subject moves.* This type of photo sequence is probably the most dramatic, but also the most difficult to obtain. It demands that the photographer follow the action physically, while producing a

continuous series of exposures. An outstanding example of this, and probably the most remarkable example of on the spot reporting, is the famous picture series by Max Peter Haas of murder on Fifth Avenue in New York.

William and Anthony Esposito robbed and killed a merchant, and then fled, killing a policeman and wounding a taxi driver before being captured. In this unusual photo sequence, Picture One shows the taxi driver lying in the foreground with a crowd gathering around the policeman. Picture Two shows the wounded driver, the dead policeman, and in the background, the wounded William Esposito. In Picture Three, Esposito has been pushed against the wall, and in Number Four, spectators find that the patrolman is dead. Picture Five shows the doorman at B. Altman's department store, gripping Esposito's leg, and Number Six shows the police arriving. Seven shows the doorman still holding Esposito as additional police arrive. In Eight, a detective is covering the dead policeman's face, while in Nine, Ten, and Eleven Anthony Esposito, the other gunman, is being dragged from across the street by police who captured him. The last of the series shows the wounded taxi driver.

In conclusion, a photo sequence is an amplification of a single picture. It is justified when it reveals more. It may require the use of special sequence cameras. In producing a sequence, many exposures are edited down to those which are most effective. Finally, it requires continuity, which may be created by the action of the subject, the event, or through the consistency of the photographic technique.

(This page and next pages) The camera position was fixed (a theater box) and the subjects moved across the stage in this sequence featuring Rosalind Russell in the musical comedy, "Wonderful Town."

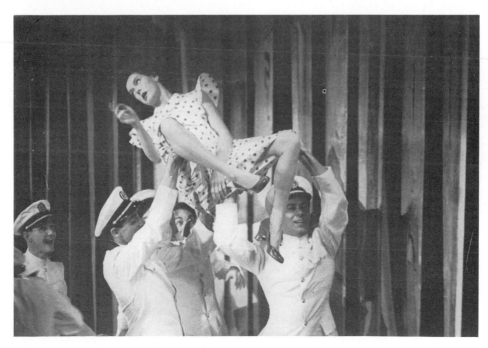

These five photographs are an instance of sequences in which the subject is stationary and the camera moves around it. The photographer has shown the Taj Mahal from the air, reflected in a pool, moved closer to look up at the intricate carvings, moved inside to watch visitors approaching, and finally viewed the whole structure through a framing archway.

In this remarkable sequence of the birth of a baby, photographer Paul Fusco used sensitivity and perception. With a fixed subject, Fusco moved in for closeups and made long shots to create various viewpoints and capture revealing expressions.

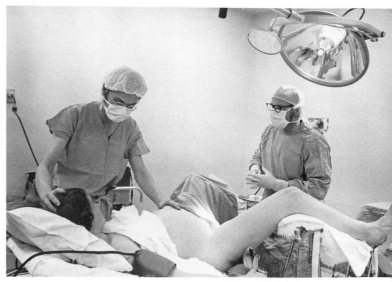

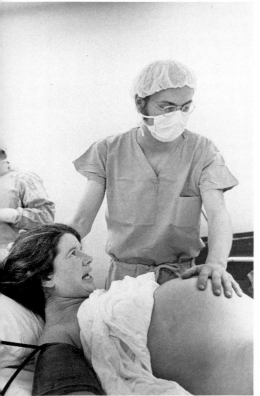

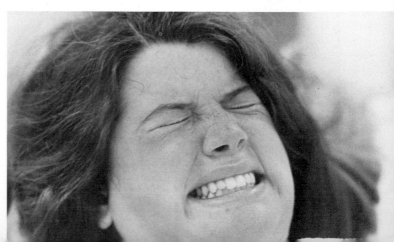

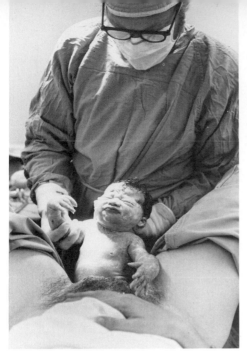

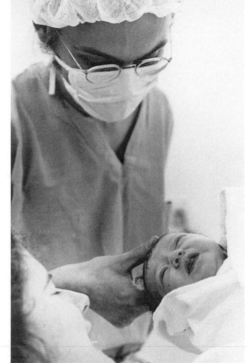

5
Photographic Narration

The Photo Essay

The photo essay or picture story is a planned and organized combination of news and feature photographs presenting in narrative form a complete and detailed account of an interesting and significant event, personality, or aspect of contemporary life. It represents the most complicated type of work done by the photojournalist, requiring the knowledge and use of the greatest variety of techniques, the ability to direct people and their actions, the application of diplomacy, tact, and persuasion, as well as a considerable amount of physical energy.

Early History of the Photo Essay

Photographic narration is a relatively new means of communication resulting from the blending of words and pictures to tell a story. The modern application of the picture story started in 1925 when Gardner Cowles and his brother John Cowles became interested in a new technique for the scientific measurement of reader interest. This technique had been developed by researcher George Gallup, who was, at that time, a graduate student of psychology and an instructor in the Journalism School at the University of Iowa.

Gallup's measuring technique was first tested on the readers of the Cowles' Des Moines *Register and Tribune*. It showed that pictures ranked high in reader interest and that related pictures ranked even higher. These findings led to experiments with picture stories and with stories combining pictures and text. Most of these experiments were conducted in the *Sunday Register* rotogravure section, which soon acquired a national reputation for its handling of sequence and related picture stories. Publishers and editors throughout the country watched the experiments with mixed feelings, but

any sceptics were soon convinced by evidence from the *Register*'s circulation department. As the picture narratives were more skillfully handled and published at greater length, the Sunday *Register* circulation increased by 50 per cent.

Picture Magazines

The great success of these experiments with the picture language eventually started Gardner and John Cowles thinking about a national magazine utilizing the same technique. From 1933 on, they were actively preparing a picture language magazine. A handful of people selected from the *Register and Tribune* experimented on all kinds of layouts and related stories, reworking the dummy many times before *Look* finally made its appearance in January, 1937.

In November, 1936, *Life* magazine, dedicated to presenting the news in pictures, appeared. *Life* also used related pictures combined with text to create the photo-essay. Both picture magazines developed enormous readership and became the most influential users of photography in the world. *Life* and *Look* arrived on America's newsstands within a few months of each other. Both were convinced that people's interests are as broad as the world, and there was nothing in the editorial policies of either magazine that would limit its appeal to people of any sex, age, geographical location, education, or income level.

That there was merit to this new editorial concept was immediately evident in the circulation results.

For a period of almost a half-century, *Life* and *Look* dominated the mass magazine market. Their appeal to the American audience lay in the wide variety of journalistic subject matter that they covered pictorially. The *Life* format was found to be so effective that foreign publishers created magazines like *Paris Match* and *Manchette*, almost exact copies, often running the same photos and stories of events of international importance. Exclusive photographic coverage of Martin Luther King's assassination in 1968, for example, appeared in *Life*, which sold the story to magazines in many countries.

The closing of *Look* and *Life* might indicate that the general reader is no longer getting his news through the picture magazine; he has TV film and videotape coverage in his home at all times. Indeed, the trend in the magazine world seems to be toward specialization; studies show that the American reader seems more inclined to purchase several magazines giving intensive coverage to his particular areas of interest than a general news pictorial magazine.

For the photojournalist, however, the work remains the same. Whether he is working for a fashion magazine, or for a "house organ" on computers, the structure of the photo essay is the same; his equipment will often be the same or more specialized for particular uses; his relationships with art directors and editors might be the same or more or less intense,

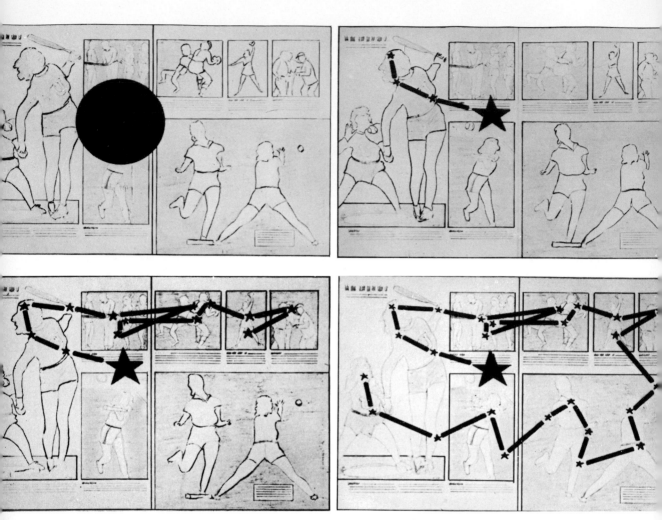

Studies conducted by *Look* magazine and the Visual Research Laboratories at Drake University, Des Moines, Iowa, with over 3,500 subjects indicate that readers first glance at the area marked by the black disk in the first of the series, the "primary area of fixation." From there, in a typical magazine two-page spread, the eyes tend to move toward the left and upward in the next moments of attention. This tendency seems very strong, even when color and design in specific layouts would seem to operate against it. The eye now moves rapidly across from left to right, glancing back and forth and changing direction several times. This scanning movement is normal, even on a field of symmetrical dots or pictorial symbols. The glance tends to continue in a generally clockwise movement, quickly sweeping around the page. This last sweep, however, is markedly influenced by the details of the particular layout. Such scanning movements, it is important to note, apply only to the first seconds of viewing.

depending on the size of the magazine, its frequency of publication, and the degree to which it uses the language of photography to make its presentation more interesting and effective.

Picture Language

The modern newspaper or magazine uses this picture language in three ways. Probably the most commonly used approach is the combination of pictures and words in such a way that the story is told by related pictures arranged in continuity. The words occupy less space than the photographs and, although they are very important, are subordinated to the pictures. The words are presented in the form of short, related captions.

Another type of picture story is the kind that requires no captions at all. A brief headline, a word with each photograph, or perhaps a general text block is all that is necessary.

The third form of photographic narration is the use of the picture story continuity within a text story to increase readership by making the story visually appetizing. Reader tests show that the connected picture story used as illustration often gets twice the readership given to the text it accompanies. The text also benefits from the picture story, often getting twice the attention it would receive if it were presented alone.

Ideas for Stories

Every picture story starts with an idea, and these ideas come from a variety of sources. They may originate from an editor or a photographer on the staff of a publication. They may come from the inventive brain of a press agent, a free-lance writer or photographer, a faithful reader, or an interested citizen.

The photojournalist creating picture stories gets his ideas in various ways. He subjects himself to stimulating experiences; he talks to people, travels, and reads newspapers, books, and magazines. Ideas result from the stimulation of an old experience to a new expression. He becomes aware of new photographic techniques and keeps abreast of developments in his publication's field of specialization, e.g., medicine or fashion. Picture ideas are often achieved by knowing how to convert ideas from words into visual terms. In producing a picture story, the photojournalist must also be aware of the editorial view of the publication for which he is working. Different publications will require different approaches to a picture story.

Editorial Approaches

The various editorial views of magazines may be illustrated by the manner in which they might handle a basic, prosaic subject like bread. *Fortune* would do a photo essay on wheat ranches, grain elevators, bakeries, and varieties of bread. *Business Week* would ask, "Is Your Baker Cheating You?" *Parade* would focus down on the daily activities of a baker. *McCalls* would

Reprinted from the February 8, 1954, issue of LOOK

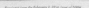

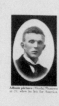

Album picture: Nicolai Thomsen at 21, when he left for America.

Return to the Old Country

A Norwegian immigrant, after 34 years in America, pays a visit to his family on the tiny island where he was born

During his 34-year absence from Norway, Nicolai Thomsen accumulated a large collection of nostalgic odds and ends. He came to America in 1920, married a Norwegian girl, settled in Brooklyn, became a tailor and raised a family of four American daughters. And for 34 years, he wondered about Lygra, the tiny island off the coast of Norway where he was born. This winter, Nick Thomsen went home to Lygra to visit his brother and sister—the only remaining members of his family—and the 92 other inhabitants of the island. He also tested his memory of boyhood tricks. The tiny sailboat he had carried above the cellar window was missing. The spruce trees he had planted in front of the house had been destroyed by winds. The figures "1864," carved on the barn at the time it was built by an ancestor, were barely visible. But Lygra itself had changed very little, and where Nick's stay ended, he knew he had only been a visitor. If he had doubted it before, he knew now that his home was in Brooklyn, N. Y.

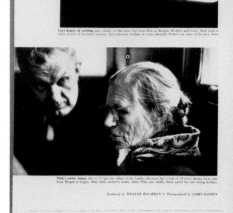

Last hours of waiting pass slowly on the train trip from Oslo to Bergen. Restless and tense, Nick tried to make stories of ancestral scenery, but sometimes travels en route strength blotted out some of his best shots.

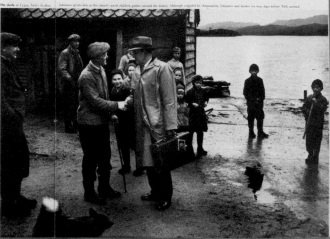

On deck at Lygra, Nick's brother Johannes greets him as the island's speed children gather around the visitor. Although crippled by rheumatism, Johannes met Inness ten days before Nick arrived.

Nick's sister Anna, who is 77 and the oldest of the family, discusses the events of 34 years during ferry ride from Bergen to Lygra. After their mother's death, when Nick was small, Anna cared for her young brother.

Produced by WILLIAM DOUSEMAN • Photographed by JAMES HANSEN

Homecoming brings gladness, reflection and a solemn visit to the churchyard

Outfitted for Norwegian winter, Nick shakes his keys over a washbasin in the same bedroom he used as a boy. Modern touch in the house is a radio.

At a family reunion, Nick shows off by squeezing into his old regional costume and demonstrating folk-dance steps. As a surprise, he had brought costume from U.S.

Karolina, Johannes's wife, and Nick enjoy leafing through family album. Other items of family lore include 100-year-old Bibles, Nick's schoolbooks.

In the Lygra cemetery, Nick takes flowers to his mother's grave. The Lutheran church, where Nick and other children were confirmed, is attended by Lygra people and also some from nearby islands. Since the congregation is too small to support a full-time pastor, Sunday services are held only once a month.

Nick may never see Norway again, but he has satisfied an American's curiosity about the quiet life he left

The picture story on the two pages above demonstrates the essential qualities of photographic narration. The idea for the story came from photographer James Hansen, who is of Norwegian descent. Although it has the timeless, universal appeal of a man's nostalgic return to the environment of his youth, the story is limited to a small area. It is concentrated and focused upon a man and a town. It has a beginning, a middle, and an end. The text, subordinated to the photographs, is written so that both information and mood is conveyed to enhance the visual effect. Note that the captions and text blocks are prepared to fit the space. This results from making the picture layout first and then writing the words.

show: "Why Your Bread Costs More Today." *Woman's Day* would illustrate: "How America Lives Without Bread," and *Playboy* magazine might do a story on how bread affects your sex life.

A picture story begins as an idea or as a piece of writing that demands photographic treatment. The pedestrian editorial approach is satisfied with photographs that merely illustrate the text. But the smart editor will assign it, with as much freedom as possible, to a photographer who will be able to put himself into it and make pictures that tell the story.

117

S.S.(

14x58

To spot a good teacher, you look first a

IN CHILDREN'S FACES, you can see a good teacher. Carolyn Wilson teaches a typical class of second graders at Garfield School in Decatur, Ill. She is 23, unmarried, a graduate of Eastern Illinois State College in Charleston. This is only her second year of teaching. Already, however, Carolyn shows the qualities that make a good teacher. She is fair, knows her subject matter, understands her children. With them, she finds excitement in the simple truth that six of a thing and two of a thing are always eight of that thing, whether it be pennies or ice-cream cones or battleships.

With enthusiasm and clarity, she bridges the imponderable gap between adult and child, between information and understanding. Carolyn Wilson's artistry is obvious (*see sequence of photos on these pages*). You see it in a stifled gasp and in a prolonged period of concentration. Most of all, you see it in those magic moments when knowledge leaps across the gap like a spark, and a child flings up his hand, exulting, "I know. *I know!*"

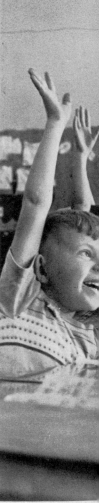

30

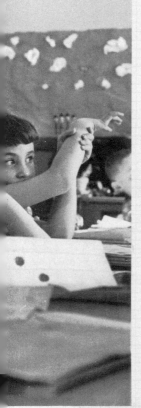

continued

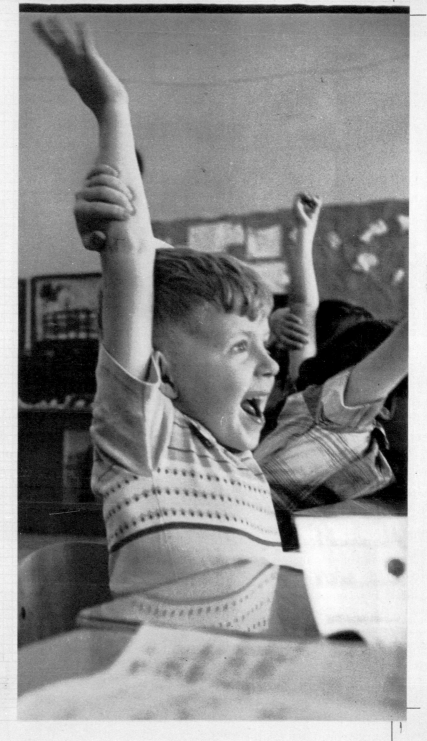

The preceding two pages present a spread from a photo essay about a teacher. Note that photographer Charlotte Brooks waited patiently for the right expressions to capture the exact moment that illustrates the joy of learning. This layout contains the final instructions to the printer. Headlines and text have been written to space. Sizes indicated are in picas (six picas to the inch).

Shooting the Story

At most major magazines every idea is carefully considered by an editorial board composed of key staff members. Once an idea is approved an elaborate machine for the production of a picture story is put into action. The story is assigned to a department editor and becomes his responsibility. He conducts preliminary research on the subject, and helps the photographer assigned to the story work out a tentative shooting script.

The writer and the photographer work as a team until the story is completed. From the time a writer begins working on a story, he is thinking in terms of visual presentation. After preliminary planning and research, the photographer and writer go out on location and start making pictures. Here the shooting script serves only as a guide and often, when working on the scene, major departures are made from it.

In shooting a picture story the photographer has to keep several points in mind. He strives for a lead picture that combines as many elements of the basic idea as can be used in one dramatic, story telling, well composed photograph. He tries to have a beginning and an end to his picture story so that the photographs will start at a given point and flow smoothly from one to another to a logical conclusion.

Photographer's Role

The photojournalist creating the picture story attempts as complete coverage as possible. This means shooting many more pictures than are required for the final layout. In some cases the photographer may compose a shot in both horizontal and vertical arrangement, as well as for possible use on a left- or right-hand page. On an average picture assignment a photographer will often shoot more than ten pictures to every one that is published.

In producing pictures that have story-telling qualities, backgrounds, used with proper direction, create visual images requiring a minimum of explanation and carrying a clear and definite meaning. This becomes particularly important in the illustration of an abstract idea. For example, in

120

order to get across the story that wherever soil erosion exists, farming is unprofitable, people are poor, and houses are in disrepair, a boy was asked to lean against a farmhouse and look out at a badly eroded field. The resulting photograph told the story of erosion and its effect on people.

A more effective presentation will sometimes result from the repetition of a scene before different backgrounds with some changes in gesture or in the direction of movement. It is often a good idea to re-enact a scene. In such cases it becomes necessary to interrupt the natural course of action by stopping or repeating. A knowledge of the subject matter and careful observation of the action desired in the picture are important.

Directing the Story

Angle shots and the movement of objects in relation to the horizon often add much to the properties of a picture. In order to make a scene more forceful it is sometimes desirable to distort or accentuate the effect by photographic means. When the photographer has taken into account the final visual impact on the person looking at the picture, deliberate distortion may actually add a sense of reality. If the reader, in turn, is willing to accept the photographer's interpretation, distortion can create a faithful representation of a scene.

A picture story can be so expressive and forceful that it will influence the thoughts and opinions of the person reading the text and looking at the photographs. In the development of the story, each photograph is required to tell its part of the story as clearly and vividly as possible. It forces the photographer to become not only a camera man but also a scenarist, dramatist, and director as well. It is necessary for him to plan each picture carefully from the original inception of the idea to the final visual impact on the reader. This involves not only complete control of the subject matter appearing before the camera, but also influences the person looking at the completed story. To do this successfully demands dramatic perception on the part of the photographer.

Picture Story Production

After the photographs on the picture story have been taken, the negatives are processed and the prints are edited. The selection of the pictures to publish is usually made by the editors and the art director after the editor and photographer have returned from location. The editor determines the amount of space to be given to the story and selects the pictures in consultation with the art director. The art director employs his knowledge of visual techniques and typography to crop the pictures and design their layout. The editor then writes the text and the picture story is ready for the printer.

In some cases, especially on the newspaper picture supplements, the

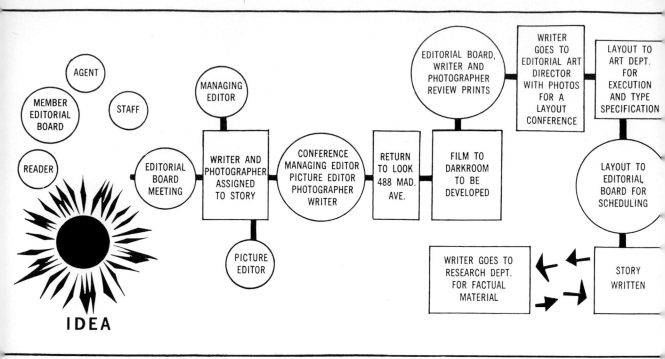

This chart indicates the steps between the original idea for a story at a major magazine and its final appearance in print. Many people are involved at each stage; although the photographer is a key person, others must work both before and after him.

photographer may perform his own editorial research. Some photographers use portable tape recorders to record their verbal impressions of the scene and provide the writer with material upon which he bases his story.

In producing the picture story, the following three points must be considered:

1. *Thorough preliminary research* is desirable so that all facts are known before shooting.
2. *A detailed and complete shooting script* stressing continuity of action and every picture possibility is prepared. In shooting the story, every picture possibility is covered in a variety of ways. The subject is covered completely. The photographer strives for a lead picture and makes sure that there is an intelligible beginning and end to the story.
3. *The photographer coordinates the events and subjects* before the camera with props, camera viewpoint, and composition to make the final visual impact effective.

The writer's responsibility in the production of the picture story may be summed up as:

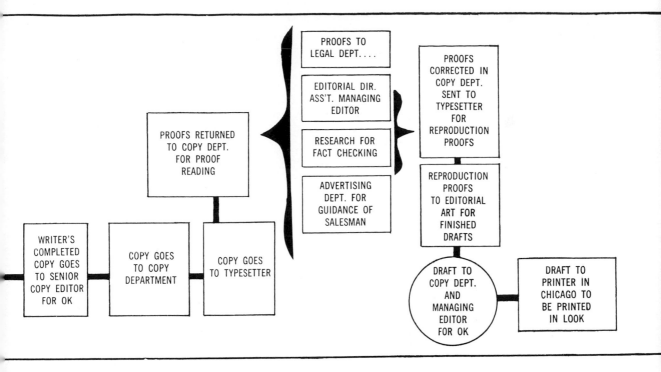

1. *Suggest* an event or an idea for a possible picture story.
2. *Present* the idea to the editor for evaluation and discussion.
3. *Undertake* its planning.
4. *Perform* the necessary research.
5. *Assist* the photographer during the taking of the pictures.
6. *Study and organize* the pictures after they are produced.
7. *Help* make a layout.
8. *Write* whatever text is required.

It is obvious that the functions of the writer and the photographer in the production of a picture story are in themselves a full-time job. But there are some photographers who are able to incorporate all these activities in one person. One of the wonders of modern photojournalism is the growth of the photographer-writer or writer-photographer.

On the following pages are the rough layouts prepared for a photo essay on fire fighters. Photographer Karales and writer McKean focused on one city fire house and its firemen. For three weeks, day and night, they followed the members of Rescue No. 1 and recorded their activities. Karales exposed 91 rolls of 36-exposure high-speed panchromatic 35mm film. From the more than 3,000 photographs, 5 pictures were selected for the 6 page layout. The dummy layout that follows is now ready for the writer to complete. The title, headings, and picture selection have been approved and the text is to be written to fit the space.

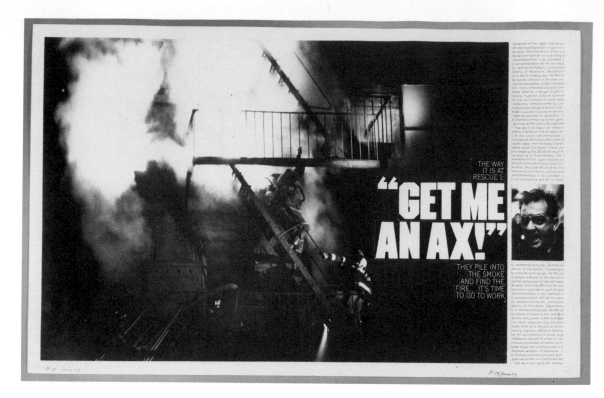

THE WAY
IT IS AT
RESCUE 1:

"GET ME AN AX!"

'THEY PILE INTO
THE SMOKE
AND FIND THE
FIRE ... IT'S TIME
TO GO TO WORK.'

T
HE PRIZE:
A FIRE FIGHTER'S
FACE SHOWS
WHY HE AND
185,000 OTHERS
IN THIS LAND
CHOSE TO
PUT THEIR LIVES
ON THE LINE
IN THE NATION'S
MOST HAZARDOUS
OCCUPATION

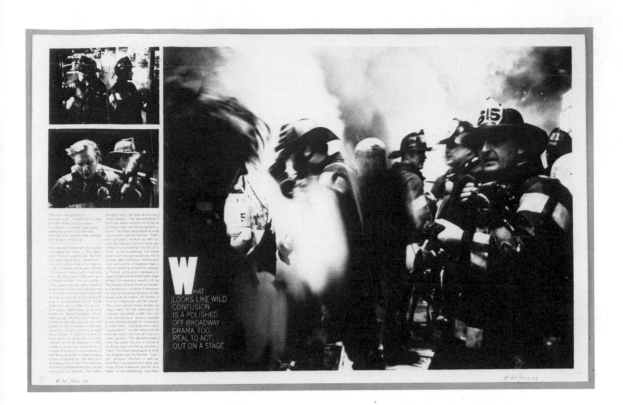

WHAT LOOKS LIKE WILD CONFUSION IS A POLISHED OFF-BROADWAY DRAMA, TOO. REAL TO ACT, OUT ON A STAGE

Qualities of a Picture Story

Good picture stories have five essential qualities: The first requirement is an interest that transcends spot news, a vitality that cannot be sapped by news developments. One reason for this is that most picture articles require considerable planning. Their preparation is a time-consuming process. An idea for a picture story that will be dated in a few weeks, or even months, is therefore of little value.

The second quality of a good picture story is picture impact. This means that the picture story producer must think in terms of visual images rather than word images. Fashion magazines, such as *Vogue* and *Harper's Bazaar*, always have good examples of this quality.

The third desirable quality is concentration. This means that the successful execution of a picture story must be planned with a limited scope. For example, a single picture story on a small town would be possible but difficult to do. On one block in a town, it would be less difficult. On one family, it would be comparatively simple, and on one member of a family, it would be easy.

The fourth desirable quality is to focus the story on people. Whatever the story is, the chances are that it would be more interesting if it is told in terms of people doing things.

125

(Top left) Photographer Jim Karales and writer Bill McKean on location at a fire. They concentrated on the activities of one fire house for three weeks. (Top right) After negatives are processed and contact prints made, the photographer and writer carefully examine the many images with an illuminated magnifier. (Bottom left) From the selected pictures on the contacts, full frame blowups are made. These are cropped for best composition. (Bottom right) A rough layout is prepared. Photographer and writer check their blowups against the layout to see if their selection can be improved.

The fifth essential quality is universal interest. In a mass circulation magazine it is indispensable for picture stories to be based on ideas that reflect the experiences and feelings of large masses of people. The photojournalist who has ideas that fascinate him but do not appeal to the millions of people who read his newspaper or magazine would do well not to produce them as stories.

General Interest Magazines

For 35 years, *Life* and *Look* recorded our times in perceptive, revealing, sensitive words and pictures. Photographers and writers for these magazines pioneered the concept of related pictures and developed the picture story to a new form of communication—photojournalism.

The photojournalists who work for newspapers and magazines are communicators with a camera. They witness history-making events and remain objective, yet able to select and interpret. They are aware of the power of the visual image and maintain high standards of integrity. Their photographs have universal appeal, reach large audiences, and inform, entertain, or provoke the viewer.

Now a major portion of that audience has gone. *Life* and *Look* have published their last issues. Does this mean that photojournalism is dying? Gardner Cowles, who founded *Look* in 1937, said: "*Look* was edited for readers who see a better America being born out of the issues that now divide us... for those people who are more interested in tomorrow than yesterday, and who want to change things for the better. The editors of *Look* believed that peace, poverty, pollution, and other problems could only be solved if people understood them."

The fact that *Look* succeeded editorially was indicated by the dozens of awards received, including the first National Magazine Award ever given for "skillful editing, imagination, and editorial integrity," and still another National Magazine Award for visual excellence. Why did *Life* and *Look* cease publication? An understanding of the magazine business will help explain the reasons.

There are two ways to publish a magazine. One approach involves charging the reader the cost of production and distribution plus a percentage for profit. Any revenue from advertising becomes so much extra profit. But, at all times, as long as its readers buy the magazine, it can still be published profitably because the publication does not depend on advertising for its success. Another method of operation has been used mainly by general interest magazines of large circulation. This method relies on obtaining millions of readers by offering the publication at a price that is lower than the cost of production. Advertisers are then encouraged to influence these large audiences. When successful, the added revenue from these advertisers more than makes up for the cost of manufacturing and distributing the magazine. It is this latter approach to publication that resulted in

Look's early and continued success for 32 years and losses in recent years.

It is important to understand also that the editorial costs of magazine production are a very small percentage of the total. The main expenses are from payroll, plant, paper, presses, promotion, and postage.

During the last year of publication, 1971, the response to *Look's* subscription offers and renewals was better than at any previous time. There was strong reader interest and desire for *Look* by its audience of 28 million. But in 1969, *Look* magazine lost money for the first time and its losses continued to mount as advertising declined and production costs increased. The final blow was the United States Postal Service proposal to raise the costs for mailing the magazine by 142 per cent! It is important to realize that *Life* and *Look* magazine did not suspend publication because of their editorial content and use of photojournalistic techniques. The collapse was caused by other factors related to the business of publishing.

Furthermore, it is a basic consideration that a magazine is a medium for communication, and photojournalism is a method of communication. One needs the other. The approach to conveying visual information that is photojournalism must be more effective in the future. True, it is sad to see a magazine cease publication and take away all those beautiful color pages that were a showcase for the photographers of a generation. But other outlets exist: magazines, newspapers, and a growing need for pictures to be used by television, learning machines, and video devices.

For example, newspapers are using photographs in ever growing quantities, books are more heavily illustrated, special interest magazines are devoting more space to pictures, and television is using still photographs in increasing numbers with skill and imagination.

There is reason to be optimistic about the future of photojournalism. There will always be a need for people with the ability to tell a story in pictures. There will always be events that the still camera can cover better than any other visual device. The photojournalist may have lost a major medium but his method of visual expression is valid, vigorous, and vital!

6

Assignment and Selection

Photographic Direction

In modern photojournalism, the picture editor is an important member of the team that communicates in this visual language. The picture editor has the following functions:

1. He obtains photographs to illustrate news and feature stories. These may come from a variety of sources—staff photographers, free-lance photographers, public relations agencies, photo-syndicates, archives, and picture collections.

2. He is the executive on the publication who supervises and administers the photographic staff, studio, picture research operation, print filing, and storing of negatives.

3. From the many photographs he sees, the picture editor will select those to be published and decide how and where they are to be printed.

Not all publications have picture editors and not all picture editors do the job described above. On many newspapers there is no fixed pattern for anybody to handle pictures. Picture assignments may come from the managing editor, the copy desk, or the chief photographer.

On a magazine, a picture editor may be responsible for supplying photographs from agencies and services as well as assigning photographers. One picture editor devotes all his efforts to supervising a large world-wide network of staff and free-lance photographers. He does not select photographs for publication. This job is done by the managing editor.

Some newspaper editors not only assign photographers and select the photographs to be published but also determine their size, crop them, and make the layout of the finished picture page. On the Sunday picture supplement, *Parade*, the top editorial executive functions as picture editor

Photo editors often complain that photographers turn in routine, conventional pictures, yet when these two prints were distributed, the unimaginative hand-waving photograph was chosen by many papers, the other completely ignored.

also. This publication, which is one of the most modern exponents of photo-journalism, has an editor who not only thinks up ideas for picture stories, but also assigns the photographer, and sometimes works with him in the production of the picture stories. He also directs and supervises the selection and editing of the photographs, oversees layout and writing, and adjusts the finished sequence of stories to provide variety and interest in the complete issue. *Parade* is a publication in which the top editor, although not a photographer himself, understands photographs as a means of communication and knows how to use them.

A Good Picture Editor

As a liaison man the picture editor has some additional, intangible functions. A good picture editor casts the photographers on his staff in the sense that he picks the right photographer for the right assignment. He tries to select a photographer who will be enthusiastic about the job. The good picture editor inspires and stimulates the photographer so that when the assignment is carried out, the men behind the camera are creative and imaginative. A good picture editor does not have to be a good photographer. It does help greatly if he knows enough about photography to be able to evaluate an idea in advance and to appreciate the photographs that are taken. The good picture editor will understand the mechanical limitations of the medium. He can judge the photographs objectively. Although he may not be a photographer himself, he does know enough about photography to have high standards of craftsmanship. The good picture editor has a fine appreciation of news and pictorial values, as well as a background of photography, art, design, layout, and reproduction techniques.

The relationship between the photojournalist and the picture editor is an important one. They have a common denominator: pictures. The photojournalist creates the pictures and the picture editor uses them to their best advantage. The picture editor expects initiative, creative thinking, avoidance of clichés, and the unusual approach from the photographer. The photographer expects the picture editor to give him as much information as possible before going out on assignment, to fight for his rights, and to make him a part of the editorial operation. One of the most effective methods of creating a sense of participation and cooperation on the part of photographers is the credit line. The photojournalist who knows that his name will be placed under his photograph will necessarily make every effort to make that photograph perfect.

Selecting and Editing

It is generally agreed that photographers are poor editors of their own work. Most photographers become too involved in the mechanical and emotional aspects of producing a photograph to be completely objective

Placement of lenses

180mm

21mm

When a newsworthy event is scheduled, careful advance preparation is vital. To give the strongest picture coverage of the return of Cuban prisoners at Miami airport, the Miami Herald's chief photographer, Doug Kennedy, and Graphic Arts Director, William B. Stapleton, went to the airport and spotted the position of all cameras inside and outside the terminal. They then assigned seven photographers—two of whom spoke Spanish and were assigned to close-in work—who used lenses ranging from 21mm to 350mm to cover the arrival. In addition, they had two photographers stationed at the hospital to photograph the arrival of sick or wounded prisoners. At the top left is a diagram of the positioning of all the lenses.

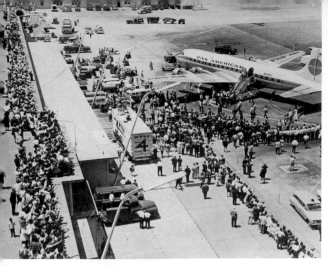

50mm

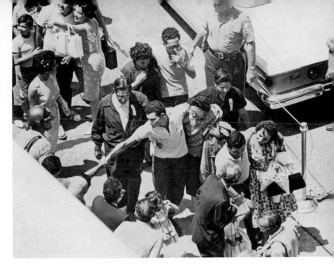

180mm

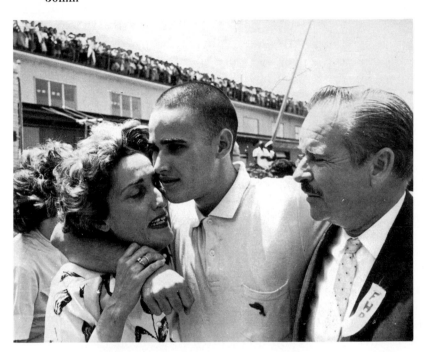

35mm

350mm

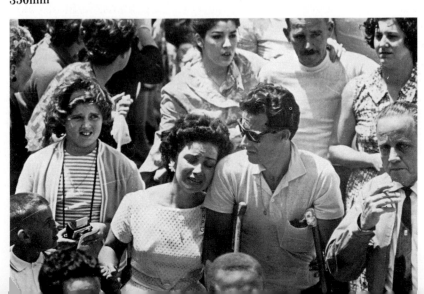

about the results. They tend to associate with a picture all sorts of personal, irrelevant features. Sometimes the difficulties in taking the photograph make the photographer think it is a great picture. It is a rare photographer who can take a detached, cold-blooded view of his own work.

Every photojournalist should develop the ability to select and edit photographs. Picture editing has many subjective elements. The reactions of an individual to a photograph are controlled by his preformed ideas, previous associations, background, and prejudices. The person looking at a photograph with an untrained eye sees only the obvious features, those that can be observed without effort. Many people look at pictures the way they read headlines. Their eyes are bombarded with so many visual images that they do not give each one of them the attention it deserves.

In editing pictures it is necessary to look for the 1,000 words that the photograph is supposed to be worth to explain or narrate in a quick, easy, and intelligent manner a circumstance, an object, or a person.

Some pictures are bold, crude, and obvious. Others are subtle, refined, and restrained. Just as the words used in a literary monthly differ from those used in a tabloid, photographs are selected to conform to the type of publication in which they will appear. Every picture editor has a mental, perhaps subconscious, photographic style book. The photojournalist who wants to get his pictures published must be aware of these differences. One of the important reasons for the employment of staff photographers on a publication is that the staff man has a better appreciation of the special needs, requirements, and approaches of his own paper or magazine.

A picture editor prefers to have his photographers cover a subject thoroughly because he can only exercise his experience and ability to select when he has a large number of pictures to choose from. On a fast breaking story, successive opportunities arise to show what is happening from different angles and to indicate its development. As a photographer covers this event there will be one picture that is better than all the others. Since it is not possible for the photographer to edit his pictures as he shoots them, it is better for him to cover the story thoroughly. A good picture editor will look at all the material that is shot, including those that may have technical defects such as movement, blurs, lack of sharp focus, light streaks, or bad exposure. Unhampered by technical standards, the picture editor will sometimes find valuable material in what the photographer would like to throw away.

In selecting photographs the editor assumes certain standards of technical excellence. These technical standards vary considerably and are based usually upon the printing methods of the publication. For example, some magazines will not accept color transparencies that are less than 4″ × 5″ in size; others prefer 35mm color. The sharpness and contrast of the picture may be an important consideration, especially if a coarse screen and poor paper are used. The make-up of the page may dictate the selection of the picture, so that a vertical shot of a scene is preferred over a horizontal one.

Many newspapers have so many pages in which ads go clear to the top of the page that often there are only one or two columns in which the tops are open. This means that the photographer often has to shoot a picture that will be only one column wide. This is a pretty tight squeeze for many subjects.

On some publications the problem of selecting and editing photographs is an enormous one. One magazine uses approximately 100 photographs per issue and its picture editing staff looks over more than 1,000 photographs every day.

The problem of selecting and editing these photographs becomes not only intellectual, but physical. Publications that use large quantities of photographs employ a refining or distilling method to pick out the pictures that finally appear in print. As the collection of pictures passes up through the editorial staff, the obvious discards are winnowed out and the more striking ones are selected and noted so that the final selection by the top editors is made easier.

Whether the photographs to be edited are a dozen or a thousand, the process of elimination and selection should be done in the following manner. The photographer must forget about the difficulties involved in taking the pictures and measure them on the basis of informational content and editorial quality. It is important to evaluate expressions and composition. The latter should not be thought of as rigid or formal with S curves and triangles. Select a rational and clear organization of the subject. Think of what is included, left out, and implied.

There is a difference between editing the best pictures from a shooting session and selecting those for a story. In telling a story with pictures, it may be necessary to include some that are not the best in order to create a narrative.

The actual process of editing starts with a quick but careful scrutiny of all the photographs. During this first look, those which deserve further study are marked. This group is then studied more thoroughly.

Mechanical Aids

Because of the high quality of modern lenses and films, it is possible to blow up small sections of a 35mm picture. A 5X illuminated magnifying glass is used to examine the sharpness of contact prints and to find details that might be enlarged.

After the pictures are selected, they may be cropped for more impact. Skillful cropping may alter the proportions of the background and the foreground. The horizon line can be lowered or raised to shift emphasis. The center of interest may be moved to a better location within the picture area and objectionable or distracting material may be trimmed away. In this way the picture idea can be tightened, unified, and presented more clearly.

Many mechanical aids are used for editing and cropping. Magnifiers are essential for viewing 35mm contacts. Slide rules and proportional rules

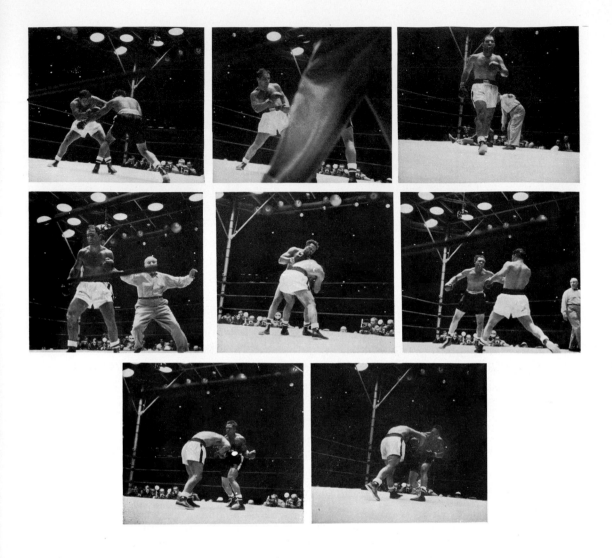

are helpful for figuring enlargements and reductions. Cropping may be visualized with two overlapping L-shaped pieces of cardboard.

Reasons for Elimination

Photographers are often frustrated in getting their pictures published. An editor may find himself on a slow day without enough material to fill the paper. He assigns a photographer to photograph the activities at the county fair, asks him to cover it thoroughly, and to bring back enough photographs for a whole page. The photographer works hard and produces a beautiful collection of human interest and pictorial shots. He rushes back to the newspaper, develops the film, and brings the wet negatives over to the editor. Instead of choosing enough pictures for a page, the editor picks only one. The photographer is defeated and baffled, but there is an explanation.

While the photographer was gone on the assignment the ad dummies

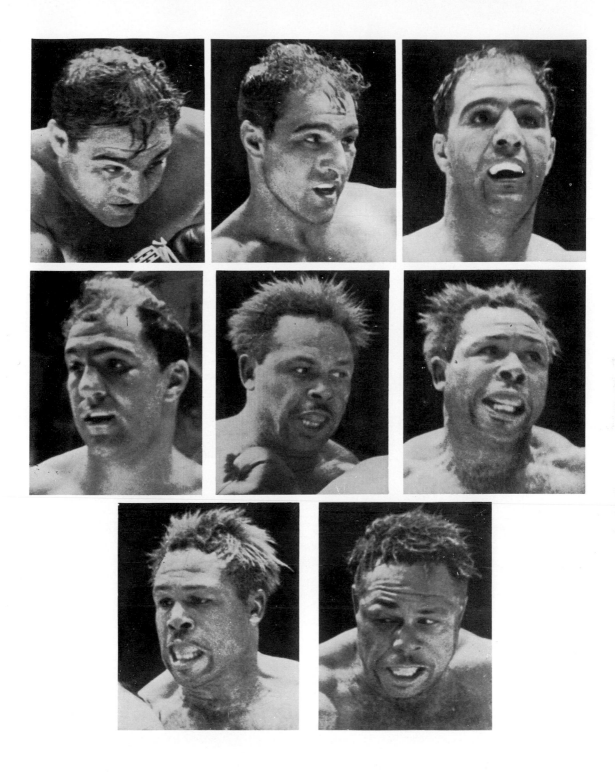

An example of creative picture editing is the series of pictures of two fighters, which were cropped from the prints and sent out by wire. The intense facial expressions bring home the vigor of the contest much more effectively than the more often seen long shots of boxing matches.

The contact sheet of 35mm photos at the left was taken for a story about children who were play-acting a trip into space on their home-made spaceship. If you had been asked to select and crop photos that would tell the story best, which would you choose? On this page and on pages 140 and 141 are the pictures the editors chose, with white rules to indicate cropping.

were finished, which showed how much was left in the paper for the news. Also, the production department limited the size of the paper because of the number of color ads that have been sold. In the meantime, the circulation manager persuaded the editor to run a series of snapshots of a suburban beauty queen in order to boost circulation in that area. At the same time, an airplane hit an apartment house, some movie stars quarrelled, there was a three car crash on the turnpike, a five alarm fire on the East Side, and five policemen were indicted by the grand jury. Then the wire photos came in with pictures of the foreign ministers' conference. Thus the pictures of the county fair became relatively unimportant, in view of the space that was available.

In taking the pictures and selecting them, both photographer and editor must be aware of their audience and their readers' interests. Surveys show that babies and animals have universal appeal. Men are more interested in sports and politics while women prefer photographs of weddings and fashions. The editing, selection, cropping, and organization of photographs is done best with full knowledge of the subject matter. Therefore, the photographer who makes the pictures may often be the best one to edit them. But to do this well he must be skillful, imaginative, and objective.

Sources

Pictures may come from many sources. For the exclusive photograph a publication must rely on its staff photographers or purchase the exclusive

rights from free-lance or amateur photographers. The exclusive photograph is most desirable because it presents a fresh visual image and this makes the publication different and interesting. Photographs that are new, unusual, and exclusive in a given publication become more important as competition from television increases and the distribution of photographs by wire and radio spreads. A publication can preserve its identity and reader interest only by presenting visual images that cannot be seen elsewhere.

Where exclusivity is not a factor, sources of pictures are varied and many. The newsphoto services supply pictures by mail, wire, and radio. Picture agencies represent individual photographers on an international basis and also maintain files of special subjects. Advertising agencies and public relations agencies will distribute photographs on behalf of their clients. U.S. Government bureaus and foreign government agencies maintain extensive files and provide pictures on request. State and city travel and information services supply photographs. Large private corporations make available photographs of their operations. In the entertainment field, producers of films and stage shows, and radio and television broadcasters supply valuable free photographs. The newspaper or magazine's own picture files as well as those of museums, libraries, universities, and other institutions are important sources. Finally, other newspapers and magazines resell and syndicate their published material.

Photo Markets

The successful photographers who sell their pictures regularly use well-established methods. One of the first is to know the market and to adjust subject matter and technique accordingly. Start by studying the editorial approach of a publication. For example, a news picture magazine requires photographs of timely and significant events. These pictures must be submitted promptly to preserve their immediate interest. A feature picture magazine may want picture stories or related pictures. Examine the contents of previous issues to learn more about the various departments. In some instances, sequences are effective. These contain highlights of revealing action of the same subjects in chronological order. When picture stories are submitted, they should all deal with the same character or subject, and have a beginning, middle, and end. A collection of pictures taken at odd times is not a picture story.

The photographer who is devoted to another hobby may be able to sell pictures to a special interest magazine. For example, a horticulturist who produces fine color photographs can find a ready market in those magazines that cater to the gardener and flower grower. A sailing enthusiast can sell pictures to a boating magazine. Other publications seek illustrations in such diverse fields as fashion, cooking, sports cars, science, fishing, and hunting.

With the growth of color in newspapers, the press associations are becoming a better market for color. This is especially true of spot news

142

pictures that will interest people beyond a local area. For example, color photographs of a major fire rushed to the nearest UPI or AP office have a good chance of being accepted.

Calendar publishers have always been a good market for color photographs. The majority still select pretty girls or beautiful landscapes. Other subjects that are suitable include outdoor scenes of hunting and fishing, appealing children with or without mothers, fathers, and pets. Calendar photographs stress poster type color, established rules of composition, and sharp focus.

Another type of display photograph is the record cover. This is basically a packaging method to attract attention. Most color photographs chosen for this purpose show some relation to the mood or theme of the music. Color and design are used to convey a literal or symbolic image of the album's contents. There is more opportunity here for the abstract or subjective photograph. Paperback book covers also fall into this category.

One point that all photograph buyers stress is the need for releases. This applies to every market except news coverage. There are laws that assure the individual's right of privacy. This means that whenever you take a picture that you intend to sell, of a recognizable person, ask for a release. This document should be carefully filed for your protection. Remember to be sure that the release covers the purpose for which the photograph is to be used.

Submissions and Sales

More markets are open to 35mm color than ever before. Avoid sending these in glass mounts; use an acetate envelope for protection. Special plastic and cardboard mounts are available for holding twenty 35mm transparencies. These are convenient for mailing and viewing. A small rubber stamp is useful for marking name and address on each slide mount. When captions accompany the transparencies, number the latter and list the information on a separate sheet. For those buyers who still prefer to see 4" × 5" transparencies, make enlarged duplicates from your 35mm color. Sometimes this may be an improvement on the original. Larger transparencies should be mounted in black cardboard and protected by acetate sleeves.

When a sale has been made, specify the arrangements for publication. Usually, photographers sell their pictures for one reproduction in one publication. The transparency or negative remains the property of the photographer and must be returned after use. This is called "one time rights." Sometimes the purchaser wants complete and exclusive control of the photograph. In this case, the photographer sells "all rights" for a higher price. See table on "Rights," page 221.

For the photojournalist, buying and selling of photographs have special considerations. A photographer may be paid for his photographs with a fixed price for each picture or he may receive a rate based upon the number of

pages he illustrates. Page rates are more prevalent in the magazines. Payment may be made either upon acceptance of the material or upon publication of the photographs. Sometimes an editor will want to purchase exclusive world rights to a photograph or a set of photographs. This means that instead of a photographer selling his picture for a single reproduction he disposes of his rights in the photograph and usually in the negative as well. In this situation the photographer receives a larger sum for his work. The purchase of all rights is worthwhile only for those publications that intend to syndicate, promote, or advertise these photographs.

In selling his photographs, the photojournalist has certain responsibilities. His pictures should be identified and captioned accurately. He should have permission to publish the photographs and obtain the necessary written releases. Whenever possible, agreements about rates of payment should be made in advance. The photojournalist also has the moral obligation not to sell the same photograph to competing publications without their knowledge.

Aesthetic Trends

Most important, picture editors and art directors who purchase photographs are seeking the more creative and unusual approach. This is a result of the growing sophistication and visual awareness of their audiences. The cliché photograph of the kitten in the fireman's boot, or the baby eating a chocolate cake, is no longer appreciated. Neither is color for its sake alone. A believable, realistic, honest picture of a person or event is wanted. The modern picture buyer prefers the informal, candid, warm, emotional, and mood-creating photograph, rather than one that is contrived and artificially posed.

The aesthetic trends of today have been summarized by Beaumont Newhall in his newly revised book, *History of Photography*. In discussing the photographic style of today, he says. "One common denominator, rooted in tradition, seems in the ascendancy: the direct use of the camera for what it can do best, and that is the revelation, interpretation, and discovery of the works of man and of nature. The greatest challenge to the photographer is to express the inner significance through the outward form."

The photographer who uses creative skills, careful preparation, a knowledge of the needs of potential buyers, and the ability to interpret their requirements will receive the rewards.

Newspaper Use

In the newspaper, photographs are used in two ways: as illustration for a news story, and in the form of a picture page. Some sound theories have been developed as to the proper use of the news photo on the various pages of a paper. The front page of a newspaper is comparable to the cover of a magazine in the sense that it must accomplish the dual purpose of selling the paper and getting the reader interested in the inside. When

144

the front page in the standard newspaper is folded in half and displayed on the newsstand, the most dramatic news photo of the day should be displayed under the nameplate and above the fold. Many tabloids use a single square photograph under the headline. Inside the paper it is desirable to have the photographs spotted to create a variety of visual interest and the cuts should be made as large as possible.

Picture Pages

It is in the picture page or pages that the greatest opportunity for the photojournalist exists. Many newspapers have a "variety show" picture page on which all the good pictures assembled during the day are displayed. This is a certain method for attracting the reader. However, a concentration of the best pictures on one page often deprives the rest of the paper of any visual impact. Also, the individual pictures on the variety page compete with each other. It is also difficult to design such a page effectively when all the photographs are unrelated.

A more satisfactory approach is to create a one-subject picture page. In the case of a big news story, a more thorough and comprehensive coverage by a photographer will result in an interesting and detailed picture presentation. Both motion pictures and television are getting the viewer more accustomed to seeing photographs in related sequence. Related photographs are best presented when they start at the upper left and move down and across the page from left to right. It is also a standard practice to have the pictures face into the page. The key or lead photograph should be selected first and the others conform to it.

On a one-subject picture page a feeling of unity can be created by putting the headline inside the page. If maps or charts are run on a picture page it helps to reproduce them as a halftone so that they will not distract from the photographs.

Sunday Magazines

Every newspaper includes as part of its Sunday edition one or more nationally syndicated rotogravure magazines containing a heavy proportion of photographs. Some, like the St. Louis *Post Dispatch* and *The New York Times,* produce a supplement of their own that is outstanding. Good rotogravure offers excellent reproduction. Photographs not suitable for the coarse halftones of the daily can be used. In order to make the rotogravure magazine more effective it should have its own photographers, or they may be regular members of the newsphoto staff who are given more time to cover a subject thoroughly. It is in the roto section that the photojournalist on a newspaper can display his virtuosity. Here is where the picture story and the use of color become important.

The magazine gives the photojournalist his greatest opportunity. The magazine usually has better reproduction, more careful layout, a greater

use of color, and more space in which to tell a story. Emphasis here is on continuity and the use of related pictures.

Filing

On a newspaper or a magazine the filing of negatives or prints must satisfy two basic requirements. First, provision must be made for their secure storage so that they will be as free as possible from the damaging effects of dust, fingermarks, scratches and age. Secondly, they must be arranged systematically, according to an easily worked out scheme of classification, which makes it possible to locate any negative or print easily.

One method is to give every staff-produced assignment a sequential job number that includes the date. After the negatives are processed, number them with fast drying acetate ink on the base side, in the clear margin. Then cut the 35mm negatives into strips of five or six frames each and 120 rolls into strips of three frames each. Place each negative, regardless of size, in a paper envelope with a glassine window. Label this envelope with the original assignment job number, as well as the story identification and the photographer's name.

Photo Library

Contact print negatives on sheets of 8″ × 10″, so that each represents a contact-sheet roll. The writer on the story should prepare captions that refer to the numbered negatives. File the captions and contact sheets together so that picture research is made easy. Place each negative that is published in a separate file. This will mean that the photographs that appear in each issue of the publication can be easily identified from marked pages in a file copy. Each story and its accompanying subject matter can be broken down and cross-indexed on small 3″ × 5″ file cards. It is helpful to keep an accession log on each photographer so that there are several ways of finding negatives or prints.

Enlargements, publicity photos, syndicate photos, and all other prints that are worth keeping for possible future use in the picture library should be filed by subject matter, alphabetically, each print stamped on the back with indications as to its source, rights for use, and number of times it has been used.

The negative and print file on any publication must be handled by trained personnel. It is primarily a library operation and with some flexibility, people trained in library practices can do the job efficiently. In this, as with any type of filing, it is important to be orderly and to keep up to date. Great respect should be given to the negatives and prints when staff members are handling them. Cleanliness is very important.

Safeguards against loss of negatives must be effected. Any negative removed from the file should be replaced by a slip of paper indicating where the negative is and when it will be returned.

On a magazine or a newspaper, photographic files may become very bulky and require more space than they justify. If the documentary quality of the work is considered important, a separate dead storage file in some other location should be provided. The active file, however, should be kept free of the deadwood of discontinued projects, completed jobs, and outdated work by a continuing program of review. On many publications authority is given for the disposal of material that is over five years old. A periodic screening of the files should be made for purposes of record, or probable future use before the material is withdrawn. In addition, the careful appraisal of all negatives and prints before they are filed will serve to eliminate much useless material by keeping it out of the file entirely.

101 Photographic Ideas

The following ideas were suggested by participants of a seminar of the American Press Institute of Columbia University.

1. Turn the camera on the spectators. Particularly effective at high school football games when you get parents' reactions.
2. The public is always curious about what it's like to live in confinement. Picture essay of life in the county jail has good pulling power.
3. A day in the life of a doctor, social worker, truck driver, construction worker, police officer.
4. The outsider. Most papers serve areas where the student or serviceman lives in the community but isn't really part of it. What's his life like? What does he do for friends, recreation?
5. The local airport probably draws more people on a weekend than the amusement park. A picture essay on airport activities.
6. Picture essay on how things are made by area firms: how baseball bats are made, how seat belts are tested, how maps are drawn, and so on.
7. We sent photographers out to make pictures of various hair styles favored by men—compared present styles with those of past. Also, during an election campaign, we put together layout showing how a Senator had changed his hair styles over several years.
8. Valentine's Day we sent two photographers out, one with camera equipped with long lens, one with flowers to give to women. We caught their reactions, wrote a short story.
9. Cold-weather workers—no matter how low the temperature drops, some people must work out of doors: policemen, firemen, railroad employees, mechanics, and service station employees.
10. Short skirts—everyone likes to look at legs. Photographers were

asked to shoot young ladies in mini-skirts, maxi-skirts, and so on.

11. Every town has a decaying area with a great history. A street, soon to be renovated through urban renewal, was a perfect place for photographers to go hunting.

12. Girl watching. Have a girl dress in a short mini-skirt. Try to capture expressions on men's and women's faces. Good place to have the girl is in front of an outdoor newsstand. Photographer should be hidden or at least 30 feet from the girl.

13. Feature on air freight; what planes carry. Recently, at our airport freight office there were snakes, mice, and dogs.

14. Parents at a little league game excited by a bad call or a home run.

15. Feature on city workman at night. Cleaning streets, garbage pick-ups, and so on.

16. Kindergarten art class. Storybook hour at the library. Have students draw pictures of how their fathers look to them.

17. Jealousy on the part of an older child over arrival of a new baby in the family. Probably for women's pages.

18. The physically hard life of some women in rural areas. We found one in the mountains who had no electricity, therefore none of the usual household appliances. We were fortunate to get there during a heavy snow and the resulting spread was one of the best we've done.

19. You can rent a small plane. If you plan the trip ahead, you can cover a great deal of territory around a city in one hour. Such a trip should net from 10 to 20 good pictures.

20. Ever notice the facial expressions of people walking the airport concourses? Those heading out to airplanes are usually anxious, often dour. The people are walking quickly and they are tense. Then turn around and watch those who just disembarked and are walking into the airport.

21. The emergency room of a city hospital on Saturday night.

22. A "Where Are You?" series of pictures of familiar scenes around town. But these are different because they were made from a totally different angle (like maybe directly overhead) or with a seldom-used technique (through a telescope, or infrared, or with a fisheye).

23. Series of snow shovelers; try to catch their moods: happy, grouchy, industrious, faker, smoothy.

Photomontage is a practical method for assembling many images that are related but actually removed in space and time. One of the earliest examples is "The Two Ways Of Life" made from more than 30 negatives by Oscar G. Rejlander in 1857. A montage may be made in the camera, with an enlarger, or by cutting and pasting. A current example is the montage produced by the author as an illustration for a nostalgic review of the Thirties.

24. How bowlers grimace when the ball nears the pins.
25. Different types of lawn sprinklers and sprayers.
26. Kids at the public library, showing how they read, study, and so on.
27. What's being done at the post office to handle the avalanche of mail getting bigger every day? Is next-day delivery possible? Has technology kept up with the increase in correspondence?
28. Most cities have on the books laws or ordinances prohibiting such things as spitting on the sidewalk, kissing in public, riding horses on the sidewalk, and so on. A whimsical set of pictures of folks doing these things—maybe some with a policeman writing a ticket—could be an attention getter if done properly.
29. Most newspapers with staff photographers often do not share the opinion of what is the best picture taken on a given story. Once annually it might be interesting to let the photographers do the editing—and print a page of "best picture I've taken that didn't see print" pictures. (It takes a strong editor to permit this.)
30. "Have a Heart." Each week an animal at the humane society shelter is selected to be photographed: a dog or cat about to be destroyed. The picture is usually 2 or 3 columns and used with a real "tear jerker" cutline. After over two years, we still have a 100 per cent record for having saved the lives of these animals, a steady flow of praise from the public for the pictures, and the gratitude of the humane society.
31. "Man at the Top." A weekly feature started when a reporter became curious about what commuters to New York did. The result was a short biography on top executives in our area and background on their jobs and the companies they work for.
32. Getting in on a dope raid—from raid to arraignment.
33. Know of a soldier coming home soon? Get the wife alone, playing with the kids, in church, and then the reunion.
34. A military funeral—the taps, firing squad, sadness, the flag presentation.
35. Children looking out a rain-streaked window on a wet day.
36. In the affluent society many items are thrown away that could be of further use and would be if it wasn't so easy to obtain things. a) Pictures of these discarded items in the dump. b) Pictures of men, often licensed, who make a living in dump salvage. c) Trace the path of a discarded item from the house to the dump to the new owner.
37. Among the corps of crossing guards in any city there will be a stand-out personality. Story would show relationship of guard to traffic and children at a particular crossing.
38. Most hospitals have volunteers. Some of them help feed the chil-

dren on special diets. A picture story on the facial expressions of a helper trying to entice a reticent child to eat—We did this on a woman feeding custard and called it "Having Custardy of the Children."

39. Put a pup and a full-grown rabbit together, a kitten and a large frog. Most things in juxtaposition can be utilized this way.

40. Place someone or something not usually seen in a busy street corner at noon and photograph the reaction: a mini-skirted girl cleaning shoes, a man in a complete skindiver's outfit—mask, tank, and all—reading the latest edition. (Sometimes the story is the non-reaction of passersby.)

41. Most clergymen are seen in cleric's garb. Picture series of well-known ministers and priests at physical fitness class: swimming, playing basketball, push-ups, lifting barbells, and so on.

42. In winter, take some pictures of resort beaches covered with snow. Most vacationers never see these beaches except in summer.

43. List of former mayors still living. Picture series of what they do now. Hobbies in retirement.

44. Personality pictures with stories on the men who really run city hall. Also pictures of wives and families—they're often quoted but seldom seen.

45. What are kids doing in school, and what are schools like? Pictures of new and unusual courses, e.g., boys' cooking school.

46. Picture the changing architecture in your city—contrast the new and the old.

47. Layout of how medicare and medicaid are working in your city, how it affects the lives of older people, what type of changes it brings about in the medical treatment of citizens.

48. Picture story on the teen-age fads, including hair styles, special clothing accessories, types of shoes, and so on.

49. Have photographer spend a day with an intern assigned to the emergency ward or ambulance for a full day.

50. Tell the story of your city in the hands of its people. Perhaps make a guessing game layout—are these the hands of a policeman, fireman, laborer, butcher, typist, lawyer?

51. Picture story on how people spend their leisure time.

52. A day with a camera in a kindergarten class or orphanage.

53. The local sports hero, with a layout on what makes him great.

54. Do you have a local community theatrical group or school acting group? Photo layout on how it prepares for a performance.

55. We avoided trying to photograph a mass of 2,500 musicians during a regional music competition for soloists and ensembles. Instead, we concentrated on two attractive flutists and had the photographer stick with them. He showed them practicing nervously,

making notes on their music, and finally performing before the judges.

56. Send two photographers instead of one to a sports game; have one shoot only individuals or groups in the crowd, the cheer leaders. Get the story of the game between two top-notch teams reflected in the faces of the spectators.

57. Art museum show. A photographer took an active, good-looking six-year-old boy with him to a show on armor and photographed him as he looked over the display. Instead of the usual Sunday attendance of about 200, the museum reported more than 1,000 had visited the show the day the page ran.

58. Familiar sights of the city seen through a rain-splattered windshield.

59. Young husband at clinic for about-to-be fathers.

60. Women at an exercise class.

61. Dogs and owners at obedience school.

62. Ballet lessons for little girls.

63. Careless handling of handbags, shopping bags, etc. (aid to thief).

64. Series on what to do to avoid burglaries while away on vacation.

65. Construction: This is really news—we do this instead of covering the check presentations, ground breakings, ribbon cuttings, corner stone layings, and whatnot.

66. Weather: In most cases any assignment in this area must be very broad. It's the treatment rather than the subject matter that makes a good photograph. We ran a young boy through a car wash on the hood of a Volkswagen one hot day.

67. Animals: We've done pictures on patterns in a pet shop—lizards in a cage, close-ups of tropical fish, and extreme close-ups on turtles. People with wild pets. How about a story on the very good care that's given to lab animals; everyone says it's bad, but it's not. A day in the life of an animal hospital.

68. Hospitals: These places are a gold mine. We've done operating room nurses, even the maintenance department and linen service.

69. There are a lot of subjects that can make a series and be handled as above: school of the month, park of the month, etc. Since there is little that has to be told, you can get very visual and graphic. This is great for breaking up a slow paper.

70. Digging up your past—any archeological activity in your area? Any summer diggers that would make a story, even if shot over a period of months? Close-ups of hands and brushes, the finds, the people doing the work, and how they live.

71. Demolition contractor—ever wonder what happens to all the stuff

salvaged from a razed building? Spend some time with the contractor; see how much of the "junk" he salvages and what happens to it.

72. Gardening in the city. There are many attempts made by city dwellers to grow things to eat—porch gardens, window boxes with tomato plants, space by the side of the house or on the roof. Keep your eyes open for them as you cover other assignments.

73. Training police dogs—picture story on one new canine recruit, from its arrival, through school, and then going to work.

74. Hate to wash windows. Pictures of the poor guy who has to take care of the hundreds of panes in one of your city's new glass and steel buildings; how he does it and the view from where he sits. Then, does he do his own windows at home, or does he hold the ladder for his wife?

75. Music moonlighters—story of the part-time professional musicians in town.

76. Doodling in the back 40—a spring airplane ride when farmers are in the fields can provide a layout of pattern pictures as they turn over the fresh earth.

77. Giant step—good series of pictures as parents encourage a little one to take those first steps.

78. Thirst quenchers—a hot summer day and a park drinking fountain might supply a bright layout. The kids, and the adults, and the variety of expressions and poses.

79. Child's eye view—everything is built for the comfort of adults. What does the big world look like from the eye level of a three- or four-year old in a crowded department store or on the busy street, always looking up?

80. Helicopter flights for air views, but you must be located in a picturesque locale.

81. A day in the life of a woman legislator—and her methods of operation in a man's world.

82. A series on the best-known local sports figures (either collegiate or professional) concerning their ways of making a living during off-season.

83. Rescue training with the fire department or mountain search and rescue.

84. Seasonal fashions in your city, using local stores, models, and fashions each week.

85. Underwater series. Scuba-diving classes or children learning to swim.

86. Series of helicopter jobs. Crop dusting, smudging, laying power

lines, or rescue work.

87. Go to golf course early in the morning and shoot golfers yawning or otherwise trying to stay awake.

88. Empty a kid's pockets and lay everything on a piece of glass. Shoot up through the glass with the kid looking down at the camera.

89. Machines and other objects have human-like faces. Try shooting them.

90. Get a grade school teacher or scoutmaster to conduct a class in shaving for kids who never have. Photograph the instructor showing how and the kids all lathered up.

91. Get your photographers to try for pictures of athletes in anguish, triumph, or the like, and run a series of similar shots from three or four sports on Tuesdays, the dull sports picture day.

92. Women changing faces with expert guidance on makeup.

93. Kids making Valentines.

94. Arrange for a man carrying a sack of oranges to drop the fruit in a busy downtown pedestrian crosswalk. Photographer could shoot series of pictures showing how few people help to retrieve oranges. Stage the same scene with a pretty young girl and show men scampering to help her.

95. Many state prisons are trying to rehabilitate prisoners by preparing them for life on the outside. Prisoners learn mechanics, carpentry and wood working, typewriter repair, printing shop, leather crafts, foreign languages, use of machine tools such as lathe, and other trades. Face prisoners away from camera for close-ups showing them learning these various trades.

96. The small country doctor or general practitioner is becoming a thing of the past. You might show doctor making rural- or small-community house calls as well as treating a few patients in his office.

97. One-room schools are fast disappearing from the American scene. Many picture possibilities including recess activities showing the playground and lunch pails at noon.

98. Farming has become a science. Farms are much larger than they used to be and extensive machinery is often required for preparing soil, planting, and harvesting. Then crops and livestock are shipped to market place. This material is good for an entire picture page.

99. Child having his first dental work done.

100. Picture pages with word copy of small communities that may be in your circulation area, but not necessarily your own city. A candid look at the people, buildings, recreation, and so on.

101. When a celebrity comes to town, photograph the people's reaction to the celebrity.

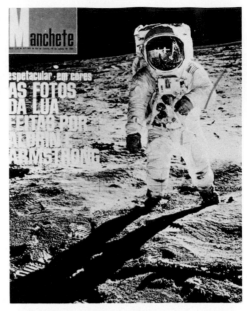

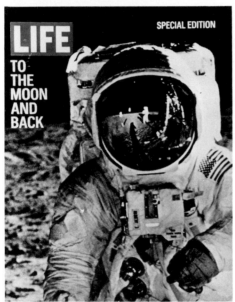

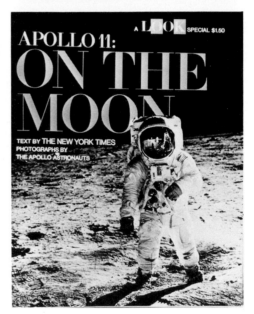

When the same photograph is released to many publications, the only distinctive treatment may result from cropping. Note the different approaches to the use of the first photograph of an astronaut on the moon on the covers of picture magazines published in North and South America.

7

Effective Display

Design and Layout

The photographer who makes pictures for publication realizes that the success of his visual statements depends upon the methods with which they are displayed and reproduced. On many magazines and newspapers there is a growing realization that the proper combination of pictures and type must become the responsibility of a skilled and experienced artist trained in journalistic techniques.

We live in a world of visual accuracy where our eyes are becoming trained to reality. Images appear before us in motion pictures and television, but the photograph in a newspaper or magazine has more permanence compared with these other media. With the printed publication a person can be alone, relaxed, return to it, and study it at leisure. The fleeting visual image of television and cinema require only a continuity of time and a logical sequential order. The printed page, however, demands an organization that will stop the reader, hold his interest and effectively display the statements made by the photojournalist.

The job of layout and design is handled in various ways. On a small publication the editor, photographer, and printer may collaborate. Larger newspapers and magazines employ the services of an art director who works closely with the editors and photographers. He is properly concerned with standards of quality and technique in photography, makeup, layout and sequence of pages, the design of covers, the selection of type faces, and supervision of printing and production from a quality standpoint. Because the photojournalist is so dependent upon this aspect, it is important for him to be well informed on these matters. Some publications, because of the relative newness of the photograph as a medium of expression, have re-

duced their use to a formula. The full potential of a photographer's efforts can only be realized when the photographs and text are given a typographical or design treatment that enhances both. There must be an integration by the layout artist of the text and picture so that the reader becomes aware of the information being communicated as soon as he sees the page.

Basic Concepts

The layout and design of the page are as personal and subjective as the taking and the editing of the photographs. However, there are some basic concepts in color and design. We know that a flat line, such as the horizon at sea, is restful and optimistic, possibly because when we were infants we did not fall off flat surfaces. We know that the downsweep of a bird contains a certain excitement because it is related to an eventual recovery or a regained flight. We know that blue contains a message of distance, possibly because it is the color of the sky. We know that red is an exciting color, possibly because it is the color of blood. The instinctive awareness of simple, fundamental laws such as these are combined with established techniques for picture presentation.

The layout of the page is essentially for effect. A person looking at the page will be influenced by this effect, even without studying the pictures and text. Therefore, it is first necessary to establish the effect that the page is supposed to create. This effect may be dictated by the nature of the publication and it may also vary, depending upon the location of the pages. On a newspaper, the front page may be much more sensational than an editorial page. On a magazine, the cover may have a design that is entirely different in its appearance from the lead article. The layout is also influenced strongly by the nature of the subject matter. The axiom that form follows function often prevails.

Directing the Eye

The organization of visual material on a page should be characterized by simplicity and directness. The headline, text block, photograph, and caption are so arranged that communication is smooth, orderly, and unobtrusive to the reader. In order to avoid monotony, it is desirable to have one photograph dominate the page. When the subject justifies this treatment dramatic and eye-stopping effects can be created by using a single photograph to fill a page. The selection of a dominant photograph is based on its strength as a visual statement. In a picture story the lead photograph is often dominant. Another approach may involve the use of numbered photographs of the same size presented in continuity. Pictures may be made to follow the direction of the action that is shown and may move up, down, or diagonally across the page. An often used eye-catching device is the juxtaposition of photographs that have similar subject matter or composition. Magazine and picture supplements make use of the bleed photograph to create emphasis. Here the photograph is printed over the

158

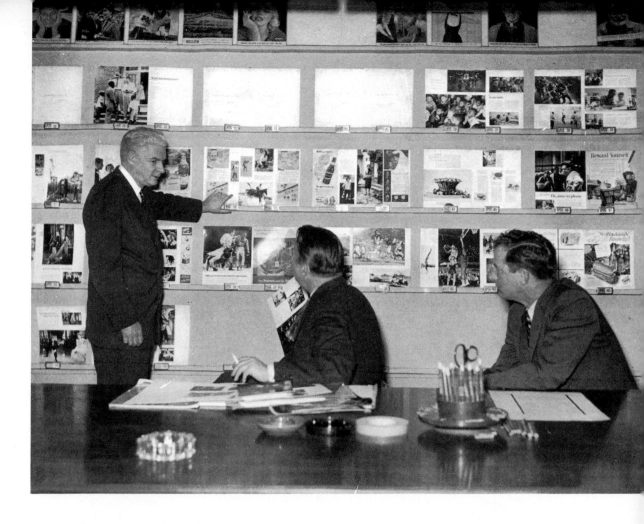

Dummy pages for an issue of a major magazine are arranged on a wall for a final check of contents and appearance. This method has the advantage of presenting the editorial pages in relation to the advertisement pages and makes it easier for the editors to arrange the pages in an interesting variety.

margin of the page to the trimmed edge. It is good to use at the beginning and end of a picture story but should not be overdone or its effectiveness will be lost.

Most photographs tend to fall into a rectangular shape that is either vertical or horizontal. The rectangle is a good shape to work with because of the variety of ways it may be fitted with other pictures on the page. However, the subject matter may often suggest the use of another shape. A skyscraper will look taller when placed in a vertical strip. Sometimes a circle or square will be used, but it is considered bad taste and poor judgment to cut pictures into irregular shapes merely to attract attention.

Cropping

In designing the page, photographs may have to be cropped. This is a great responsibility for the layout artist because a photograph is a sacred

159

Cropping the "important" areas out of a photograph does not always make a more effective result. At right is a section of a picture by Ralph Steiner shown in full at left. The two figures are a director and an actor, working together, but the full picture gives background and mood, and tells a more complete story.

and profound statement by an artist, and it should not be cut up by someone who knows nothing about the inclusion of each and every item in the composition. For this reason the photographer, or the picture-conscious writer who accompanies the photographer, should be consulted when the photographs are cropped and layouts made.

Photographs are usually cropped for the following valid reasons:

1. To emphasize the idea that the photographer is expressing.
2. To eliminate an unwanted portion of the picture that could not be eliminated at the time that the photograph was taken.
3. To compensate for technical errors.
4. To adjust the composition to fit a given layout in a publication.

Skillful cropping can also alter the proportions of the background and the foreground. The horizon line can be lowered or raised to shift emphasis. The center of interest may be moved to a better location within the picture area and objectionable or distracting material at the edges of the photograph may be trimmed away. The picture idea may be tightened, unified, or presented more clearly.

Before cropping, or in order to estimate the extent of cropping, the layout artist must determine at which size the picture will be used. This process is called scaling. Because of the rigid column widths in a newspaper, the space available for use may be smaller than the photograph and in different proportions. Picture editors and layout artists use two mechanical devices to scale or reduce a photograph in this type of situation. One consists of a transparent triangle on which inches and half-inches have been ruled. Another is a similarly ruled pair of L-shaped pieces with a plastic diagonal attached for scaling purposes.

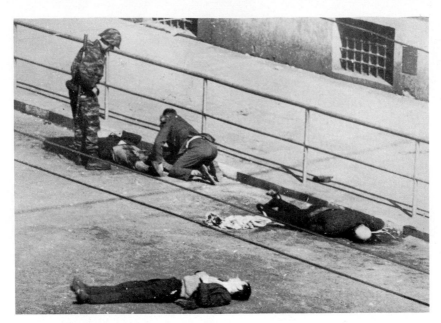

On these two pages you see a graphic demonstration of how many different photographs can be extracted from one negative. At the top of this page is the full-frame reduced slightly from the 4″ x 5″ original. Each of the different croppings—square, vertical, and horizontal—is valid. Note the different effects they convey, especially the imaginative cropping in the last photo of this group.

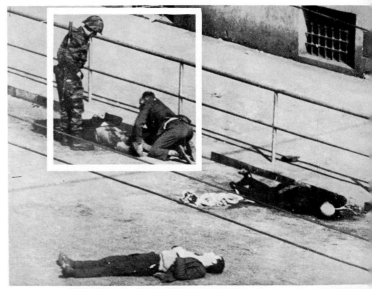

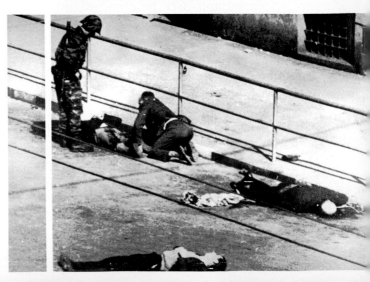

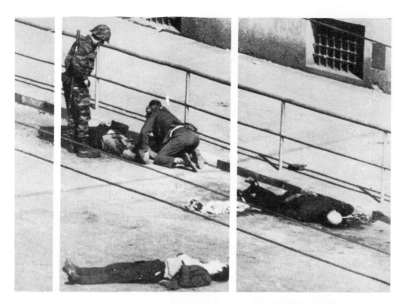

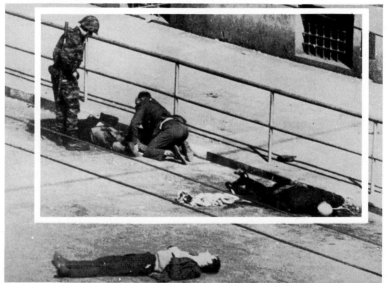

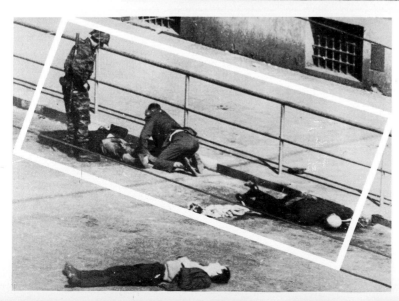

The cover of a magazine, a picture supplement, and, to some extent, the front page of a newspaper, have special design requirements that the photojournalist should appreciate. In the case of a magazine, the cover should have a poster value that will help sell the magazine on the newsstand. It should attract the reader's attention. By varying the color and subject matter of the cover, the magazine must indicate to the reader that a new issue is out. But the cover must not only attract the reader or the subscriber; it must persuade him to read the magazine. It is only by getting the reader to open the magazine and go through it that he can be exposed to the advertising messages contained therein.

The front page of a newspaper must also sell the paper on the newsstand and get the reader to go through the paper so that he will be exposed to the advertising on the inside pages. The newspaper's front page should excite the reader, get him to buy the paper, and promise him more exciting things inside.

These specialized goals can be accomplished only when the photojournalist and the art director work closely together. On a newspaper the picture editor may perform the function of an art director on a magazine, but the aims are the same. The photograph, whether for front page or cover use, must be chosen, cropped, and displayed effectively.

The magazine cover, usually in color, is simple, direct and striking. It stresses easily recognized elements and avoids details. The subject may be timely, attractive, or sensational. In the midst of the confusing mass of publications on a newsstand the cover should be easily recognizable. It must be sufficiently different from the cover of the preceding issue so that the reader will know that a new issue is available. It should also reflect

A principal responsibility of any art director is the design of the cover. Here are the changes which *Look's* cover has undergone—although newsstand sales have been excellent from the first issue. The first cover (top left) was much like a newspaper, with greater emphasis on pictures. Later, there was a complete re-design (top right), with one photograph occupying the whole space, with a box to indicate the other contents of the magazine. This made the issue appear larger and was a cleaner design with more dignity and authority. Another shift (bottom left) placed the story titles in the upper right next to the name of the magazine. This was an improvement over the previous box because on newsstand display covers may be hidden except for the title. Still later (bottom right), the cover subject was silhouetted against a white background and the name of the magazine was printed in color, so each new issue hitting the stands would have an even clearer identity. These elements are the same for every magazine, which require variety without loss of identity.

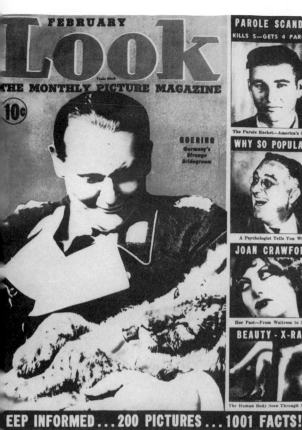

FEBRUARY
Look
THE MONTHLY PICTURE MAGAZINE
10c

GOERING
Germany's
Strange
Bridegroom

PAROLE SCANDAL
KILLS 5—GETS 4 PAROLES

The Parole Racket—America's Shame

WHY SO POPULAR?

A Psychologist Tells You Why

JOAN CRAWFORD

Her Past—From Waitress to Star

BEAUTY - X-RAY

The Human Body Seen Through X-ray

EEP INFORMED . . . 200 PICTURES . . . 1001 FACTS!

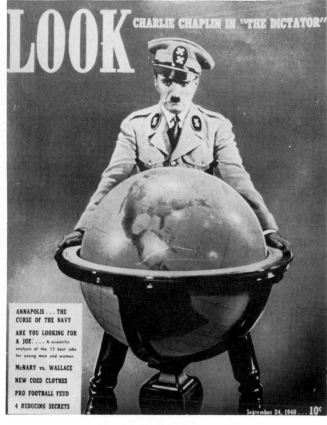

LOOK CHARLIE CHAPLIN IN "THE DICTATOR"

ANNAPOLIS . . . THE
CURSE OF THE NAVY

ARE YOU LOOKING FOR
A JOE: . . . A scientific
analysis of the 15 best jobs
for young men and women

McNARY vs. WALLACE

NEW COED CLOTHES

PRO FOOTBALL FEUD

4 REDUCING SECRETS

September 24, 1940 . . . 10c

LOOK

Is Petrillo on the Way Out?

Bill Mauldin's Cartoons
29 SELECTIONS FROM HIS NEW BOOK

Communism vs. Christianity
By DOROTHY THOMPSON

ERICA'S FAMILY MAGAZINE

YEARLY SUBSCRIPTION $2.50

UARY 20, 1948

No. 1 Debutante
(PAGE 28)

Look

15c

FIVE WAYS F.D.R.
CHANGED YOUR LIFE
PAGE 35

THE STORY OF
CHRISTIAN SCIENCE
PAGE 39

CHICAGO
CITY OF EXTREMES
PAGE 23

EASTER
SHOPPING
SPREE
PAGE 114

Design here (above left) follows function, four unequal areas contain the name, the cover photo, title blurbs, and smaller photos keyed to other articles. Still later (above right), the cover photo spread over the whole page with the name in a uniform white from issue to issue. (Opposite) A new design with the logo on alternate bands of black and gray. This has great visibility and strong identification. These designs combine continuity and display value with dignity and authority.

through its styling, design, typography, and choice of subject matter the nature of the publication, its circulation level, and its prestige and authority.

Method of Reproduction

The taking of photographs and their preparation for publication depend to some extent upon the nature of the reproduction method. Newspapers and magazines use one of the following three methods and, in some cases, a combination of them. These are rotogravure, offset lithography, and letterpress printing.

LOOK

Gloria Vanderbilt
starts a new life

4 color pages on
Hollywood fathers

15¢ JULY 12, 1955

ALL ABOUT LOVE
by Julian Huxley

(Above) *Look* covers went through another style change that gave them a more ordered and geometric appearance. The familiar bands of black and gray are retained to house the magazine's name, but reduced in size. The lead article is featured in the small box at the right of the title and other important features are listed in the band at the right of the cover photo.

LOOK

25 CENTS · JANUARY 12, 1965

A special issue devoted to the century that has produced the worst wars, the worst depressions, the greatest prosperity and the biggest revolutions in all human history

INSIDE THE TWENTIETH CENTURY

BY JOHN GUNTHER

Later (above) covers reduce the black and gray bands still further. The design of the entire cover is unified and emphasized and the name becomes part of the design, not a separate element.

A cover from *Look*'s last year. The reduced bands of black and gray remain while the overall layout and design of the cover are further simplified and unified.

Photographers are concerned mainly with the color positive as a transparency or as a print from a color negative. The fact is, however, that most of the color images we see have gone through a printing press. For every original color photograph on an emulsion, we view hundreds of color pictures that appear in magazines, newspapers, books, posters, displays, post cards, direct mail folders, labels, packages, calendars, greeting cards, and pamphlets.

When we look at the fine examples of color photography in the pages of a magazine, we do not see the original, but a reproduction. The photograph has been through a complex process to bring it to the attention of millions of people. The photograph is a means to an end—its appearance on the printed page so it may be seen by many.

Ten thousand years ago, a primitive man made a painting on the wall of a rock cave; through the medium of color photography it was revealed to the modern world. Finally, by means of the printing press, it has appeared in an inexpensive art book available to millions of school children. The combination of faithful color photography and printing with fidelity reveals

170

the minute grains of rock and flakes of pigment in the original. Thus, new meaning is given to Goethe's saying, "Art is long and life is short."

For these reasons it is important for every color photographer to understand the methods of printing reproduction and to appreciate their various qualities.

Prints for Reproduction

Special attention should be given by the photojournalist to the kind of print made for each type of reproduction. Engravers of halftones prefer glossy prints with a full scale of tonal values and plenty of detail in the shadow areas. Both rotogravure and lithography have a diffusing effect. Prints prepared for these processes should be on smooth surfaced papers and as sharp as possible. Full gradation is desirable but a higher degree of contrast may be maintained with rich blacks and clean whites.

In the preparation of pictures for reproduction certain operations may be performed on the print to increase its effectiveness. Small white spots on prints can often be eliminated satisfactorily by spotting. The negative may be retouched, etched or painted with opaque dyes in order to emphasize or eliminate certain areas. The skillful use of an air brush on the print may help the final engraving In all of these operations the final reproduction of a photograph should look realistic and natural. It is sometimes desirable to outline a figure and eliminate a cluttered background. This may be done by airbrushing or painting out the background, or the figure may be cut out with a sharp knife and pasted down on paper. In some instances, the photograph may be reversed in order to increase the effectiveness of the layout. In reversing a photograph, care should be taken that the details of dress or action do not make it look absurd. Whenever possible, however, these layout techniques should be avoided. They can be minimized by acquainting the photographer with the problems of layout and thus making him consciously avoid the defects in picture taking.

Color has long been in use in rotogravure supplements and magazines. In recent years mechanical improvements have increased the emphasis on color. Magazines have had color jobs on their presses rolling within a few days of the event. Many newspapers are printing spot news in color. Color is printed during the run of paper (ROP) by newspapers such as the *Minneapolis Star* and the *Chicago Tribune*. This ROP color is printed on ordinary newsprint by the same presses that normally print the paper.

There are many problems in the use of color. Engraving and printing costs are higher. Color is more difficult to take as well as to reproduce. With a wider use of color this added quality will not raise a dull picture from mediocrity. The growing emphasis on color does mean that the photojournalist must learn to use this enhancing quality effectively. As the emulsion speeds of color materials approach those of black-and-white, many of the difficulties faced in color are overcome. The trend and eventual goal is definitely in the direction of a negative material that will yield a

positive print in color of high quality. Latitude and accuracy will improve and the photographer will make color photographs with the same ease as he now makes black-and-white pictures.

Printing Techniques

The oldest of the ancient arts of putting ink on paper is letterpress. In this process, raised type, inked on its surface, is pressed onto paper. Photographs are printed the same way. Halftone plates are made and etched into minute dots. These vary in size to produce gradations of tone and color.

The gravure process is the opposite of letterpress. The image to be printed consists of small wells in the plate. Ink is forced into the design and the flat surface of the plate is scraped clean. When paper is pressed against the plate, it absorbs the ink from the wells. By varying the depth, rather than the size of the tiny ink wells, tones are created by the amount of ink deposited on the paper.

In lithography, images are fixed onto metal plates photographically. The plates are then treated with chemicals that make the image areas water repellent. Since water and oil do not mix, when the plate is moistened, oily ink will adhere only to the surface of the image. The plate may be curved around a cylinder and printed first against a rubber roller. This image is then transferred to the paper by the process of offset lithography.

With all these printing methods, the original color photograph must be separated by filters into three or more negatives. For a three-color process, the filters used are cyan, magenta, and yellow. Each black-and-white negative will contain the values of one of the colors in the original. These negatives are then exposed through a screen, which may vary from 30 lines to an inch to 300 lines per inch. This screen breaks the image up into small dots. These dots are transferred to the metal plates and become the ink-bearing surfaces.

Photographs are ideally suited for gravure printing. In letterpress, quantity of ink cannot be varied, but in gravure, many different intensities of ink can be transferred to the paper. Combined with the finer screens permitted, gravure achieves much better continuous tone. Some publications use a highly refined form of color gravure printing. Here, special inks, paper, and screens are used with rotogravure cylinders on a high speed press to produce great color saturation, excellent gradation, and fine resolution. In this way, color photographs are printed in quantities of eight million with the highest fidelity to the original.

Of the three methods, offset lithography is least expensive. Until recently, color reproduction in this process did not have comparable richness and saturation. However, much progress is being made not only in the development of heavier inks, but also in designing presses and plates capable of longer runs. The delicate quality of lithography may be used to advantage. When water colors are reproduced by lithography, they are hard to distinguish from the original. Also, the cost of extra plates is not a

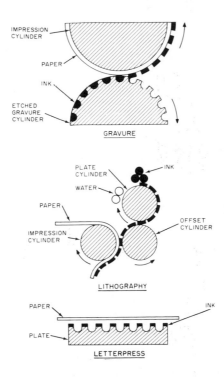

factor and thus several additional colors may be used to maintain true values. It is not unusual to print by eight-color offset lithography.

Color photography owes much of its growth to the perfection of low-cost and accurate methods of color printing. By offering these images to millions, magazines have created a growing awareness of good design and an appreciation of its desirable values. The pages of publications have become the art galleries of our times.

Layout Principles

Writers, artists, and photographers working together will produce picture pages that compel attention and action and have visual impact. Visual contrast makes the page more interesting to the reader. This should be accomplished without sacrificing the continuity of the story. Start by selecting those photos with greatest impact and display them prominently. Excitement in design is created by contrast in scale, tone, or subject. Avoid monotony on the page by using large pictures against small ones. Try to obtain a meaningful distribution of light and dark areas. Place a detail against a larger scene. Use white space to advantage in order to place emphasis and produce a balanced rhythm in design.

Since we read from left to right and from top to bottom, a large eye-catching photo at the top right of a spread will create a welcome variation. Adjust the form to the subject. A skyscraper or rocket launching demands vertical treatment. Above all, be careful to avoid imposing a design on the photos. The best layout tells the story by enhancing the effect of words and pictures. It is always easy to read.

173

This layout demonstrates a method of producing visual variety on the page by directing the eye away from its normal reading routine.

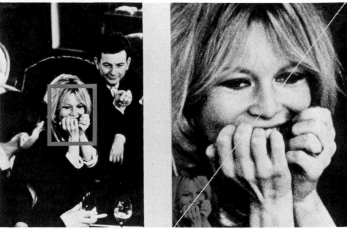

A small section of a photograph may be enlarged to give it visual impact.

Using proportions A:B = C:D, any photograph may be enlarged or reduced to scale. First find the new dimensions with two L-shaped cards, then measure the diagonal with a ruler.

In layout, form follows function. The landscapes are horizontal and the trees are vertical. Such contrast adds to the interest of the page.

In this layout, the eye is quickly introduced to the page by the outstretched arm. The center photo bridges the gutter between the pages. On the last photo, the bleed edge is an invitation to turn the page for more.

8

Equipment and Technique

Craftsmanship and Style

As a creative means of communication, photojournalism suffers from the mechanical limitations of the equipment that must be used to capture the elusive image. There is no simple or easy formula for working in this exacting field. Nowadays, in a relatively short time excellent equipment makes excellent photographers out of people who have visual talent. The aspiring photographer finds it easy to express himself with the wealth of almost foolproof cameras and techniques that are available today. For this reason we must assume technical excellence in our appraisal of the photojournalist's work and condemn those who, through laziness or ignorance, fail to comply with elementary standards of craftsmanship.

In all the creative arts there is a definite relationship between the equipment of the artist and his ability to express himself esthetically. Just as the violinist desires a Stradivarius or the painter requires oil colors of brilliance and permanence, so the photographer appreciates sensitive, accurate emulsions, corrected lenses, easily portable and powerful lights, and well-designed, balanced cameras.

Proper equipment is not the only answer to good photography. The photojournalist must not get so involved with gadgets and paraphernalia that his ultimate purpose—making a visual statement—is forgotten.

There is also a definite relationship between the equipment used by the photojournalist and the style of his picture. This stems not only from the physical nature of the camera, lens, and film used, but also from the manner of working which the equipment imposes. As an extreme example, the small, hand-held 35mm camera can be used quietly with great mobility under poor lighting conditions. The large, tripod-bound view camera is slower to operate, but makes possible corrections on the negative and prints of higher quality.

(Left) Photographers earlier in the century went to ingenious lengths to gain a vantage point from which to photograph the news. Their equipment was less flexible, too. (Right) News photographers use the same ingenuity to gain an extra yard of height for their cameras. This grouping greeted Winston Churchill on a visit to Washington, D.C.

The versatile photojournalist must know all the tools of his trade. He may be compared to a composer of music. His cameras, lenses, and lights are like musical instruments. The successful composer knows what these instruments will do and uses them properly. Whether expressing a simple or a complicated theme, he tries to pick the instrument that will make his statement most effective.

Amortization Program

Some magazines have established a plan for their staff photographers. Under this plan the company does not own the equipment and each photographer makes his own selection and purchases. The company assumes the depreciation of equipment at the rate of 25 per cent a year and credits the photographer with this amount. Thus the equipment may be replaced as it becomes worn out and obsolete.

Under this plan the company has the benefit of its staff working with up-to-date equipment in good condition. It does not have the burden of repair and maintenance. The photographer, on the other hand, chooses

177

his own equipment, has confidence in it, and usually takes better care of it because it is his own.

All photographers should keep informed of new equipment that will improve their work. Each photographer's investment in his equipment amounts to several thousand dollars. In addition, a publication may maintain a pool of special equipment for unusual jobs, which the staff photographer draws upon as needed. This consists of extremely long telephoto lenses, super-speed lenses, sequence cameras, panoramic cameras, and powerful electronic flash units.

Selection of Equipment

In determining which equipment to use, the photojournalist will soon realize that the negative size is the deciding factor. There are three negative sizes to consider; these are 35mm, 2¼″ × 2¼″, and 4″ × 5″. The negative size determines the size and flexibility of the camera, the focal length and aperture of its lenses, and dictates the method of handling the film in developing and printing. It will help the photojournalist to consider each of these as a separate system of photography, with certain advantages and disadvantages.

The Director of Photography (center) and staff of a publishing company in Buenos Aires, Argentina. The staff works for several publications including a news picture magazine, a women's interest monthly, and a sports weekly.

178

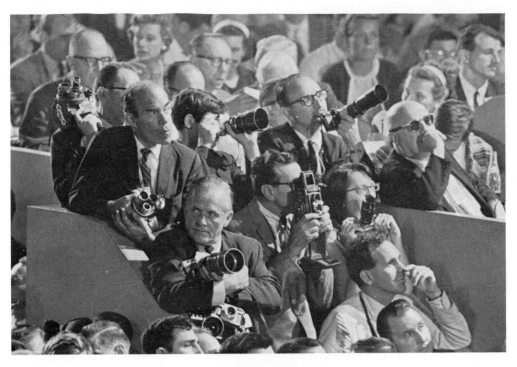

Today's photographic coverage of national political conventions is especially intensive. (Above) Special stand constructed for photographers at the Democratic convention. (Below) Special station for long lenses from 300 to 600mm.

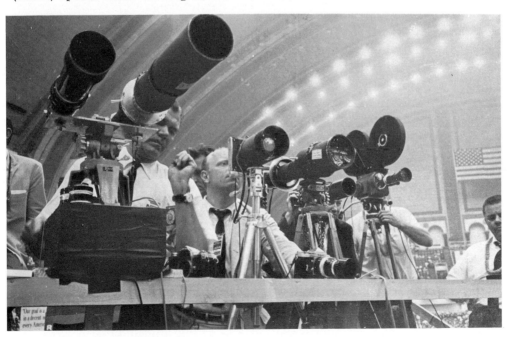

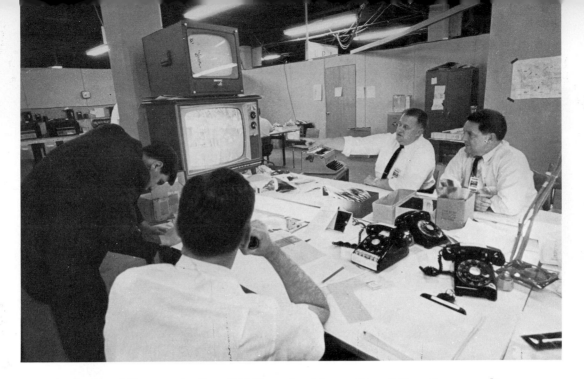

At the Republican convention, UPI-Newspix picture editors follow the proceedings on television and assign photographers accordingly.

35mm Format

The advantages of the 35mm system are: The camera is small and relatively inconspicuous, making it easier for the photographer to work unobtrusively. A great variety of lenses are available, ranging from 21 to 1000 millimeters and with apertures up to $f/1.1$. For photo sequences and rapid coverage, 36 exposures may be made in quick succession.

The disadvantages of the 35mm system are: The quality of the image suffers under extreme enlargement or under hurried processing. It is not possible to make adjustments on the negative by swinging the lens or the focal plane. Color in this size is also more difficult to reproduce.

2¼″ Format

The advantages of the 2¼″ × 2¼″ system are: Optimum image quality with minimum weight, interchangeable holders or backs with some types for color and black-and-white, and better synchronization with flash and strobe lights.

The disadvantages of the 2¼″ × 2¼″ system are: The lack of some professional accessories and film materials because manufacturers consider this an amateur size. The paper backing on roll film in this size may result in lack of sharpness at wide apertures. Tilt and swing adjustments of lens and focal plane cannot be made.

4″ × 5″ Format

The advantages of the 4″ × 5″ system are: Corrections may be made on

180

the negative before exposure by adjusting swings and tilts. The film is large enough so that it can stand considerable abuse in processing and rapid methods are possible. Retouching on the negative, or color corrections on the transparency are more easily made. The quality of the image is better because the degree of enlargement is less. The greatest variety of sensitized materials is available as well.

Whenever the convergence of lines must be corrected, as in architectural photography, or the image must be studied carefully as in multiple exposures, a ground glass view camera with swings and tilts is required. This type of camera should also be used for still life and copying.

The disadvantages of the 4″ × 5″ system are: Its size and weight make it unwieldy and difficult to handle. Depth of field is shallower and lenses are slower, requiring additional light. Fewer exposures are possible at a given time, making adequate coverage more difficult.

It is obvious from the foregoing analysis that there is no universal camera for the photojournalist. He must choose the equipment that is best suited to his needs and for true craftsmanship and versatility, he must master them all.

In the above basic types of camera there are also single-lens and twin-lens reflexes—distinct from viewing the subject through an optical or wire finder or on the ground glass. With the single-lens reflex it is possible to see exactly what will appear on the film. Selective focusing may be visually accomplished. There is no parallax problem in closeups. However, the photographer loses his image at the moment of exposure and to some, this is a disadvantage. The twin-lens reflex, on the other hand, makes it possible to observe the subject before, during, and after the moment of exposure.

Special Equipment

It is in the knowledge and ingenious use of specialized equipment that the photojournalist has the opportunity to make different and revealing pictures.

Wide-angle lenses will distort space and create unusual impressions of scale and depth. Similarly, panoramic cameras can make it possible for the camera to see more than the eye does both literally and figuratively.

Both long focus and telephoto lenses are useful in selecting significant portions from a scene. Longer than normal lenses are especially suited to the smaller cameras. For example, if a 4″ × 5″ camera with a five-inch lens is normal, the use of a ten-inch lens will magnify the image two times, but when a 35mm camera is used with a ten-inch lens, the image is five times greater than that obtained with a normal two-inch lens. A telephoto lens using reflecting mirrors is available. This makes the lens extremely lightweight, compact, and short for its effective focal length. This type of lens does not have diaphragm adjustments and usually works at a fixed aperture of $f/5.6$ or $f/8$. When extreme telephoto lenses are used,

A contrast in expressions above and opposite, as Army cadets react to a touchdown by the Navy and by their own team, was recorded with a wide-angle (140°) Panon panoramic camera. The photographer watched the crowd for two hours, with his back to the game, to get the proper expressions. The extreme wide-angle lens adds to the effectiveness.

Another wide-angle technique is the use of a special attachment to the tripod, the panoramic head, which enables the photographer to make a series of exposures in rapid succession and match them into a continuous strip. This was made in the United Nations with four successive exposures.

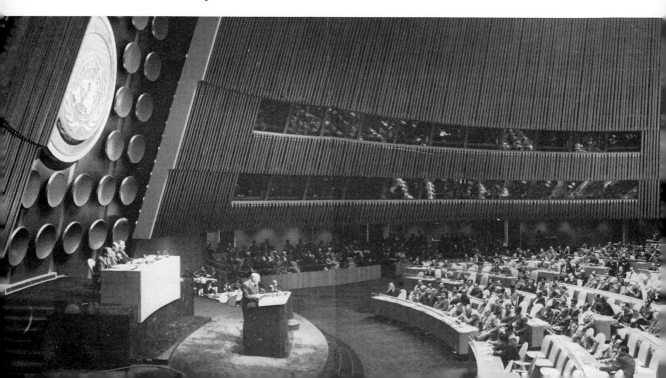

the equipment is mounted rigidly on a tripod or, if hand-held, high shutter speeds are required to prevent movement.

High-Speed Lenses

There are several super-speed lenses of $f/1.1$ or $f/1.2$ for use with 35mm cameras. In evaluating these lenses, the photojournalist should realize that an $f/1.2$ lens is approximately one-half stop faster than an $f/1.5$, and an $f/1.1$ lens is about three-fourths of a stop faster than an $f/1.5$. Also, at these apertures, the depth of field is very shallow. The use of these high-speed lenses takes on significance only when they are used in conjunction with the fastest materials available. The extra half stop means

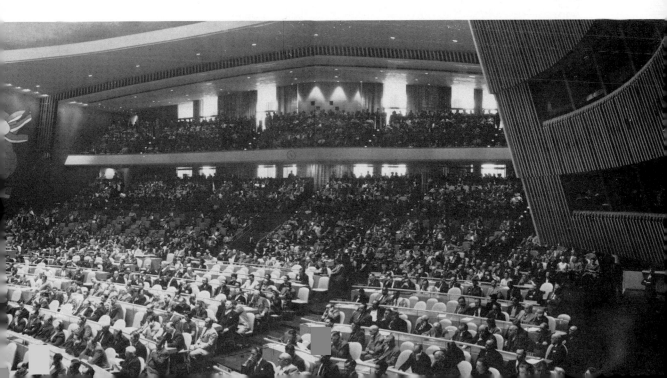

that a higher shutter speed can be used, and photographs can be made under existing light conditions that will stop action. For example, photographs can be made directly off the screen in a movie theater with the latest high-speed color materials and an exposure of 1/25 sec. at f/1.1. Such lenses are very useful when every bit of available light is important.

Motorized Cameras

For sequence photography special cameras are required. One of the most advanced uses 70mm perforated film on 100-foot daylight loading spools. It produces a negative size of 2¼″ × 2½″ and will operate at variable sequence speeds up to 50 pictures per second. Used with telephoto lenses, the camera has been very effective in sports photography. Another 70mm camera uses a 15-foot magazine load of film on which it makes fifty 2½″ × 2¾″ exposures. It contains a spring motor which, when fully wound, makes it possible to expose as many as ten consecutive single shots in as little as five seconds. A 35mm camera in wide use for sequence photography has a spring motor that makes possible the exposure of eighteen 24 × 36mm frames in six seconds. Another compact 35mm sequence camera uses a battery-operated electric motor to transport 33 feet of film at 8 exposures per second for a total of 400 exposures.

Lighting

In lighting, the photojournalist is concerned with realism. His primary concern should be to raise the level of illumination so that an adequate exposure is possible. The lighting should be natural, unobtrusive, and in keeping with the subject. In order to achieve this effect many photographers use the light that is available. Many assignments can be covered with fast films and fast lenses. Where additional light is required the most popular device is the portable electronic flash. These operate on replaceable or rechargeable batteries and permit hundrds of flashes to be made without interruption. Frequently the light is directed or bounced against a wall or ceiling in order to create a more realistic and natural effect. When several lights are used, photo cells provide synchronization. Sometimes several electronic flash units are set up in a given area for zone lighting. This permits the photographer to move freely within the zone and obtain adequate exposures. As emulsions become faster, lighting equipment for the photojournalist becomes smaller and less powerful.

Miniaturization

In the equipment of the news and magazine photographer there is a definite trend toward miniaturization. The photographer who is communicating news and ideas is often more interested in content than in quality. The larger negative produced by the bulkier, more cumbersome cameras result in photographs of better quality. The smaller negatives and the

more flexible cameras that use them produce a better approach to the subject matter and a photograph with improved content. When pictures are published, the reproduction process causes a considerable loss of quality so that given a choice, the photojournalist is justified in stressing content of the visual image. Improvements in film manufacture with regard to speed, grain, and resolving power mean that the smaller negatives can produce photographs of superior quality. The important element of this equation, however, is the photographer himself who must be sensitive, perceptive, alert, and imaginative, regardless of which camera he uses.

An Ideal Camera

There is no universal camera for the photojournalist. It is possible, however, to describe an ideal piece of equipment. The size of this camera would be based on the ideal negative size which, in turn, is based on film resolution. With present materials, the negative should be ideally 26×26mm. The negative size would, in turn, determine the lens. For normal perspective it should have a focal length of 40mm with an aperture of $f/2$, at which flare should be at a minimum. This lens should stop down to $f/32$ and focus down to two feet. Additional lenses should include a wide-angle lens of 20mm with an aperture of $f/4$ and a telephoto lens of 80mm with an aperture of $f/4$.

The ideal camera would contain a prismatic through-the-lens viewing device, a rangefinder which automatically couples to all lenses, a viewfinder that adjusts to all lenses with automatic parallax correction and a bayonet mount for rapid interchangeability of lenses. The camera should contain a film cartridge of 50 exposures with provision for removal in daylight of any amount of exposed film. A motor should be available to produce sequence exposures of five frames per second for ten seconds. Shutter speeds should range from 1 to 1/1000 sec. with provision for electronic flash synchronization at 1/125 sec. Ideally, the camera plus lens should weigh five pounds or less. This camera should be the basis for a system of photojournalistic photography that would include lighting equipment, developing tanks, enlargers, negative files, and other accessories.

Until the ideal camera is made, the photojournalist will have to continue to try and evaluate every new and improved photographic technique, whether it is a camera, film, color process, or light, for each innovation may extend the photojournalist's creative possibilities and potentialities.

Stills on Television

Viewers who watched the National Broadcasting Company's impressive color coverage of the political conventions may remember the brief display of photographs by David Douglas Duncan. Every night, right after Huntley and Brinkley got started, Duncan showed some of his photographs made the previous day and talked about his pictures. The approach was rather subdued and restrained. Duncan's comments were brief, explanatory notes.

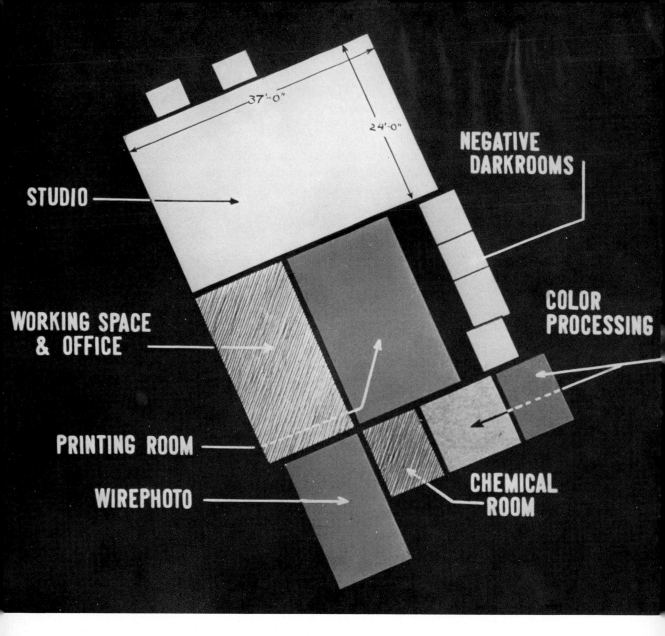

The photographs were in black-and-white on a color show. But this represented a major journalistic breakthrough. It opened up a new avenue of expression for the still photographer, with far-reaching consequences.

The photojournalist uses pictures as a means to an end. His goal is the presentation of his photographic observations to a large audience, so that his camera-witness-of-events may be appreciated by many. Until now, this has been accomplished by the mechanical reproduction of the image via the printing press. Photographs are thus reproduced in magazines and newspapers with circulations of many millions. But the true mass medium is television. Here is where the greatest circulation can be found. Duncan's work, shown at prime time, had a potential audience far in excess of any printed publication.

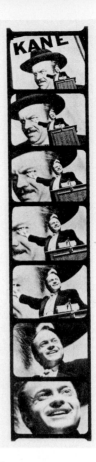

(Left) Floor plan of a newspaper's photographic studio and dark-rooms. The whole arrangement is geared for speed, consistent with quality results, and is filled with modern equipment, including several custom-made pieces. Darkrooms are air-conditioned and have stainless steel sinks. (Right) An effective use of cropping and blowup on this photograph of Orson Welles in the film *Citizen Kane*.

Another desirable quality in journalism is immediacy. The news story benefits from its presentation as quickly as possible after it happens. Here, too, the shortest possible time elapsed between Duncan's exposures and presentation of his prints on the television screen. For logistical purposes, the pictures were in black-and-white, but the coverage could have been in color just as easily. Black-and-white is an abstraction of color. In this instance, the carefully edited black-and-white report was an effective contrast against the routine, somewhat confusing convention color coverage.

Duncan made many of his pictures with a Leicaflex equipped with a new Leitz Telyt 400mm $f/6.3$ lens. He shot everything on Tri-X rated at ASA 400 and developed the negatives in D-76. His laboratory assistant, Carmine Ercolano, working in a darkroom trailer, printed the selected negatives on $11'' \times 14''$ Kodabromide paper. About 40 of these prints were placed before the television camera, which sometimes zoomed in on a significant detail. Duncan flipped the pictures at his own pace and talked about them for three to five minutes. Often he permitted the photographs to speak for themselves.

The outstanding virtue of this type of presentation lies in the fact that there is direct communication between the artist and his audience. When a painter finishes his work, it is displayed in a gallery or museum. The audience looks at the actual work created by the artist. When a musician performs, the audience listens to the actual notes he strikes and his interpretation of the music. However, except for the few exhibitions, the photographer can present his work only through publication. In the

process of getting his pictures and words on the printed page, he must go through many intermediaries. Picture editors select, art directors make layouts, copy editors oversee words, lawyers check releases, engravers make plates, production men correct proofs. All of these people bring their talents and skills to bear on the photographer's report before it appears in print. They are needed and they make worthwhile contributions.

Many years ago, W. Eugene Smith protested against this kind of journalism and attempted to control the process of publication himself. He was not permitted to do so by the editors of the great picture magazine for which he worked. It may well have been an impossible dream.

But now Duncan has solved the problem. On television there is nothing and no one between the photographer and his audience. Duncan makes the picture at the decisive moment of his choosing. He selects those images that express his views best of all. He shows them to his audience and tells them who, what, where, when, why, and how. The message is adapted to the medium in the best possible manner. For the photographer, it is also most satisfying to have this freedom.

Further, there is the resolution of a fascinating problem in aesthetics. The television screen presents a continuously moving and therefore transitory image. It has some wonderful devices, such as instant replay, but these are repeated, slow motion projections of previous continuities. The still camera, on the other hand, used by a perceptive and sensitive photographer, can select a significant moment and record it for all time. It is a permanent record, rather than a transitory one. It is also an interpretation, because the shutter may be clicked many times during an event. Mechanically, the higher shutter speed of a still camera freezes the action. Its greater mobility provides more variety in viewpoints and its unobtrusive quality takes it to many places television cannot penetrate. Thus, the still picture has different aesthetic qualities when compared with the video image.

Other television stations will recognize the value of David Douglas Duncan's journalistic breakthrough. The main problem will be to find the photographer. He must be an honest, sensitive observer with an awareness of news values, a good technician, and a likeable warm personality who can talk about his photographs with sincerity.

9

From Image
to Reality

The Photographic Laboratory

Publishers of newspapers and magazines properly consider the photographic departments an integral part of the editorial operation. This attitude has its disadvantages, however, when equipment and laboratory problems arise. Some publishers who readily accept the idea of spending huge sums for presses, engraving, and reproduction machinery hesitate at the expenses involved in setting up an adequate photographic laboratory. It should be realized that a carefully planned photographic laboratory staffed by skilled technicians is just as important to the newspaper or magazine as any of the other aspects of the photojournalistic process.

The photographic laboratory has an important and complicated mission. It is a service to photographers and editors that stresses both speed and quality. In the laboratory, negatives of various sizes and types of emulsion are developed; printing is done to exacting specifications; negatives and prints are numbered and identified; color is processed; copies and duplicates are made. Because all of this has to be done with a minimum of time and a maximum of quality, the design and operation of the magazine or newspaper photographic laboratory has very special requirements.

Many publications still require their staff photographers to develop and print their own assignments. On a small newspaper, where the volume of work is low, the photographer can not only take the pictures and process them, but may also make a plastic halftone. However, a newspaper or magazine that has several staff photographers would do well to employ one or more skilled laboratory technicians. He should not be another photographer, nor a man who considers the laboratory as a step to a photographer's job. The photographic laboratory technician must devote

himself to the special services required and concentrate all his effort and skill at working smoothly with the photographer, picture editor, layout artist, and printer. He should know mathematics, chemistry, and physics, and have a passion for cleanliness, neatness, and order. He must know enough about photography to advise and consult with the photographer when special problems arise.

Photo Lab Service

A properly staffed photographic laboratory makes it possible for the photojournalist to concentrate on the creative aspects of his work. By eliminating the time-consuming processing operations, a publication can have a smaller group of photographers handling a greater number of assignments. Also, there is no inhibition on the part of the photographer when it comes to coverage. Since film is probably the cheapest thing in the whole process of visual communication, it is desirable to use it in whatever quantities are required. But the photographer who knows that he will have to develop and print every one of his exposures may not cover his subject as extensively as he should.

When a photographer is on a long trip, it is important to have a photographic laboratory in which he has confidence. Exposed film rushed to the laboratory may be quickly processed and reports on exposure and general quality speeded back to the photographer for guidance. On a long assignment it is wise for the photographer to send his film in for processing as it is exposed. The latent image deteriorates under conditions of high temperature and humidity, especially with color. Also, in this way the photographer may be notified before too much harm is done by a light leak in the camera, a faulty shutter, or bad flash synchronization. The laboratory technician should take an active interest and pride in the work of the photographer. The photographer, in turn, must give the men who handle his precious film the confidence, respect, and appreciation they deserve for their skill.

Some photojournalists maintain that it is only by personally carrying the whole process to completion that their visual statements can have the proper significance. This may be true when the emphasis is on the aesthetic, creative content of the photograph. Provided he is a competent technician, it is only natural that a photographer who has conceived a photograph will be able to stress its important aspects in the final print. But this is a luxury that the average photojournalist cannot enjoy. While he must know enough about the photographic process so that if necessary he can do it all himself, it is neither advisable nor desirable for the working photojournalist to spend long hours in the laboratory. When the great loss of quality in printing and reproduction is taken into account, the photojournalist is employing his time to better advantage when he concentrates on the subject and content of his work.

190

On the larger newspapers there is a growing trend toward the use of a photographic laboratory staff to expedite the news and feature photographs and still maintain good quality. With the increased use of color the laboratory process has become so exacting and technical that specialists must be employed.

Film Processing

The most critical element of the photographic laboratory operation is black-and-white negative and color development. When a photojournalist after great effort, considerable patience, much thought, and even risking his life has exposed his film, it is to be expected that he will demand scrupulous attention to the development of that transitory latent image. The proper development of film may be automatic in terms of time and temperature, but it is the rigid cleanliness and attention to detail that will produce superior results. It must be remembered that if the film is mishandled, in most cases it is irreplaceable and the story is lost. For the serious photographer, the tension and nervous anticipation as to the outcome of the development of his film is comparable to an expectant father in a maternity hospital.

Film development should be standardized. The photographic laboratory, in consultation with the photographers it serves, should establish the use of certain developers and the photographers should rate their films accordingly. The technicians developing film depend on the photographer to submit detailed instructions as to the conditions of exposure. The time of development is adjusted to give the best quality of negative. The photographers place their exposed film in special printed envelopes and the envelope is returned to the photographer with the technician's comments after development. When possible in shooting, photographers are instructed to separate film exposed under different conditions. For example, after shooting with weak incandescent light indoors, a photographer may move to bright sunlight outdoors. He tries to use separate holders or rolls of film for each type of lighting and makes relevant notes. The technician frequently resorts to development by inspection so that the optimum processing time is given. Many a photographer has had his pictures saved by skillful handling at this stage. With color, the photographic laboratory will instruct photographers as to the filters required for correct color balance with given emulsions. Frequently, good results are obtained when color emulsions are forced well beyond their published ratings through the use of filters and the correct relationship between exposure and development.

Printing

On newspapers, where speed is important, the negative is often printed while wet. This is advanced sometimes as an argument against the use

When it is sharp and processed properly, the 35mm negative has an almost infinite capacity for enlargement. Here, a blowup to full page size has been made from a small section of the original photo at left.

of roll film, but 35mm film can easily be printed while wet in a glassless negative carrier, and the only extra requirement is a little care and cleanliness in handling, which is desirable with all sizes of film. Because the print is destined for reproduction, it is not necessary to wash and dry it for the same degree of permanence as a portrait or other permanent record, but the negative should be rewashed and carefully dried for preservation. Prints can always be made if the negative is available and in good condition.

When layouts are made, as in magazine work, the print is often made to a definite size specified by the artist. Printing to size is usually done without an easel and two rulers at right angles are used to measure the dimensions of the print. The print is always made on paper larger than the size requested.

In most photographic laboratories, 35mm negatives are cut into strips of five or six frames each so that the scratching and handling of rolls and individual negatives is minimized. If scratches and dust marks appear on any negative, the printer uses a thin smear of petroleum jelly applied to the front and back of the negative. When this is rubbed down with clean cotton any defects are usually gone. Glassless negative carriers must be used.

For enlargements, the printer uses three developers. Dektol diluted with twice its volume of water is standard for one-minute development at 68° F. A tray of straight Dektol is available for prints that need forcing. Dektol diluted 1:4 is used for prints that come up too fast. A skillful printer may

also use a solution of potassium ferricyanide to reduce shadows and open highlights.

Prints are made for three purposes. After development and drying, the negatives are numbered on the base side within the clear marginal area using a fast drying acetate ink. The negatives are then contact printed on sheets of 8″ × 10″ paper. A complete 36-exposure roll of 35mm film cut into 5 or 6 frame strips will fit on a sheet of 8″ × 10″ paper as will a roll of twelve 2¼″ × 2¼″ exposures. These contact sheets are used for editing and filing purposes. Each contact sheet is identified with the photographer's name, the job number, and the date.

A second type of print is that used for layout purposes. The layout print is usually made to an exact size and must be of good enough quality to indicate the content and potentialities of the story.

Finally, prints are made for reproduction purposes. These must be tailored to the printing process. When a print is used for a halftone engraving, it must be realized that about half of the tone value is lost in the halftone. The longest possible scale is required with no strong blacks. For this reason, negatives should not be developed to excessive contrast and prints should be made on paper as close to normal as possible.

Copying

Every newspaper and magazine photographic laboratory should have a copy camera set-up and a technician who is trained in copying procedures. The subjects that may require copying are: prints for which negatives are not available, cartoons and line drawings, layouts of photographs with text, and paintings. The copy camera may also be used for making black-and-white negatives from color transparencies or making duplicate color transparencies. If much copying is to be done, a camera stand and lights

Contact sheets are printed on 8½″ x 11″ single-weight glossy paper. The 35mm negatives are cut in five frame lengths. Each roll is numbered for identification.

should be assembled for this purpose. The camera should have a ground-glass, a bellows extension long enough to permit same size (1:1) copies, and a lens that covers the field adequately, is free from distortion, and has good chromatic correction. The board or easel on which the material to be copied is held must be parallel to the film plane. When books or magazines are copied, a glass pressure plate should be used to flatten the material and keep it in place. Under these conditions a vertical copy camera is better than a horizontal arrangement.

In lighting the material to be copied even illumination is important. Two lights in reflectors at opposite sides at 45° angles to the subject are used. When color copies are made, the color temperature of the lights must be balanced to the film. When many copies of a standard sized subject are to be made, a rigid setup using electronic flash is rapid and may be operated by anyone with a little instruction. For making black-and-white negatives from color transparencies, a light box illuminates the transparency from the rear and the lighted transparency is copied in the normal manner. When reflections on the surfaces of glossy prints or oil paintings must be eliminated, polarizing filters over the lights and the camera lens are effective.

Films used in copying are of three types: High-contrast materials are used for line drawings and printed matter. Ordinary panchromatic emulsions of great resolving power are selected for continuous tone subjects and photographs. Color materials are used when required. In some cases, quick copies for record purposes are made directly on bromide paper.

Rapid Processing

On a newspaper, the need for making a deadline means that the photographic laboratory must be equipped to develop films and print the resulting negatives in the shortest possible time. By using concentrated developers and rapid fixers, the negative may be ready for printing while wet in three minutes. A dry print can be produced in another three minutes and the total elapsed processing time may be reduced to six minutes or less. For such rapid processing, sheet films are much easier to handle than roll films, although the same methods may be applied to both. Since these methods place emphasis on speed rather than quality, they are not recommended for general use.

Rapid processing techniques require the use of a developer with a high alkali content. New compounds permit the formation of super concentrates, which make possible faster development with less fog. This developer is now used with a stabilizing solution that eliminates the final wash and converts the unused silver halide into a non-light-sensitive complex, thus permitting unused silver to remain in the processed negative or print in a form that will not darken easily or decompose.

The best procedure for obtaining a dry negative quickly is to use two infrared lamps. The wet negative is placed between the two lamps and a fan is used to remove the evaporated moisture from the surface of the film and to prevent the negative from becoming overheated. With this arrangement, prints or negatives may be dried in one or two minutes.

Design of the Photo Lab

The design and organization of a photographic laboratory depends on the volume and nature of the work. A laboratory that requires space for each staff photographer to develop and print his own negatives will be arranged differently from one that uses a staff of technicians to do all the processing. However, certain basic rules apply in any case. One of these is the principle of standardization. The laboratory will function best when the same chemical solutions, papers, and films are used consistently. It is important to publish data sheets for the photographers so that variations from any standard procedure are noted. At the same time, when improvements in processing methods appear, the laboratory should test them thoroughly and decide whether these advances are suitable for their publication.

The photographic laboratory should be designed to create a logical flow of work. Exposed film should be received at the entrance to the laboratory. Negative developing, drying, and numbering should be a self-contained unit. Printing units should be close enough to developing sinks to avoid unnecessary steps. Enlargers should be shielded from each other to prevent fogging of paper, and prints washed, dried, and sorted in a white-lighted room. Prints are received from the safe-lighted area through a shielded pass-through in the wall. Chemicals are mixed in a separate location away from the laboratory. If the chemical room can be placed on an upper floor, the solutions can flow into the working area by gravity. The copy room should be self-sufficient with its own camera, lights, and negative developing room.

The modern photographic laboratory has temperature controlled sinks. The concept of a darkroom is obsolete. A photographic laboratory is considered an area in which the light is controlled. This is absolutely necessary for color processing. The various rooms must be adequately ventilated. Air conditioning, humidity control, and electronic dust precipitators will improve the quality of the work as well as improve the welfare and output of the personnel. In a large laboratory a dressing room and rest room should be available.

Special attention should be paid to the materials that go into the construction of a photographic laboratory for publications. The ceilings must be high enough to permit the use of vertical enlargers or copy camera setups. The walls must be washable and smooth enough to avoid dust

accumulation. The floors should also be washable as well as inert to chemicals and resilient to the foot. Sinks and plumbing should be constructed with the injurious effects of strong chemicals in mind. For this purpose stainless steel has been in use for some time and now fiberglass and reinforced plastics are available. The volume, pressure, and cleanliness of the water used are important. Electrical requirements should be carefully estimated and adequate wiring installed.

A major publication's photo lab.

(Top left) A technician processes black-and-white film with a choice of three developers. Exposure variations are compensated by inspection during development. (Top right) Negatives are cut into strips of five frames and contact printed. (Right) Enlargements are made to sizes indicated for layout or reproduction. Four types of printing paper are available in six grades of contrast.

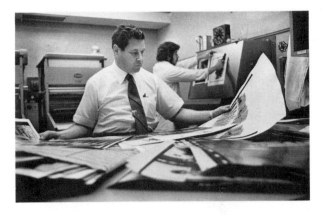

Prints are developed in temperature-controlled sinks. A hypo eliminator is used for permanence.

After washing and drying, all prints are carefully examined for quality control.

35mm color transparencies are duplicated by electronic flash. A fine grain panchromatic film is used for black-and-white negatives. Slow color duplicating emulsions minimize contrast.

Copying is done with five different types of 4″ x 5″ sheet film. Large color transparencies are exposed by electronic flash when copied.

The photographic laboratories of National Geographic Magazine are among the most modern in the country. Dry and wet stages of printmaking are separated in the National Geographic photo labs. Sharing a common aisle are a bank of enlargers and a series of sinks holding developer, hypo, and water. Once paper is exposed on the enlarging easel it goes into processing immediately.

A knowledge of the many printing variations that are possible in the photo lab is useful to the editor, designer, and photographer. Ordinary material may be given heightened interest and fresh appeal with the techniques illustrated.

The original photograph in a straight print.

A high-contrast positive is made by copying the straight print on Kodalith film and printing the copy negative on high-contrast paper.

A high-contrast negative is produced by making a Kodalith positive from the original negative and printing this on high-contrast paper.

A bas-relief effect is obtained by combining a positive film slightly off register with the original negative.

(Right) The effect of reticulation is produced on a copy negative. Before placing the negative in the fixer, it is warmed to 90°F to swell the emulsion and then plunged into 60°F water. The emulsion reticulates from the change in temperature. (Below left) Solarization is created by developing a copy negative for half of the normal time, then exposing it to light for two seconds. When development is completed, the negative will be partly reversed. A print is made on high-contrast paper. (Below right) Negative solarization is created by performing the same procedure as in solarization with a positive film.

(Above) Posterization occurs when three copy negatives are combined. One contains highlight detail, another the middle tones, and the third holds shadow detail. These are printed in register to create a tone separation. (Right) An anamorphic lens is used to distort the original in a vertical direction. (Below) A 90° variation of the anamorphic lens creates a horizontal distortion.

10

Privileges and Restrictions

Ethics and the Law

Ethical Standards

Good taste is such an elusive quality that most people cannot capture it. One would expect it to have a timeless quality so that the laws governing it would be immutable. Nothing could be further from the truth. The so-called good taste of the Victorian era is bad taste from our point of view. But from the practical standpoint of our profession we have to devise, for our own use and guidance, a working code of ethical standards. Any sharp deviation from this frame of reference we can safely label "in bad taste." Part of the code is unwritten but is perfectly understood by editors and photographers alike; some of it is written in the laws in the statute books covering libel, fraud, and copyright.

One thing is sure, bad taste is a marketable product. The demand for it is widespread and constant. On some newsstands there are huge stacks of horror and sex comic books and lurid paperback books and magazines that cater to the pornographic tastes of the buying public.

One might well conclude that the blame for bad taste may be placed on the buying public itself. With the law of supply and demand being what it is, one can expect publishers to go on printing the worst kind of tripe as long as the public will stand in line to buy it.

In every generation someone gets up and shouts, "Why don't editors educate the public taste, raise it to higher levels?" Some editors, in good conscience, have seriously tried to do just that and many have gone broke in the attempt.

Just what is bad taste? It is the use of photographs and text to create wrong impressions, to degrade, to defame, to pander to base emotions, to display the grotesque, the gross, the vulgar, or to take unfair advantage

This is one of the earliest courtroom photographs ever made. Taken by Dr. Erich Salomon in 1929 with a hidden Ermanox camera, one of the first miniatures, it resulted in his banishment from England when it was published.

of anyone during unusual emotional or physical stress or disaster, or to deceive deliberately.

President Franklin D. Roosevelt was not photographed walking because of his paralysis. Photographers, at least in part, considered the question of good taste. Women, on the other hand, have been photographed intimately during childbirth, a distressing physical effort of another kind for another reason; yet these pictures have been made with a sense of realism and good taste.

There is the classic shot of financier Morgan in a Senate hearing room holding a midget on his knee. Was this contrived bit of sensationalism in good taste? Perhaps. Being a celebrated public figure, Mr. Morgan had to surrender certain rights of privacy. He allowed the midget to be placed

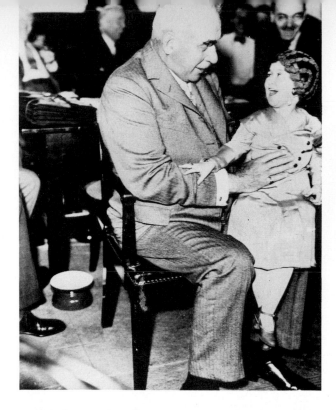

Just before a hearing of the United States Senate Banking and Currency Committee on June 1, 1933, a circus press agent placed a woman midget on the knee of financier J. P. Morgan. The use of this picture presented a problem in ethics for many editors.

on his knee, thereby giving consent. He was definitely a part of the day's news. The humor implicit in the situation was not lost upon him or the public. On the higher levels of ethics and good taste any particular editor could have rejected that picture. Very few invoked the privilege.

Editors' Responsibilities

Some of our most successful newspapers began by pandering to sensationalism. To capture the public imagination and to meet competition, they had to come up with something bold, daring, and almost not fit to print. But as the years went by, they found that accuracy and truth and something approaching good taste had to be substituted for raw indecency and libel. A few became well-known for their culture and sobriety and incorruptibility, such as the *Boston Evening Transcript*. There is a story of the Beacon Street butler who said, in announcing the arrival of representatives from several newspapers: "A man from the *Post,* a man from the *Globe,* and a *gentleman* from the *Boston Evening Transcript.*"

Or take Adolph Ochs' remark to an editor about the coverage of a murder case: "If a tabloid prints that sort of thing, it's smut; but when the *New York Times* prints it, it's a sociological study."

Editors are responsible for bad taste to the extent that they give out the assignments, to the extent that they set the rules and the policies, and to the extent that they know exactly what the law says in regard to libel, invasion of privacy, and so on. An editor often has said to a photographer, "I want this kind of a shot taken," or to a reporter, "I want to stress this angle of the subject's personality."

The great physicist, Albert Einstein, was asked to smile for a 72nd birthday photograph by Arthur Sasse. Demonstrating his buoyant good humor, Einstein stuck out his tongue. Many people complained that publication of the picture had destroyed a great man's dignity.

Many a cameraman and many a reporter have found certain assignments distasteful, even repugnant, and they carry them out with considerable loss of self-esteem. Few say, "I won't do it," or "I quit," but take these assignments as ordeals to be endured or the more unpleasant aspects of a bad situation competition so often spawns. They know that at the scene there will be other reporters and photographers working under the same instructions. "Get the story, get the picture," says the editor, "and let me worry about the ethics and the layout."

Photographers' Ethics

The photographer is not always blameless. He can use the camera to degrade, to defame, to shatter privacy, to invade intimacy; he can stress the vulgar, the cheap, the grotesque; he can take unfair advantage of people during emotional stress or disaster; he can deliberately deceive. Press agentry has some bad aspects, as far as ethics is concerned, and sometimes the photographer and the press agent combine their talents to over-exploit a tasty dish of cheesecake. Outright pornography is just a few shutter clicks away from bad taste. The nakedness of the human figure can be, and often is, art. But when it is posed in a suggestive manner or shot from certain angles, it can be salacious. The photographer knows the difference between the artistic and the vulgar, and he knows when his work is in bad taste, or he should. He knows that when he lowers his professional standards, he becomes the picture pimp.

It is obvious that the blame for bad taste rests with all who take part in the business of photography. The quiet countryside, mountains, lakes, trees, or prairies can hardly be shot in bad taste; however, human subjects,

male or female, consciously or unconsciously, can. Models can elect to pose in bad taste or refuse. Photographers can elect to shoot in bad taste or refuse. Editors can elect to use the resulting photographs or refuse.

Ethics is made up of three things that are common to everyone: One is education, another is sensibility, and the third is morality. Ethics is the kind of belief and principle that directs one's behavior and sets a pattern for judging the behavior of others.

We must not overlook the editor's use of the camera as an instrument of questionable ethics in propaganda. We know how atrocity pictures are faked and sold during a war. One set of pictures that was sold in Germany and captioned "American Atrocities" was re-sold by the same agent to Americans and labeled "German Atrocities."

The whole Prohibition Era fostered journalistic vulgarity with the press build-up of notorious gangsters. Since headlines contribute to a gangster's ego even to this day, one wonders if any ethics are involved in the constant overplay of crime news.

There is inconsistency in matters of ethics and the best rule is to let conscience be the guide. For one individual, this might mean opening the doors to obscenity. For another, it might mean nothing more than a calm continuance of work as an artist. One thing is certain, as long as the mind of man is free to seek, to inquire, to debate, and to change—and the capability to remake judgments is fundamental to our culture—the ethics of the photojournalist is truly the responsibility of all involved in the process of visual communication.

Every photojournalist must be aware of the basic legal aspects of his right to take photographs as well as the risks involved in their use. It is important for the photographer to know where he can operate. The photographer's right to shoot anything that is public is guaranteed by practically every state in the Union as well as by the First Amendment to the Constitution, which says, in part, that Congress shall make no law abridging the freedom of the press. Although this refers mainly to the *publication* of the photograph, the right to *take* photographs in a public place has never been abridged by a law or court decision. There is no statute that prevents the photographer from taking his camera into a place of public amusement, a museum, hotel, railroad station, or cafe; however, the management of these places can make whatever regulations it believes necessary and may actually exclude the cameraman. In some cases the management has a photographic concession or may have an arrangement with certain favorite photographers. Therefore it is wise to obtain permission in all cases before taking photographs. In general, though, the press photographer may legally photograph any person, scene, or occurrence in a public place, or any person, scene, or occurrence that may be observed from a public place.

As to what may be photographed: this resolves itself into property and personality. Any public building may be photographed, but a private

building such as a famous hotel or sporting arena may create difficulties. In a case involving Madison Square Garden and Universal Pictures, the motion picture company made a film about hockey and used Madison Square Garden as the locale for the film without the consent of the Garden. The court decision was that damages would have to be paid to the Garden for the publication of pictures of its building and the use of its name and publicity.

The government prohibits photographing money and securities, but this does not mean that photographers should avoid such subjects since the law is designed to prevent the photographer from passing off the securities as real money or securities. Thus, it is perfectly legal to photograph money, stamps, securities, being passed from hand to hand, or on a table.

As far as personalities are concerned the problem gets more complicated. In 1926 a federal court held that a public man cannot claim the right of privacy. This means that a man who is a candidate for public office, or who holds public office or who is a statesman, artist, or author cannot claim the right of privacy. A politician, an entertainer, a sports figure or someone involved in a crime or accident is in a position where the public's interest is so great that no complaint can be made about the taking or use of the picture.

Ownership

Every photojournalist is faced with the question of who owns the picture. The law states that whoever pays for the shooting of the picture owns it. The person who possesses the negatives and prints may not necessarily be the legal owner of the photograph. A staff photographer for a newspaper or magazine, therefore, has no rights in the photographs he makes for that publication. If a free-lance photographer has been hired by a publication to perform an assignment for it, unless he restricts the sale of these photographs, the publication then owns the right to them. It is possible for a photojournalist to license some rights and not to sell all the rights. The photographer can license the publication to use the picture for a special purpose or for one-time publication, or for a limited time.

Copyright

Every photographer who makes a photograph for himself is protected by the Copyright Statute. The law recognizes that the real value in a photograph is not just the paper, chemicals, and materials involved, but the skill, intellectual labor, and mental effort that made the photograph possible. The photojournalist should be aware that the law automatically copyrights every one of his creations without any effort or act on his part. This common law copyright exists from the time the picture is made until the time it is published. As soon as the photojournalist allows his picture to be published he loses the protection of the common law copyright and must then obtain a statutory copyright if he wishes to have the picture

protected. Such a copyright may be obtained by registering the picture with the Copyright Office in Washington. When a photograph has been copyrighted, the copyright symbol © must be affixed to it, plus the name or initials of the owner. Forms for copyrighting photographs may be obtained free of charge from the Registrar of Copyrights, Library of Congress, Washington, D.C. 20025. A statutory copyright in the United States lasts for 28 years and may be renewed for another 28 years.

Rights

Whether copyrighted or not, the photojournalist, especially the freelance, must be extremely careful in selling his photographs to a publication. Most magazines and newspapers like to obtain complete ownership and rights to a picture, including the right to sell it later and to syndicate it to other publications. The photojournalist should read the fine print of any letter or contract he signs so that his rights in the photograph are not abrogated. The best procedure in selling a photograph is to license its use for a specific purpose or for a limited period of time.

A photographer is legally classified as an artist, not a mechanic or manufacturer. This is an important consideration in his right to use the mails. The mails exclude photographs that can be described as obscene, lewd, or lascivious. They must not have a tendency to deprave or corrupt those whose minds are susceptible to immoral influence—the young, ignorant, or lacking in control of sexual impulses—who would be likely to come into contact with such pictures. However, a photojournalist may send through the post office any photograph that meets this test.

Libel

The photojournalist's restrictions are mainly those involving libel and the invasion of privacy. Libel is defined as defamation of character, which occurs when a person's reputation is damaged by showing him in a way that holds him up to hatred, ridicule, or contempt. If a picture is claimed to be libelous and the photographer or publication can prove that it represented the facts accurately, then there is no libel involved, no matter how injurious the picture may appear. In other words, truth is a complete defense in a case of libel. However, the photographer must be aware that the camera does not see what the eye does and, further, the reproduction of the photograph does not necessarily show what the camera sees. A famous libel case resulted from the testimonial for a brand of cigarettes by a gentleman jockey. The advertisement said, "Get a lift for that tired feeling." One of the photographs showed the rider holding a racing saddle. A tan strap from the saddle hung down in front of him to his knees. The effect of this photograph when reproduced was so grotesque, especially with respect to the advertising slogan, that the subject was held up to considerable embarrassment and ridicule. He sued and was awarded damages.

In another case, a newspaper lost a libel suit because in an article on evolution a man's picture was published alongside that of a gorilla. Still another case resulted from the peculiar qualities of orthochromatic film. In this situation, a girl was photographed receiving artificial respiration. Her bathing suit was light blue, and in the final reproduction in the newspaper it appeared as though she were nude.

Libel may also occur when a photograph is misused or improperly identified. This may result in an innocent person being falsely charged with some misconduct being shown in a photograph. Such situations point up the importance of accurate captions and correct left-to-right identifications of all people involved in a picture.

Invasion of Privacy

Although libel is an important restriction, the modern legal inhibition that concerns all photojournalists is the invasion of the right of privacy. This law has been developed in the past 50 years and resulted from the brilliant article by Justice Louis B. Brandeis, written for the *Harvard Law Review* in 1890. Brandeis' friend and partner, Samuel Warren, had just been married to a Boston society girl. On their honeymoon they were followed by reporters and photographers. This resulted in the youthful Brandeis' indignant article that complained about the inroads on the privacy of the individual by instantaneous photography.

The modern legal theory of the right of privacy holds that every person has the right not to have his picture published or his name publicized without his written consent. The law's purpose is to protect those who do not want undesirable publicity. There are now more than 25 states in which statutes or court decisions have established this right of privacy.

An individual loses his right to privacy if he is a public character. Also a person may not sue for invasion of his right to be let alone if the matter in which he is involved is of legitimate public concern or is legitimate news. There can be no suit for invasion of privacy if the person involved has given written consent to the use of his picture. It should be noted that in a right of privacy action the truth is no defense and is, in fact, immaterial and irrelevant. Lack of malice on the part of the photographer or the publication is no defense.

Cases Involving Invasion of Privacy

In 1939 a magazine published a picture with a caption, "Starving Glutton." This photograph showed a girl who was in the hospital because of a glandular deficiency and kept eating, but did not gain weight. The court ruled that publication of this photograph was an invasion of privacy. In another case, a magazine was doing a story on juvenile delinquency. One of its illustrations showed three boys loafing on a street corner. The implication was that such idleness led to juvenile delinquency. The boys' parents sued and collected for invasion of privacy and libel.

Consent for Publication of Photograph

Location_____

Date_____

For valuable considerations, I hereby give my consent to (photographer's name) and to anyone else whom he may authorize, to photograph me and to publish, at any time in the future, photographs of me, with or without my name, for any editorial, promotion, trade or other purpose whatever, except for testimonial and endorsement of product advertising.

SIGNATURE OF SUBJECT OF PHOTOGRAPH_____

ADDRESS_____ TEL. NO._____

WITNESSED BY_____

ADDRESS_____

Consent of Parent for Publication of Photograph
of Minor (under 21 years of age)

Location _____ Date _____

For valuable considerations, I_____(name of parent), hereby give my consent to (photographer's name), and to anyone else whom he may authorize to photograph and to publish, at any time in the future, photographs of my child,_____, (name of child), with or without his or her name, for editorial, promotion, trade or other purpose whatever, except for testimonial and endorsement of product advertising, and I hereby waive any rights I, or said minor child, might otherwise have in connection with the publication of such photographs.

SIGNATURE OF PARENT OR GUARDIAN_____

ADDRESS_____ TELEPHONE NO._____

SIGNATURE OF MINOR (IF OVER 16
 BUT UNDER 21 YEARS OF AGE)_____

WITNESSED BY_____

ADDRESS_____

210

Standard Form Model Release

In consideration of $1.00 and other valuable consideration paid to me by

(the "photographer"), receipt of which is acknowledged, I consent for all purposes to the sale, reproduction and/or use of photographs of me (with or without the use of my name), by the photographer and by any nominee or designee of the photographer (including any agency, client, or periodical or other publication) in all forms and media and in all manners, including advertising, trade, display, editorial, art and exhibition.

In giving this consent, I release the photographer, his nominees and designees from liability for any violation of any personal or proprietary right I may have in connection with such sale, reproduction or use.

I am more than twenty-one years of age.

(signed)_____

WITNESS:_____

DATE:_____

Guardian's Consent

I am the parent and guardian of the minor named above and have the legal authority to execute the above consent and release. I approve the foregoing and waive any rights in the premises.

(signed)_____

WITNESS:_____

DATE:_____

These are samples of typical model-release forms. These forms do not need to be elaborate but they are necessary when photographs are used in advertising or promotion and are desirable for many editorial uses.

On the other hand, a public entertainer and fan dancer was photographed in a revealing pose by a photographer in a night club. The court maintained that the entertainer had no privacy, therefore there could be no invasion of privacy.

Even a written release has its limitations. A skilled lens grinder was drafted from his job in an optical company. While in the army he agreed to allow his picture to be used for wartime publications. When he returned to his job he found the same photographs being used to sell and promote the company's product. The lens grinder sued for invasion of privacy and collected.

A private individual does not waive his rights when he walks or rides on a public street. A news picture of an automobile accident was used 20 months later by a magazine to illustrate an article on safe driving. One of the victims of the accident sued the magazine and recovered damages for invasion of privacy.

In an interesting case in California, a man and his wife were seated in their shop at the Los Angeles Farmer's Market, which is a public place. The couple was photographed in an affectionate pose. This picture was published by a magazine to illustrate problems in marriage. When the husband and wife sued for invasion of privacy, the magazine claimed that the photograph was being used as part of a news event. The court held that it was not and made a very important statement that affects every photographer who might want to take a striking picture by singling out an individual from a crowd and catching him in an unusual pose: "Members of the opposite sexes engaging in amorous demonstrations should be protected from the broadcast of that most intimate relation. Nothing could be more intrinsically personal or more within the area of a person's private affairs than the expression of the emotions and feeling between such persons. This should be true though the display is in a public place. They may be unthinking of the stares of those in the vicinity and thus unaffected by them, but that is far from consenting to the photographing of their likeness and publishing them in a magazine."

Precautions

In determining his restrictions as far as the rights of privacy of the subject are concerned, the photojournalist may be guided by the following: there is no problem if the photograph is to be used for current news purposes or if it is to be used in an informative and educational story in which the public has interest. However, if the photograph is used in a strained connection, if it has no legitimate relation to the caption or text, if it is used to promote the sale of the publication, if it is used in fiction or in advertising, then a carefully worded written release must be signed by the subject. It should be noted that the cover of a magazine is considered a trade or advertising use and a written release here is very important. The photojournalist who makes feature pictures obviously may be more

likely to invade the privacy of individuals than one who does news photography. The photographer who goes into his files and selects an old photograph to be used in some new context may also be guilty of violating the law.

Workman's Compensation

A precedent-setting ruling that is of special interest to staff photographers on newspapers and magazines was the decision of the New York State Board of Compensation. On August 26, 1952, the New York *Post* staff photographer, Sam Mellor, was covering General Eisenhower in an American Legion parade. It was a hot and sultry day and Mellor was carrying a bag of heavy photographic equipment. He chased the General's car for

This is another famous "stolen" photograph—the verdict of guilty by the jury which decided the fate of Bruno Hauptmann on charges of kidnapping the Lindbergh baby. Despite the judge's threat of a six-month sentence if a camera were found in court, Richard Sarno smuggled a 35mm Contax into the dim-lit courtroom and made a one-sec. exposure at *f*/2 as the jury foreman announced the verdict. This picture made almost every front page in this country and abroad. Many used it a full eight columns.

over a mile, then collapsed and died in a doorway. The Board granted his widow funeral expenses and a pension of $21 a week for her lifetime. The ruling was that Mellor's death was considered to be the result of an industrial accident and his heirs were entitled to compensation.

Photographer's Civil Rights

In another case, a precedent was established that makes it clear that the violation of a photographer's civil rights will not be tolerated by the United States Government. The police chief of Newport, Ky., had seized the camera of a photographer from the Louisville *Courier-Journal* and destroyed the films taken during the course of a gambling raid and then arrested and jailed the photographer. The Department of Justice obtained a conviction against the police chief and he was fined $1,000. A camera and photographic equipment are personal property in the eyes of the law as well as in the eyes of the photographer's employer. If any law-enforcement officer confiscates such equipment or film, he is violating the Constitution, which states that no person shall be deprived of his personal property without due process of law.

Professional Societies

One of the most vigorous professional societies dedicated to the advancement of photojournalism is the National Press Photographer's Association, which was founded in 1945. It has the following basic aims:

1. To help every press photographer to become more proficient in his craft by attaining greater technical competence.
2. To give all possible assistance to colleges and universities that are training press photographers.
3. To make it possible for every press photographer to function in the public interest without fear of illegal interference or physical attack.
4. To make a firm and continuous effort to open public doors now closed to the news camera by the courts, legislatures, and government groups.
5. To represent the press photographer at the national level in dealing with military and civil agencies of the government.
6. To establish an employment clearing house for the benefit of both publishers and photographers.
7. To encourage and assist manufacturers in developing and producing better technical equipment needed by press photographers in keeping photo reporting abreast of the times.

The membership of the NPPA consists of photojournalists connected with the nation's newspapers, wire services, magazines, newsreel, and television companies. It is an organization concerned primarily with craftsmanship and technique.

One of the most effective campaigns of the NPPA has been dedicated toward the relaxation of Canon 35, adopted by the American Bar Association, which prohibits the taking of photographs in courtrooms. The arguments against continuation of this rule are based on the fact that modern news photographers use equipment that is much more unobtrusive and less conspicuous than the equipment used at the time the rule was adopted. Today, picture reporting is considered on a par with word reporting in presenting the news. Photography in the courtroom is necessary in order for the press to conform to its obligation to inform the public by means of discreet photographic journalism.

Another professional organization of photojournalists is the American Society of Magazine Photographers, now officially called the Society of Photographers in Communication. This group includes among its members some of the most creative and talented editorial photojournalists in the world. Since the majority of its members are free-lance photographers, the Society has concerned itself primarily with creating economic order in the field. Agreements have been concluded with many magazines concerning rates of pay and use of photography.

In addition to the problem of maintaining economic security for its members, the ASMP provides stimulating forums where ideas can be exchanged freely. It encourages close contact between member photographers and editors who are concerned about magazine photography. It is concerned with furthering technological advances and creative opportunities. The members of the ASMP are interested in seeing better editing, better layouts, better research, and better reproduction because they want to see their photographs displayed to the best possible advantage. They also know that as circulation and advertising of magazines increase, their economic well-being increases also.

The Attorney General of the United States has said that in every phase of life—political, economic, social, religious, or educational—the proper use of photography can be an instrument of good, of unity, of reason, of tolerance, of justice for mankind. The photojournalist is urged to use his great power and freedom wisely and faithfully for the benefit of the people to whom the freedom of the press belongs.

Summarizing Questions and Practical Exercises

The following summarizing questions and practical exercises relate to each chapter. Readers will find these helpful for a thorough understanding of the subject.

Chapter 1

Summarizing Questions

1. Why is photography a universal language?
2. Describe two basic inventions that contributed to the growth of modern photojournalism.
3. What are the four characteristics of the photographic process that are important for the journalist?
4. If the camera is an honest observer, how can some photographs be misleading?
5. What is the relationship between documentary photography and photojournalism?
6. Give an example of a situation where the photograph may reveal more than the eye can see.
7. Why are ideas for stories important?
8. List the requirements for a successful photojournalist.
9. When photographs are sold, what is meant by first rights?

Practical Exercises

1. From magazines and newspapers, clip examples of the following photographs:
 A. One where the photographer was an eyewitness to an event.
 B. One that emphasizes pictorial qualities of composition.

216

C. A straightforward record photo.

D. A photograph that comments on society.

2. Write a paragraph describing an idea for a story with visual impact that you would like to photograph for *Today* magazine.

3. Assume that you have completed an assignment for *Today* magazine. Note their rates on page 33. You worked for three days. Your pictures have been published in four pages of black-and-white with a cover in color. Prepare an invoice for the amount you should receive for the job.

Chapter 2

Summarizing Questions

1. What are the characteristics of a news photograph?
2. Describe the three basic requirements for successful news photo coverage.
3. Why is a small unobtrusive camera desirable for news photography?
4. How is a caption written?
5. What are the special requirements for sports photography?
6. List the desirable personal qualifications for the news photographer.
7. How does a news photo wire service operate?
8. In what way is news photo coverage affected by television?

Practical Exercises

1. Clip an example of each type of news photo as follows:
 A. Foreign news.
 B. Local news.
 C. Sports action.
 D. Fashion.
 E. Entertainment.

2. Describe the camera, lenses, films, lights, and any other equipment you would choose to photograph the following:
 A. An automobile accident in a busy city street at noon.
 B. A political demonstration at night.
 C. The presentation of an award at a hotel banquet.
 D. A rocket launching.
 E. A ballet dancer on stage.
 F. An oil painting.
 G. The image on a television tube.

3. Produce a quick news personality portrait. Select a subject in an appropriate location, home, office, store, or outdoors. Using a single light or none at all, make as many pictures as possible in five minutes. This includes the time to arrange the subject, suggest a pose, adjust the lights, and check the exposure.

Chapter 3

Summarizing Questions

1. How does a feature photograph differ from spot news?
2. What is the contribution of effective composition?
3. Describe three ways to create the illusion of motion.
4. Explain the difference between a news photograph and one made for public relations purposes.
5. What is the "third effect"?

Practical Exercises

1. Clip a magazine or newspaper photograph that demonstrates the use of creative photographic technique.
2. Analyze the composition of a photograph you admire.
3. Create a juxtaposition of photographs with new significance.
4. Photograph a group of people at a meeting. Use the existing light, but adjust your viewpoint, angle, and vary your lenses to produce several group arrangements. Analyze the results to determine which is best.

Chapter 4

Summarizing Questions

1. What are the unique qualities of a photo sequence?
2. What was history's first photo sequence?
3. Describe four types of photo sequences.

Practical Exercises

1. Clip a photo sequence from a publication.
2. Give an example of a situation in which a photo sequence reveals more than a single photograph.

Chapter 5

Summarizing Questions

1. Describe three ways to use related pictures in continuity to tell a story.
2. Explain the five essential qualities of successful picture stories.
3. When shooting a picture story, what three points should the photographer remember to cover?
4. How does a photo essay differ from a picture story?

Practical Exercises

1. Select an idea for a picture story that you would like to produce. Write a shooting script indicating the photographic situations that should be covered.

2. Select one of the ideas from the list starting on page 147 and produce a series of related photographs. Assemble these to make a picture story or photo essay.

Chapter 6

Summarizing Questions

1. Why are photographers poor editors of their own work?
2. What are the functions of the photo editor?
3. Why are exclusive photos desirable?
4. List five sources for photographs.
5. How is a photographer paid for his work?
6. When selling his pictures, what are the photographer's responsibilities to the publication?
7. What are the requirements of a good filing system?

Practical Exercises

1. Write a memorandum to a photographer describing an assignment with information as to how it should be covered.
2. Prepare some photographs for submission to a publication.

Chapter 7

Summarizing Questions

1. How does the presentation of photographs on the printed page differ from the continuity of cinema and television?
2. What is the contribution of design and layout to the impact of the photograph?
3. Describe how form follows function in layout.
4. What are four reasons for cropping photographs?
5. How do the cover of a magazine and the front page of a newspaper relate to the reader?
6. Explain the three forms of printing used in publications.

Practical Exercises

1. Design a cover for the magazine *Today*.
2. Analyze the layout of the front page of your local newspaper.
3. Make a pair of cardboard L-shaped pieces for cropping. Place these over any picture with variety in it and see how many different images you can create. Change the shape to horizontal, vertical, or square. Select the most important elements; remove distractions. Which arrangement makes the message most direct?

Chapter 8

Summarizing Questions

1. Describe the special qualities of 35mm, 120/220, and sheet film cameras.

2. Under what conditions would you select a telephoto lens?
3. When is a wide-angle lens required?
4. How does the choice of equipment influence the work of the photo-journalist?

Practical Exercises

1. Clip a picture from a publication and describe the equipment that may have been used to produce the photograph.
2. List the equipment you would use to cover a football game.
3. List the equipment you would choose to photograph an African safari.
4. List the equipment you would select for photographing a theatrical performance.
5. What equipment would you need to copy an oil painting?

Chapter 9

Summarizing Questions

1. What services are performed by the photographic laboratory?
2. Should a photographer develop and print his own pictures?
3. How does the photo lab protect the photojournalist when on a long assignment?
4. Describe the techniques for rapid processing.

Practical Exercises

1. Design a photographic laboratory that will perform the services required by a newspaper of 50,000 daily circulation.
2. Design a photographic laboratory for a regional magazine with three staff photographers.

Chapter 10

Summarizing Questions

1. How does the First Amendment protect the photojournalist?
2. What is the procedure for copyright?
3. Explain the difference between libel and invasion of privacy.
4. When is a written release desirable?
5. How do professional organizations benefit the photographer?

Practical Exercises

1. Clip photographs from publications that demonstrate the photojournalist's freedom to operate.
2. Using illustrations from current newspapers and magazines, show how society's changing moral views have affected the subject and treatment of published photographs.

Reproduction Rights

The following definitions may prove helpful to the photographer:

Photograph: A print, engraving, photograph, negative, color transparency, or any illustration capable of being reproduced, whether taken by a photographer, copied, photographed, or created.

Photographer: One who owns or controls the reproduction rights to a photograph.

Purchaser: One who seeks to obtain the use of or any reproduction rights to a photograph.

All rights: The permanent transfer of all right, title, and interest in and to a photograph by the photographer to the purchaser of such rights, with the guarantee by photographer that no duplicate photograph will be offered for sale or rental to any other person during this period.

First reproduction rights: The release of a photograph by a photographer for a specific period of time but not more than one year, to the purchaser at a premium reproduction fee for the privilege of being the first to use the photograph. First reproduction rights do not involve transfer of permanent ownership of the photograph to the purchaser. After the purchaser shall have exercised his right to use the photograph, the photographer may offer second reproduction rights to others. If not used within the specified period of time, first reproduction rights are automatically forfeited.

Second reproduction rights: The release of a photograph by the photographer to any purchasers subsequent to the expiration of the option period to exercise the right to be the first to reproduce the photograph, or the exercised right to so reproduce.

Exclusive rights: The exclusive use of a photograph offered by the photographer to the purchaser in a specified field for a specified period of time.

Single reproduction rights: Rights to a photograph offered by the photographer to the purchaser for one-time or single reproduction only, in one publication or media or for the specified and agreed upon purpose, and within a specified period of time. Use of the same photograph on the cover and in the inner pages of the publication constitutes more than one-time reproduction and shall be subject to a fee for each such reproduction of the photograph in the same publication.

Country rights: The sale of a photograph by the photographer to the

purchaser for any of the reproduction rights indicated only for use in that particular country.

Language rights: The sale of a photograph by the photographer to the purchaser for use in a particular book, publication, or periodical that is printed in a particular language whether in the United States of America or abroad.

First North American rights: The release of a photograph by the photographer to the purchaser for sole or syndicated use, in a newspaper or magazine within a specified period of time.

Serial rights: First serial rights: The reproduction of a photograph in a newspaper or magazine prior to book reproduction. *Second serial rights:* The reproduction of a photograph subsequent to book reproduction, either in newspapers or magazines.

Periodical rights: Released, on rental basis only, and in accordance with terms and conditions of submission, for one-time reproduction only in one issue of one publication only.

Book rights: Released, on rental basis only, and in accordance with terms to reproduce above described photograph(s) is granted for first United States edition only of the book entitled by and separate fee must be paid for each subsequent edition, revised edition, foreign edition, and/or foreign language edition of the aforesaid book containing (any of) the above described photograph(s) in United States or foreign newspapers or magazines without additional payment for such use.

PHOTO CREDITS

All photographs are by the author, except those credited in the captions or below.

Fig. I-1: L. Wright: George Eastman House. **I-7:** Library of Congress. **II-1-10:** Nick De Sciose. **II-15:** Wide World. **II-16:** Fred Hansen: © New York *News.* **II-17:** Joseph Costa: © New York *News.* **II-18-19-20:** Murray Becker: A.P. **II-21:** N. Wong: U.P.I. **II-22-23-24:** Joe Rosenthal: © A.P. **II-25:** Sam Caldwell: *St. Louis Post-Dispatch.* **II-26:** Keystone. **II-38:** Bob Jackson: © Dallas *Times Herald.* **II-40:** Wide World. **II-52:** Wide World. **III-14:** Maurice Terrell. **III-15:** Frank Bauman. **III-16:** Frank Bauman. **III-17:** Bert Emanuel: Detroit *Free Press.* **VI-1-2:** U.P.I. **VI-10-11:** A.P. **VI-12-20:** James Hansen. **VIII-7 & VIII-8:** Frank Bauman. **VIII-9:** Paul Berg. **IX-6-9:** Si Solow. **IX-10-12:** National Geographic Society.

Index

ORACLE STAFF
Denfeld H. S.
44 th Ave. W.&4th St.
Duluth, Minn. 55807